OCT 97

GUIDE to CARTOONING

AL BOHL

PELICAN PUBLISHING COMPANY
Gretna 1997

*The word "Pelican" and the depiction of a pelican are trademarks
of Pelican Publishing Company, Inc., and are registered
in the U.S. Patent and Trademark Office.*

Library of Congress Cataloging-in-Publication Data

Bohl, Al.
 Guide to cartooning / Al Bohl.
 p. cm.
 Summary: Provides instructions for drawing different styles of
cartooning, including political, strips, books, and illustration, and gives
advice on how to get a job in the field.
 ISBN 1-56554-177-4 (alk. paper)
 1. Cartooning—Juvenile literature. [1. Cartooning—Technique.
2. Drawing—Technique. 3. Cartooning—Vocational guidance.
4. Vocational guidance.] I. Title.
NC1320.B66 1997
741.5—dc21
 96-44340
 CIP
 AC

Manufactured in the United States of America

Published by Pelican Publishing Company, Inc.
1101 Monroe Street, Gretna, Louisiana 70053

CONTENTS

ACKNOWLEDGMENTS

I dedicate this book to my wife Doris and our children: Aaron, Allison, and Alex. Thank you for giving me the time and encouragement to write this book. I also dedicate this book to my parents, Henry and Auline Bohl. You have always loved and believed in me.

I gratefully acknowledge Steve Helm who provided the computer on which I wrote this manuscript. I appreciate Harold and Diane Buchholz for their wisdom and input into the chapter on animation. Finally, I acknowledge with gratitude Al Hartley and Rich Buckler, who inspired me and taught me how to write comic books.

CHAPTER ONE

INTRODUCTION

A cartoon is defined in the dictionary as a drawing that caricatures, often satirically, some situation or person. The word "cartoon" was originally used to mean a preliminary drawing or sketch for a fresco painting or tapestry. It was derived from the Italian word *cartone*, which means heavy paper. Cartoon and carton (as in cardboard box) have the same root meaning. Cartoon received its popular connotation in the 1800s when caricature was imported into England from Italy as an aristocratic humorous diversion. John Leech is credited with first using the word cartoon to mean something other than an initial drawing.

As this course of study will prove, the use of the term cartoon has broadened considerably. There are as many different styles of cartooning art as there are artists to render them. These drawings can range in appearance from very loose to painstakingly realistic and still be labeled simply as cartoons. No two cartoonists' doodles are exactly alike.

I view cartooning mostly as a form of communicating ideas. Too often, people wrongly see cartooning as a shorthand version of *real* art. Good cartooning varies in art styles from the barest essentials to fantastically elaborate and ornate.

Cartooning is an abstract art form that has its roots dating back to the earliest writings of man. Of course, they didn't refer to these cave scratchings as cartoons. Nevertheless, that's what they resemble.

Cartooning has always enjoyed a wide range of fans in virtually every demographic group. Every day

these gentle folk pick up their newspaper and read the "funnies." They even turn their refrigerators into makeshift humorous art galleries. Children sit mesmerized in front of the television watching an animated cartoon or playing video games based on cartoon characters. The comic book genre was once considered to be a "kiddy thing" but is now a favorite of children and adults alike. The motion picture industry is spending and making millions of dollars on cartoon heroes. Since the births of movies and television, it has been very popular to have live actors play the parts of cartoon characters.

Millions of people annually reach for a cartoon greeting card to say "I love you!" College courses and even entire technical schools are dedicated to teaching cartooning for earned credit or as a trade. Museums are springing up in this country that fill their galleries with purely funny drawings. Traveling cartoon exhibits are always well received, wherever they're displayed. Political masks are exposed and challenged daily with ink pen, paper, and razor-sharp wit.

Imagine for a moment, if one can, a world without cartoons. What would our world be like? The first assignment in this course will be for you to go to a large variety department store near you and make a list of all the items that have a cartoon image on the package or the actual article. This exercise should surprise you when you realize how ingrained cartoons have become in the literal "fabric" of our society.

People of all ages have asked me to give them the

secret of becoming a good artist. I always tell them the same answer: *draw, draw, draw.* This book is filled with *Golden Nuggets* of information. You must apply them and then join me in the never-ending search for other golden nuggets of cartooning bliss. The following book will introduce you to and instruct you in the various dynamic avenues of cartooning.

THE HISTORY OF CARTOONING

This book will cover the subjects of greeting cards, illustration, editorial cartoons, animation, comic strips, and comic books. The following is a brief history of each subject in its approximate order of creation. Determining an accurate order was somewhat difficult due to the fact that the individual origins split off from the same family tree. It is very possible that historians could find a reason that the chronological order of these subjects should be different than I propose. To them I apologize, but I did my best to put them in order.

GREETING CARDS

The Egyptians were believed to be the first to go into the "social expressions" business; they scratched New Year's greetings into scrolls of papyrus. The Chinese and the Romans sent greetings pressed in clay, written on scrolls, or in the form of metal coins.

The oldest existing holiday greeting card was printed in Germany in A.D. 1450. No one at that time saw it as a way of making a living, since travel and any kind of postal service were still slow.

In the 1700s, children in Europe created handmade Christmas cards for their parents in order to demonstrate their educational progress. This quickly became a holiday tradition that adults embraced. Today, the Christmas card is still the most popular card given.

Cards were first mass-produced on the printing press in England during the early years of the 19th century. In 1843, John Calcott Horsley designed the first American Christmas card, which was a combination seasonal greeting and business advertisement. The first American greeting cards were published in 1846 in Boston by Louis Prang. He believed that the mass population was reached through their hearts. Mr. Prang and a man named Albert Davis developed the greeting card concept into an industry.

In the 1920s, the Hall brothers began the Hallmark company. Currently, Hallmark is joined by American Greetings and Gibson as the three largest card companies, controlling 91 percent of the market share. In spite of these three giants, there are almost 1500 smaller publishers doing quite well in the business too.

BOOK, NEWSPAPER, AND MAGAZINE ILLUSTRATION

Illustration is as old as man. Art seems to have appeared in societies as soon as they could establish a consistent supply of food, water, and shelter. The first illustrators worked on the walls of caves and other dwellings.

Next, they apparently started decorating their homes and religious and civic buildings. They drew on weapons, tools, clothing, household goods, and other items for religious and historical remembrances. Look around most dwellings of today and you realize that we haven't changed much through time.

Books

The first books were nothing like our modern books. They were pressed into wet clay tablets and baked dry some 5500 years ago in Babylon and Ninevah. The Egyptians used a reedlike plant called *papyrus* to make an early form of paper. Actually, the word "paper" comes from the word "papyrus." This papyrus roll or scroll served the world until the time of the Romans.

The first illustrations were called *illuminations*. They were hand drawn on manuscripts and consisted of elaborate initial lettering, various designs, and pictures. The Romans also used the roll form of book, but it was hand lettered on parchment paper made of the treated skin of lambs, calves, or kids (baby goats). This paper was called *vellum*.

The roll book was used until A.D. 300, when a new form of book appeared called a *codex*. It was made up of three or four sheets of vellum folded into a section called a *gathering*. The gatherings were sewn together into a book.

The birth of the modern book has to be divided into two origins because there were unique circumstances surrounding these events. Due to the separatist beliefs of the Chinese, there is no known

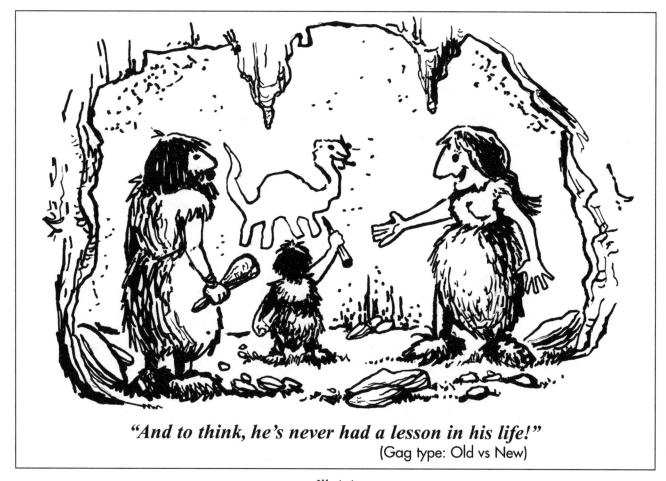

"And to think, he's never had a lesson in his life!"
(Gag type: Old vs New)

Ill. 1-1

inventive link between their first books and those created by the Europeans. The Chinese were hundreds of years ahead of the Europeans. The German manner of approaching the creative problems in invention reflects no exchange of research with the Orientals.

The first illustrated book was printed by the Chinese, using wood-block printing, as early as A.D. 770. The Chinese had been making paper from wood fibers since around A.D. 105. Sometimes they combined wood-block pictures into *block books*. This process was painfully slow, so only a few books were made.

In about A.D. 1040, a Chinese printer named Pi Sheng made *movable type* out of clay. Movable type is where each letter or symbol is an individual piece. These pieces are then arranged and bunched together by hand. Ink is applied to the type and it is printed, or pressed, onto the desired surface. The printer can separate and rearrange the type again for the next printing. Pi Sheng used separate pieces of clay for each letter of type. This didn't become a popular printing method because the Chinese language has several thousand separate characters. Actually, the carved wooden blocks were easier to make, and less expensive.

Four hundred years later in Europe, a German printer named Johannes Gutenberg succeeded in his experiments with movable type. As stated earlier, there is no evidence that he got his idea from the Chinese. Therefore, he is regarded as the inventor of movable type. He is also noted as the first to print in another color (red) instead of black. The publication of the Gutenberg Bible some time before A.D. 1456 marked the beginning of the history of the modern book. It was also called the 42-Line Bible because each column contained forty-two lines of type. This Bible isn't considered to be the first book printed, but it certainly was one of the first.

The first illustrated book after Gutenberg's movable type invention was printed in 1461 in Bamberg, Germany, by a printer named Albrecht Pfister. His illustrations were printed from woodcuts. Often, early book illustrations were colored by hand. The woodcut was replaced in the late 1500s by the process of engraving on copperplates.

The invention of movable type made books accessible to the masses and accelerated the literacy of the common people. Words and art have always enjoyed a happy union. The enjoyment of books quickly led to ways of communicating thoughts in a more timely and disposable manner.

Newspapers

The Chinese are again credited for their literary powers of invention. *Tsing Pao* was probably the first newspaper. It began in about A.D. 500 and continued until 1935.

In Europe, the forerunner of the newspaper was the handwritten newsletter. Romans posted bulletins of daily events in the Forum in 60 B.C., which were copied by scribes and sent out as newsletters to businessmen and politicians to keep them informed of the happenings of Rome.

After Gutenberg's invention of movable type, news pamphlets were occasionally issued. These news pamphlets didn't catch on quickly because governmental rules frowned on any negative publicity, and besides, most people still couldn't read. The first European newspaper, the *Strasburg Relation,* was issued on a regular basis in A.D. 1609.

The first American newspaper was published on a continuing basis by John Campbell in 1704. Another Boston-based paper was the *New England Courant* in 1721 by James Franklin. He employed his younger brother, Benjamin. American newspapers received a big boost during the Revolutionary War because George Washington and Thomas Jefferson appreciated their help in building and maintaining patriotic morale. Cartoons and illustrations filled these papers before photography became commonplace.

The papers of the early 1800s were mostly political in their editorial and news stories. These papers cost six cents each. The populace couldn't easily afford these, so the Penny Papers were started in the 1830s. The penny papers were smaller in size, and gave more attention to news events than politics. From this meager beginning, the newspapers traveled west with the pioneers and soon blanketed the entire nation. In the 1900s larger newspapers began to merge into chains of ownership. This refining practice of consolidating newspapers is still happening today.

Magazines

Magazines are really a hybrid of the newspaper, so it is difficult to point to one specific time of origin. The earliest magazines were probably developed from newspapers or pamphlets. The *Gentlemen's Magazine* from England, in 1731, was among the first real magazines. It began as a compilation of previously published pamphlets and newspaper articles, although it wasn't long until it began generating its own original material.

Benjamin Franklin's *Journal Magazine* was one of the first magazines published in America. Many magazines have influenced American thought. The drawings of Civil War battles made readers turn to *Harper's Weekly.* Hundreds of magazines have come and gone since the *Journal* or *Harper's Weekly.* Styles and formats have changed as well. But there is still a place for creative cartoon illustrators.

POLITICAL AND EDITORIAL CARTOONING

Every society has spawned its own artists with an eye for criticism. The Egyptians, the Greeks, the Romans, and the Chinese all show historical evidence of politically oriented cartooning. During the Middle Ages a lot of cartoons and caricature dealt with religious themes, especially death and the devil. These have been found in prayer books and churches to remind believers of their need to remain faithful. Of course, not all of these cartoons were aimed at the negative aspects of religion.

In the 17th to the 19th centuries, we have what is known as the time of the "Old Masters" of political cartooning. Some consider this time period to extend into the 1950s of the 20th century. These centuries were times of great exploration and discovery, with the founding of America, the French and American Revolutions, the U.S. Civil War, and the continuation of the Industrial Revolution. People tasted freedom and the grip of the royal ruling classes

were wrenched free to make way for the great experiment of "government by the people." We find that even these early cartoonists often wrote words within their art to show who the cartoon was about, and even used speech balloons to further explain their message.

The Old Masters

Little is known of who actually drew the first political cartoons and caricatures, because they didn't sign their work. The first of renown was William Hogarth (1697-1764), a noted social and political caricaturist before he became a famous English painter.

Benjamin Franklin (1706-1790) is considered the father of American editorial cartooning. His now famous cartoon of a cut-up snake served three separate times as a call to action. It was used during the French and Indian War, the Stamp Act, and when the colonies revolted. Each segment of the snake represented a colony.

James Gillray (1757-1815) is regarded by many to be the best British satirical artist ever. Some considered him to be the foremost living artist in all of Europe at the time. He was brutal in his portrayal of the ruling class, especially King George III. In 1802, Gillray's art entitled *The Consequences of a Successful French Landing* aroused such patriotism that Napoleon had to drop his plans of invading England. Even while he was alive, Gillray's work was considered highly collectible.

Robert Cruikshank (1789-1856) and his brother George were famous British cartoonists who were mostly noteworthy because of their ability to inspire other people to be cartoonists. John Leech (1817-1864) is an example of this; he started out drawing in a style very similar to the Cruikshanks. His own style developed as he became more politically oriented. He drew some of his greatest work in *Punch* magazine for twenty years. In 1843 John Leech first coined the word "cartoon" to mean a humorous drawing instead of a preliminary sketch for a fresco. Up to this point, cartoons had simply been called caricatures. *Punch* was founded in England in 1841. It dominated 19th-century caricature as the most famous and longest-lasting satirical journal in the world. But *Punch* didn't have any artists who were as good as the Frenchman Honoré Daumier or the American Thomas Nast.

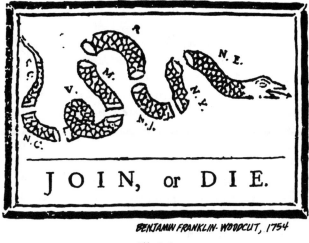

BENJAMIN FRANKLIN- WOODCUT, 1754

Ill. 1-2

The *Punch* cartoonists lacked the anger and prophetic fervor of the caricaturists before them.

Honoré Daumier (1808-1874) is considered the greatest political cartoonist of all time. He especially detested the ruling class of Paris, France. One of his cartoons decrying King Louis Philippe caused such a disturbance that Daumier and his publisher were imprisoned for six months. He emerged from jail with more fire in his pen than ever. He served to shine the spotlight on social and political injustice until he eventually became blind. Daumier showed a wonderful flair for dynamic anatomy and grotesque caricature.

After Ben Franklin, very little is known about political cartoonists in the United States at that time, because many cartoons were produced but few were signed by the cartoonists. This was the case until the German-born Thomas Nast (1840-1902) came along. He is thought by many to be the greatest editorial cartoonist of the Civil War, and possibly of all American history. (When it comes to greatness, sometimes timing is everything.) With the build-up of tensions between the North and the South, newspapers and reporters became increasingly partisan. As a staunch Republican (which was different then from the current political party bearing that name), Nast dangled the Democrats over a very hot flame.

After the Civil War, he crusaded for minorities such as the American Indian and the Chinese, but his most famous fight was with Boss Tweed and the corrupt Tammany Hall government in New York

City. Nast used the symbolism of a tiger to represent the ferocious power of Tammany Hall.

Nast is also credited with inventing the Republican Party's elephant, the Democratic Party's donkey, and our current representation of Santa Claus. Uncle Sam, another character prominent in editorial cartoons, was created by an unknown artist in the 1880s, and was partially developed by Nast. The term "Uncle Sam" dates back to the War of 1812.

The magazine *Harper's Weekly*, founded in 1857, was the first American publication to firmly establish itself in the field of political caricature. It was followed two years later by *Vanity Fair*. Other cartoonists of the late 1800s who deserve mention are Charles Stanley Reinhart, Joseph Keppler, Bror Thure Thulstrup, Homer Davenport, Frederick Burr Opper, and Thomas E. Powers. Most of these were somewhat in the shadow of Nast and were stuck with using symbols developed by him. If you couldn't draw a tiger, you wouldn't get much work during the crusade to stop Tammany Hall.

By the turn of the century, the American continent was colonized and newspapers were firmly established. Editorial and sports cartoonists became too numerous to count. The format of the political cartoon was established; all who have followed have served to refine more than pioneer. Editorial cartoonists have remained close to the mainstream of global thinking, and their daily work can tell us a great deal about what people worried about, or laughed at, during different times of history.

ANIMATION

Evidence of early animation dates back to the time of the cave dwellers. These early artists rendered consecutive drawings, even overlapping animals' limbs and superimposing animals on top of each other in an apparent attempt to explain or understand movement. Greek and Roman soldiers carved or painted small figures on the outer portion of their shields. A fellow comrade at arms would be entertained by looking at one spot as the soldier rotated his shield.

It wasn't until the 17th century that moving pictures were given any serious thought. In 1640, Althanasius Kircher, a Jesuit, invented a "magic lantern" which is similar to our modern slide projector. Along with another clergyman, Gaspar Schott, he created a primitive filmstrip. Schott resorted back to the Greek shield concept by putting a filmstrip on the outer perimeter of a revolving disc.

In 1736, a Dutchman named Pieter Van Musschenbroek further developed the concepts of animation by making the vanes of a cartoon windmill appear to move. He drew each vane in a different position and projected them through the magic lantern in rapid sequence, which gave the illusion of motion. For nearly a hundred years the art form was relegated to the use of magic lanterns at carnival side shows.

An Englishman, Dr. John Paris, created the *Thaumatrope* in the 1820s. This was nothing more than a disc that had an image drawn on both sides. Two pieces of string were attached to the sides of the disc. By using the strings to twirl the disc, the two separate art images seemed to combine into one drawing instead of two.

Around this same time, Peter Mark Roget introduced the remarkable theory of the *persistence of vision*. (Most people know the name Roget from the thesaurus that he compiled.) In essence, this theory says that if numerous art images are placed next to each other, the human eye and brain will read them together as one collective piece. But if those images are separated by a black frame, and the eye is exposed to them in rapid succession, then the eye will try to capture and carry each image to the brain. As this is being accomplished, the eye is already being exposed to the next picture. The eye and brain deal with this overload of information by piling one image on top of the other image. If those images are altered even the slightest bit, the brain will translate this as movement.

Belgian artist Joseph Plateau developed the *Phenakistoscope* as a direct result of learning Roget's persistence of vision theory. Plateau drew sixteen images in consecutive positions of fluid motion on the rim of a disc. A series of animation drawings that begin and end with the same position is called a *cycle*. He made another disc that had small slits cut out. By rotating the discs and looking through the small holes, only one image could be seen at a time. This made the characters appear to move. The Phenakistoscope became instantly popular and numerous variations of the device were developed.

The most noteworthy was the *Zoetrope* (Wheel of Life) invented by William Horner. These inventors finally grasped the principles of animation. The next step was to combine this discovery with the magic lantern. This was accomplished by Baron Franz von Uchatius in 1845.

The *flipbook*, or *Kineograph*, invented in 1868, became the most durable of all animation toys. Thomas A. Edison took the flipbook one step further by developing the *Mutoscope*. This mechanized device mounted a flipbook on a ring inside a viewing box with a crank. The user would pay money, turn the crank, and watch a show. As of this writing, there are still some of these old devices in the Penny Arcade at Disney World and possibly some other places.

Emile Reynaud was the first to combine colored animated stories with synchronized sound in his *Praxinoscope*, between 1877 and 1892. The Praxinoscope was a more advanced Zoetrope coupled with a projector. Reynaud marveled audiences at his Theatre Optique, which was part of a wax museum.

Photography and animation combined to push for the creation of an authentic system of movable projection. Eadweard Muybridge began experimenting with using a camera to analyze sequential motion in humans and animals. Thomas Edison's invention of the motion picture camera and projector provided a practical way to make modern animation a reality.

The Silent Era (1914-1928)

J. Stuart Blackton from England made a film by drawing on a blackboard. He would snap a couple of frames with a camera, erase the image, and draw another image in a slightly different position. This culminated in a 1906 short film called *Humorous Phases of Funny Faces*. In 1908, the Frenchman Emile Cohl drew two thousand drawings to produce a two-minute film titled *Phantasmagoria*. Mr. Cohl created Fantoche, the first character to be used in animated films. In the same year, the famous American cartoonist Winsor McCay produced his first film, *Little Nemo*. The next year McCay took a cartoon film of his character, *Gertie, the Dinosaur*, and played it in vaudeville theaters. While the animation cycle had been around since the time of the Greeks, it was McCay who was the first to use it as a time and expense saver. He drew the repetitious cycles to show continuous motion as his characters moved across the scene. McCay is considered the father of American animation.

J. Stuart Blackton, Emile Cohl, and Winsor McCay are three of the most important figures in the infancy of the animation industry. It is important to note that all three men eventually left the business they helped to define.

The work of Winsor McCay served to inspire a host of young people to become animators. These converts formed an explosive community of competitive creativity. Each cartoonist's new technological discovery was gobbled up and improved upon by another artist. Animation studios seemed to spring up overnight in what is now commonly called the Silent Era.

The next name to surface in the world of animation was J. R. Bray. His film *The Dachshund and the Sausage*, made in 1910, was the first cartoon to tell a story. To the best of my knowledge and research, Bray was the first to have "funny animal" characters drawn with only three fingers and a thumb as a means of saving time for his animators.

Raoul Barré contributed several things to the fledgling industry. He was the first to institute the apprentice program. He also devised the "peg" system of registration and the light table. This is a sheet of glass with a light under it so that the artist can see through several sheets of paper at once. Max and Dave Fleischer developed the *Rotoscope* method of animation. They made a live-action film of a person and traced the footage frame by frame onto an animation cel. Fleischer is known for his *Out of the Inkwell* series. This was a combination of animation with live-action movies. Paul Terry was the first to draw on several layers of transparent material called "cels." Using this method allowed him to separate characters from each other and the background. The most famous animated character of the Silent Era was Felix the Cat. Otto Messmer is considered the person who breathed life into Felix; he worked in the Pat Sullivan studio. Felix was patterned after the comedic style of the silent motion picture star Charlie Chaplin.

The final noteworthy hero of the Silent Era is of course Walt Disney. He began his career by combining live-action movies with animation in his short film adaptations of *Alice in Wonderland*. He also

handled the creation and animation of Oswald the Lucky Rabbit until he lost the character by not owning the rights. This was a very difficult time for Walt's young studio, but as a result he created his most famous character, Mickey Mouse. Walt Disney may not have been a great artist himself, but he more than made up for it in his skills as an organizer and his understanding of storytelling. Walt was a visionary who could see ahead to the next logical step in animation, and get there first. Some people, like Thomas Edison and Charlie Chaplin, who reach tremendous heights of achievement, come to a place in their lives where they refuse to progress any further. Edison balked at AC electrical current and Chaplin never warmed to sound motion pictures. But Disney was a genius and innovator to the very end of his life.

Disney's *Steamboat Willie* (1928) has been credited with being the first sound cartoon. This isn't true. Both the Fleischers and Paul Terry had made cartoons with sound. However, Disney's effort was so superior that these other films have paled by comparison.

The Golden Age (1928-1941)

Steamboat Willie ended the Silent Era of animation and ushered in what has been sometimes called the Disney Era. Disney wasn't content to bathe long in the initial success of Mickey Mouse. Walt and his growing army of talented cartoonists conquered black and white by the addition of color in *Flowers and Trees* (1932), which earned him an Academy Award. While *Snow White and the Seven Dwarfs* (1937) was not the first feature-length cartoon in history, it certainly was the first that combined animation with sound, color, and the use of Disney's multiplane camera. The multiplane camera aided in achieving the illusion of depth.

This era saw an explosion of studios and characters. Betty Boop, Popeye, Superman, Woody Woodpecker, and the Looney Tunes crowd make up a list of some of the more popular ones. Warner Bros. assembled a zany cast of creators such as Tex Avery, Friz Freleng, Chuck Jones, and Bob Clampett to lead in the creation of Bugs Bunny, Daffy Duck, Elmer Fudd, Porky Pig, the Road Runner, Yosemite Sam, and more. These characters weren't better than Disney's Goofy, Donald Duck, or Mickey; but they certainly

were very different. The comedic genius that flowed out of Warner's "Termite Terrace" (the section of the studio where the animators worked) was electric and original. The staying power and craftsmanship of Disney's and Warner's creations are evidenced by the fact that these older cartoons are still as fresh on daily television as when they were first introduced. The Golden Age of animation ended during World War II, when the studios focused on the war effort along with the rest of the world.

The Silver Age (1946-1960)

The Silver Age saw a variety of contrasting styles. Of course, Disney owned the feature film niche and elevated animation to unparalleled heights of perfection. Other studios tended to push the experimental side of animation with different graphic and storytelling styles. In these offerings everything was often minimalized by making simplified and/or abstracted characters and backgrounds. The latter were unknowingly preparing the way for animation's near death experience in television.

The Golden Age of Television Animation (late 1950s-1960s)

The first cartoon created for television was *Crusader Rabbit* in 1949 by Jay Ward and Alexander Anderson, Jr. They later created Bullwinkle the Moose, Rocky the flying squirrel, and Dudley Do-Right. Television took a big bite out of the popularity of motion pictures, radio, and comic books. For animation, this meant that the cartoons which were shown before the live-action features were now unnecessary and too costly to produce. The natural course of action was to recycle the old theatrical animated shorts on television. The 1950s saw a surge of newly produced animation featuring such characters as Art Clokey's clay animation Gumby, Jay Ward's Bullwinkle, and Bob Clampett's Beanie and Cecil.

Unlike movie theaters where a film repeats over and over for days, television had a ferocious appetite because it was on all day, every day. This meant that animation produced exclusively for television had to be done quickly and on a lower budget. TV animators like the Hanna-Barbera studios were leaders in the development of "limited animation." Theatrical animation requires twenty-four frames per second, but limited animation can get by using as few as

twelve frames per second. The human eye can retain an image at a tenth of a second, so the extra two frames were needed to make Roget's persistence of vision theory work. Hanna-Barbera's studio has given us some of the world's favorite characters. They developed Huckleberry Hound, Yogi Bear, the Jetsons, the Flintstones, and Scooby-Doo.

Animation nearly died in the 1970s. Small production budgets and extremely tight deadlines forced the studios to sacrifice in every area of filmmaking. A lot of work was done overseas with little or no input from the American director. It appears that just as a foreign country would get the hang of animation, they would demand more money. The powers that be would simply move the work to another less expensive country. Pressure from anti-violence groups made the television networks hypersensitive to anything aggressive in nature. There were other problems that contributed to this slump, but some feel that one of the big factors was the creation of cartoons that served as a half-hour commercial for toys.

Speaking of commercials, animated television commercials have always been popular and a source of revenue for the various cartoon studios. One such example was Will Vinton's California Raisins. The Raisin commercials were done in "claymation" and started a merchandising craze, paving the way for wonderful claymation specials and programs.

Animation Today

The 1980s and 1990s have seen a turnaround in the production of animation. In 1985, Disney entered television animation with "The Wuzzles" and "The Gummi Bears." As Disney has always done, they set the pace for better programming. I feel that a major contributing factor to the revival of animation was the motion picture *Who Framed Roger Rabbit?* It was a technological wonder that fascinated and revitalized the interest of the general audience. It was soon followed by Disney's hit film *The Little Mermaid*.

The creation of the Fox Television Network and the expansion of cable television opened the door for more original material. Steven Spielberg joined the playing field with "Tiny Toon Adventures" and the "Animaniacs." "The Simpsons" became the first successful prime-time animated television show since the "Flintstones." Another bright spot in animation has been DC Comics' "Batman" animated series, and

Marvel's "X-Men" and "Spiderman" shows. Disney and Pixar's wonderful hit film *Toy Story* served to keep the flame alive in 1995.

As of this writing, animation continues to grow and expand. Computer-generated art and special effects for motion pictures, television programs, video games, commercials, and music videos are seen as commonplace and expected. Apparently, no one sees the advent of computers as a threat but rather as a welcomed helper. I don't feel that computers will ever negate the need to know and use the fundamentals of animation, but it may make it much easier, less expensive, and more accessible to the cartoonists.

COMIC STRIPS

The comic strip is a healthy branch on the genealogical tree of cartooning. As with the other subjects covered in this book, its roots go back to the humble Neanderthal cave graffiti artist, Egyptian hieroglyphics, and Renaissance tapestries. The cartoon twig that branched off started from the satirical prints and the illustrated magazines published in Europe during the 18th and 19th centuries. The Europeans pioneered the use of speech balloons, sequential panels, and other elements of the comic strip. Nevertheless, it was in the American newspapers that the *authentic* comic strip was born. America holds onto this global distinction as dearly as we cling to the parentage of baseball.

In 1889, Joseph Pulitzer, publisher of the *New York World*, got an idea from the success of American humor magazines. He launched a Sunday comic section in his paper. It contained features for sports fans, children, and women. It also had cartoon illustrations.

Five years later Pulitzer introduced a new color printing press. That same year an artist named Richard Outcault came to work at the *World*. He brought with him from the humor magazine *Truth* a cartoon character that was a bald-headed kid wearing a yellow nightshirt. The "Yellow Kid" was part of a fictitious neighborhood known as Hogan's Alley. The Kid cartoon character became tremendously popular in the *World's* Sunday comic section. On September 7, 1895, Outcault filed for a copyright on the character he called Mickey Dugan, or The Yellow Dugan Kid. On October 25, 1896, Outcault

first put together all the elements of the modern comic strip. It had a continuing cast of characters talking through speech balloons in a continuous sequential storyline. This made Richard Outcault the father of the modern comic strip.

William R. Hearst hired Outcault away from the *World* to draw the Yellow Kid cartoons for his newspaper, the *New York Journal*. So Pulitzer hired another artist to replace Outcault and draw the Yellow Kid for the *World*. The Yellow Kid was running in two separate newspapers at the same time. A terrible court battle was said to have been waged by Pulitzer and Hearst over the use of the Kid, but this battle may be nothing more than a myth. These two papers were, however, fighting a circulation battle and using the Yellow Kid as the tug-of-war rope. The papers also pushed their editorial slants to the edge by sensationalizing their news stories. This tabloid-type reporting earned them the name "The Yellow Kid Papers." The term was later shortened to "Yellow Journalism" and applied to stories concerning the Spanish-American War.

The Yellow Kid was quickly merchandised on everything from soap to whiskey. In late 1896, the Adams Gum Company issued a set of twenty-five bubble gum trading cards. This was the first card set featuring a cartoon character ever published. By 1896 Outcault had become a wealthy man. As popular as the Yellow Kid was, it is important to note that it was only well known in the New York area. Richard Outcault's next cartoon creation, Buster Brown (circa 1902), became much more widely known.

By 1900, the speech balloon, cast of characters, and panels were considered the norm for comic strips. This genre caught on quickly in the color comic strip section of the Sunday papers. In 1907 the black and white strips entered the daily arena.

From this point, I could go on listing the history of these creators, their creations, and the fine-tuning they each did to comic strip art. That would take a number of volumes to accomplish. It is amazing how many creations and creators there have been in just one hundred years. There are some major differences in the strips of today and yesterday, but the main one is the size at which they are printed. The original comics took a full page, then they were cut down to a half-page, and now they are almost postage-stamp size.

COMIC BOOKS

Originally, comic books were comprised of recycled newspaper comic strips. The scattered elements of the modern comic strip may have appeared in other countries first, but the comic book is uniquely American. In 1929, George Delcorte produced the first comic book featuring all new material. He charged ten cents per copy and couldn't sell them all, even after cutting the price in half.

Other ventures into this medium saw little or no success until two high school boys from Cleveland, Ohio, had an idea for a story about an alien. They spent five years trying to get someone to publish or syndicate their creation. In 1938, Detective Comics (DC) gave the boys a try and the comic sold like wildfire. Their extraterrestrial, Superman, gave birth to the superhero. Batman soon followed, and virtually overnight, superheroes came from everywhere with a vast array of powers.

Through the 1940s, the comic industry flourished by adding to the superhero genre books about crime, the Old West, romance, humor, funny animals, and horror. The horror comics put more and more gore into their contents, which led to a messy U.S. Senate hearing on charges that comic books were changing the young people of America into delinquents. All comics caught the heat and publishers dropped out of the business like flies. In order to try to regain acceptance, in 1954 the industry inaugurated the Comics Code as a censoring watchdog group. This did little to boost an enterprise already sagging from the explosion of television.

Superman and Batman continued to enjoy a loyal following. DC decided to reintroduce some of their old superhero standbys, but they were met with little enthusiasm. In 1961, Marvel Comics felt that they had nothing to lose, so they let a family member take over the choice of books to see if he could succeed—or at least, relieve their misery. This young relative, Stan Lee, developed a new kind of superhero with the release of a comic book featuring the Fantastic Four. The phenomenal success of this title opened the door for other now famous characters such as Spiderman, the Incredible Hulk, Thor, and the X-Men.

Even with this new type of comic book, sales didn't return the industry to its former glory through the 1960s and 1970s. But one thing did spark a change.

Comic books had always been considered a "kiddy thing." By the mid-1970s, adults who had grown up with the comics of Stan Lee didn't want to let go of their youthful hobby. Comic book specialty shops began to spring up all over the United States and Europe. Comic book conventions became huge affairs and the creators of "funny" books became superstars.

New independent comic book companies began producing new exploratory comics that rivaled the "big two" publishers (Marvel and DC). Writers and artists went from sweatshop labor to owning their creation's copyrights and trademarks, and realizing a slice of the pie in the form of royalties. The retail comic shops gave birth to a specialized non-returnable distribution system.

Today, comic book publishing is up and down. The medium as a form of literature has always been as much of a cliffhanger story as the books it has produced. Certainly, no one can predict the future of comics, but there is always hope that the *good* will eventually triumph over the *evil* in the end.

MY INCREDIBLE JOURNEY

I feel that this book is a natural progression of my career in cartooning because it comes out of the overflow of my personal experience. For the most part, I have lived this book. I have been interested in cartoons for as long as I can remember. Some of my earliest childhood memories are of the Superman and Batman comic books and the Li'l Abner comic strip. The first illustration I recall doing was in the second grade. My teacher, Mrs. Allison, asked me to draw a picture on a big tablet illustrating the poem "Trees." I don't remember what my interpretation looked like, but I do retain the positive impression I felt. I caught the bug. I began drawing on everything. I tended to be on the average, thin side, and was never in any accelerated education classes. I found reading, math, English, science, and anything that didn't require pictures or hands-on construction to be very boring. To be honest, I felt I just wasn't very bright. I didn't even think of college because I saw it only as a continuation of the same (yawn) boring

Ill. 1-3 *Used by permission of the Evangelistic Association of New England.*

stuff. I soon learned that not everyone could draw as well as my humble efforts. Cartooning afforded me a means of excelling in an area and helped open doors for making friends. Even to this day I find myself using cartooning as a means of meeting new people.

I took one art class in high school. Cartooning was not part of the course of study. Hook rugs and papier-maché didn't interest me at all. At the time, I didn't see the true value of contour or dimensional investigation. I saw drawing as my life vest of self-worth in an educational system where I felt I was treading water at best. However, my teacher was very encouraging about my drawing skills and interest. I continued to draw cartoons on my own.

Music became very important to me in my late teenage years, so I went to college and majored in music. I enjoyed singing but music theory courses soon convinced me to seek another major. I took an extensive battery of aptitude tests and the results indicated that I was best suited to be a Funeral Director. I have the greatest respect for that profession, but that wasn't high on my personal list of career choices. My college career was on and off for several years, mostly because I didn't know what I'd like to major in.

I went back to college when I turned twenty-seven years old. I majored in art. I felt as if I were a butterfly that had burst out of its cocoon. I exploded with creative power. My wife helped me overcome a lifetime of poor study habits, and my love for art spilled over into all the other courses. I even started sincerely thanking my professors for tests, even final exams. I proceeded in my zeal for cartooning, but not during class. I realized that cartooning was only a small star in the gigantic universe of art. I jumped feet first into classical art and graphic design. As much as possible, I consciously forced cartooning out of my class work. As a result, I feel I emerged after four years with a cartooning style that had a much broader range and depth. Too often, one's self-worth is attached to drawing cartoons because that is the area that comes the easiest and receives the most praise from family and peers. Do not be afraid to set cartooning aside, for a time, to learn new techniques. It won't hurt, it will help. I finished school on the dean's list and the honor roll.

Upon graduation, I put a listing of my graphic design services in the telephone directory and made

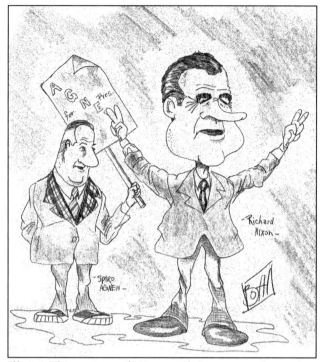

Ill. 1-4 *This cartoon of Nixon and Agnew was done when I was in high school in about 1970.*

part of my garage into a studio. A wide variety of graphic design and advertising art assignments steadily trickled in. I came to better understand the printing business, the sign painting business, the screenprinting business, and the you-name-it business. Space does not afford the opportunity to list all the varied and unusual projects I've worked on. I freely admit that any success I've enjoyed has been enhanced by the aid of others in the business. I have endeavored to help others push the artistic boulder up the mountain of life as well.

 GOLDEN NUGGET: Never, never, ever underestimate the value of sincerely helping others and allowing others to help you.

I have been asked if I thought education was really important to becoming successful as an artist. I have met some dynamic artists and cartoonists that didn't have any formal training. After talking with them for a short time, I found that most were actually somewhat limited in their areas of expertise. Too often, non-educated artists seldom venture past

drawing whatever comes naturally to them. I've heard a lot of people brag on another person's artwork and say that they accomplished this work without ever having had an art lesson in their life. They say this as if education somehow spoils true creative genius. A quick survey of their work has generally revealed a lack of very basic art training. I knew fellow students in art school that declared that they loved doing abstract art. I knew their work habits, and the truth was that they were too undisciplined to learn classical anatomy or make sure their basic sketch was correct when they started.

I have been surprised by a few untrained artists' work. However, I have generally found out that most of these drawings were really interpretations of another professional's work. I know some will be quick to bring up the names of a few exceptions to my opinion, but education has helped more people than it has hurt. If you decide to become a professional cartoonist you will be competing with many very, very talented (educated) people for any position you go after. Give yourself every chance to be the best you can be. I'll put it another way. Why take fifteen years to learn on your own what you could learn in four years at the proper institution? The appendix of resources at the back of this book offers a good list of colleges and art institutes for your investigation.

In 1984, I began in earnest trying to break into the field of book illustration. I did some editorial cartoons and spot illustrations for a monthly newspaper and a few books for a local publisher. Al Hartley, who wrote and illustrated *Archie* comics for twenty years, became a dear friend and mentor to me. He opened the door for me to begin illustrating books on what has become a full-time basis. As of this writing, I have designed covers for, written, and/or illustrated nearly fifty books. Currently, in addition to writing this book and other projects, I am broadening my efforts into television and motion pictures.

MARKETS AVAILABLE

From time to time, people will ask me to look at their work or their children's work and give an opinion. Most ask if I can suggest anything to encourage their progress. More than one parent has bluntly asked if I thought that their child has a special, inspired gift to make a lot of money with their cartooning. I am always happy to look at anyone's talent and offer my humble speculation. It is true, there is a pot of gold at the end of some people's rainbows. However, money is never a good reason to choose any career. The most successful cartoonists I'm acquainted with do it because they love cartooning.

I recall a few years ago, an elderly lady in a very small town in rural Louisiana approached me about looking at her grandson's artwork. I told her I would be happy to take a look and we set a time to come by for coffee and cake. On the appointed Thursday morning, a friend and I stopped by and enjoyed the dessert. When I brought up my desire to see her little grandson's work she left the room. I could hear her going through a cabinet or something looking for what I thought would be a time-worn keepsake. To my surprise, she handed me a perfect-bound published book of her little grandson's work. Her grandson was a very grown-up Joe Johnston. The book contained his conceptual designs for the motion picture *Star Wars*. With no hint of sarcasm on her face, she asked me if I had ever heard of a "little movie" called *Star Wars*. I now have my own copy of her "little grandson's" book (*The Star Wars Sketchbook* from Ballantine Books) and I have enjoyed studying his genius many times. Little Joe is also known as the director of the Walt Disney motion picture, *The Rocketeer*, and *Jumanji*.

This favorite story of mine presents a good place to begin a list of the various opportunities that cartooning affords. Other avenues will be sprinkled throughout this book.

One area not often considered is motion pictures. Every film needs conceptual art, storyboarding, set design, prop design, and character design. Animation has these same positions to fill and more. The advertising business is always looking for cartoonists/illustrators to grab the attention of a fickle public. Industry scans the horizon for new ways to soften and make appealing their technical information for their stoic corporate image. There are magazine, book, greeting card, newspaper, newsletter, and comic book publishers. Don't forget clip art services, institutions, associations, hospitals, performing art groups, record companies, the garment industry, public relations firms, grocery store chains, restaurants, and many more.

The chapters and assignments in this book are designed to give real, concrete direction for anyone who wants to learn the various disciplines of cartooning so that you may pursue a rewarding career.

Assignment #1: Operation Character Count

Obtain a two- to three-inch, three-ring binder that you can fill with lined or non-lined paper, and manila pocketed dividers for use throughout this course. On a clean sheet of lined paper, draw a vertical line down the center of the page. In the upper portion of the left half of the page, write as a heading the word "Product." As a heading for the column on the right half of the page write "Character." Go to a large retail department store that sells a variety of products. Inform someone connected with the store's management that you are working on a school assignment. Take no more than an hour and walk through as many departments as time allows. Save the obvious toy section for last. List any items that have a cartoon image on the product or packaging. Most characters will be highly recognizable, but there should be some generic art. Determine for yourself which department to begin with and cover that area before moving to the next section. Use as many sheets of paper as are needed. For your own information, the next time you enter a large grocery store, take note of the amount of cartoon characters that sell food.

Review Questions

1. Define the word "cartoon" and explain the historical roots of the word.

2. What is the most popular greeting card that people send?

3. Why are there two separate inventors of movable type and who are they?

4. Name the first newspaper and how long it was in existence.

5. What was the first American magazine published and who was the publisher?

6. What Englishman first coined the word "cartoon" to mean something other than a preliminary drawing for a fresco or tapestry?

7. What political cartoonist is considered the best of all time? Why was he imprisoned for his work?

8. Explain the term "persistence of vision" as it relates to the animation process.

9. Who is considered the father of animation in America?

10. What is the difference between limited animation and full animation?

11. Who is the father of the modern comic strip and what was his famous character's name?

12. What circumstances led to the establishing of the self-censoring Comics Code for the comic book industry?

CHAPTER TWO

THE FUNDAMENTALS OF CARTOONING ART

The following information and instruction in this chapter will serve as the foundation for the types of art you will need to do in order to complete the remainder of this book.

ARTIST'S MORGUE

Every professional cartoonist has an *artist's morgue* in some form of order or disorder, because everyone needs a visual reference occasionally. It will force you to leap beyond primitive rendering skills. Morgue harvesting may seem painfully boring, but after three or four weeks it should surprise you to discover the number of different types of chairs there are in the world. Remember, the purpose of this book is to give you every means possible to become a first-rate cartoonist. Every chapter in this book will require morgue assignments. At the completion of this course, you will have a good cross-section of reference material labeled, filed, and within your grasp. Should you become a professional, this collection of reference matter will need to be supplemented with various published photo reference books. For information contact The Fairburn System of Visual Reference, Mitchell Press Limited, P.O. Box 6000, Vancouver, B. C. Canada V6B 4B9. Another source is Dover Publications, Inc., 31 East 2nd Street, Mineola, NY 11501.

For your purposes now, you should be able to find every reference example needed. Begin the search for reference material in the privacy of your own home.

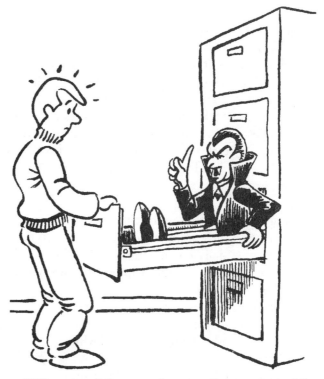

"The Art Morgue is two drawers up!"
(Gag type: Trade Talk)

Ill. 2-1

You might check with a neighbor or relative also. Old magazines, catalogs, the daily mail, photos, and newspapers are good places to start. *Do not,* I repeat, *do not* cut up encyclopedias or other published books. The library in your school or area carries a large variety

23

of magazines. *Do not* tear examples from these periodicals. A photocopy will be sufficient. If all else fails, you could trace or redraw the desired prize.

Norman Rockwell had an extensive morgue of materials. He gathered material, had countless photos made of models, and even had a large room filled with all kinds of costumes. When I visited art museums in Holland, I noticed students everywhere doing their own artistic versions of famous pieces of art. My art has been enriched by doing the same. One can learn volumes from studying the artistic greats and using good reference materials. A good morgue is a time-saving must for any artist.

Assignment #1: The M Files

Acquire some legal-sized manila file folders. Label them with different types or subjects of illustrations (see following list). Collect at least one example a week to fill each folder. In a few weeks, look back through this collection. If three or more samples seem to fit a new description, place them in a new folder under a new heading. (Example: If you find four cartoon illustrations where oranges are the dominant characters, simply start a new folder under the heading Cartoons: illustration, oranges.) Your name should be clearly marked on each folder. Write the following headings on the raised portion of the folders:

Cartoons: illustration, black and white
Cartoons: illustration, color
Cartoons: daily comic strips (This folder could house one particular comic strip or a certain type of art or kind of humor.)
Cartoons: comic book
Cartoons: magazine
Cartoons: advertising, black and white
Cartoons: advertising, color
Cartoons: editorial (This could easily splinter off into many separate folder headings.)
Cartoons: caricature
Cartoons: animation
Cartoons: type and lettering styles
Cartoons: greeting cards
Cartoons: logos
Cartoons: news story articles (any news items concerning the field of cartooning or cartoonists)
Cartoons: animals or birds

The above list is only a starting point for file titles. It should give you a place to begin compiling the very important reference morgue. After the instructor has checked the folders each week, place them in a cardboard box or file cabinet. It may work out best to have two folders for each heading: one to hold the weekly harvest, and one to hold the entire collection of each subject.

GETTING READY TO DRAW

When I was in college studying art, I got to take a painting class. I had a lot of respect for my instructor. But every time I asked for his guidance, he would reply, "There's a hundred ways you could do that." I would have been more than satisfied to have been told just one. Getting started is often the most difficult part of any creative endeavor.

 GOLDEN NUGGET: Creativity begins when the pencil moves.

In Norman Rockwell's book, *Rockwell on Rockwell*, he said that he always began his idea process by drawing a lamppost on his blank sheet of paper. It is odd to me that of all the objects in the universe, Norman Rockwell chose to start fishing for ideas with a simple lamppost. I don't think that I have ever done this. Most of the direction of my work has been predetermined by the job assignment itself.

PAPER

Many people dislike blank white paper to the point that they find the creative juices flow better if they draw on colored paper. White paper doesn't bother me. When you practice, work on any paper that is easily accessible. Doodling on a notepad isn't a bad thing since you can carry it in a pocket. I prefer using average grade, 8½" x 11" white typing paper. Sometimes I fill up a sketch pad. When working on the development of a character or a universe for a story, I like to work on a tablet of layout bond paper, medium weight, measuring approximately 18" x 24". This way I can move over and redraw a new

version of the same character or use one sketch as a mood guide to another character or environment. When I prepare to save something I draw, I render it with pencil and then ink on Bristol board paper. This comes in 1, 2, and 3-ply thicknesses. The surface textures are *plate* (smooth) and *vellum* (rough.) Another way to reference these paper textures are plate (hot press) and vellum (cold press.) For comic book work that requires lettering, I prefer the 2-ply plate (hot press) finish. If I am working in colored pencil, watercolor, or airbrush, I will use a cold press (vellum) board.

 GOLDEN NUGGET: For work that requires the use of airbrush, I like the 2 or 3-ply vellum surface because the template adhesive material, called *frisket*, is less likely to damage the surface of the paper.

 GOLDEN NUGGET: Before I draw something that I intend to ink or paint, I always erase the entire surface of the paper with an eraser.

 GOLDEN NUGGET: I like to wear white cotton gloves when I ink a drawing to keep my hands' natural oil and perspiration from altering the surface of the paper. In order to better hold the pen or brush, I cut off the thumb and pointing finger of the glove of my drawing hand.

PENCIL AND INK

I always draw with an HB leaded pencil. I find that the good old traditional number 2 pencil doesn't make a dark enough line unless the user presses down and grooves the paper surface. This makes it almost impossible to completely erase any mistakes. The HB lead is softer and darker. You don't have to bear down into the surface of the paper to get a good dark line. *Do not*, I repeat, *do not* draw with an ink pen. Inked lines are permanent. Draw using a pencil first, then redraw over your drawing with ink, and finally erase the pencil lines. Notice that I said the word "redraw" when you ink your pencil drawing and not "trace" or draw over your pencil lines. Inking is part of the process of getting your drawing correct.

I have always looked upon erasing an inked drawing as if I were unwrapping a gift. Any kind of eraser will do. I generally use a white plastic eraser, or a kneaded (self-cleaning) eraser, or one called a Pink Pearl. Titanium White acrylic paint is an excellent choice for correcting inking mistakes.

I will repeat this again later in the book, but my choice of black inks for dip pen and brush work is Higgins Black Magic India Ink. This is permanent, opaque, and smooth, with no bubbling. Black Magic ink has a clogging problem when used in technical or reservoir pens; in these pens I use Koh-i-noor Rapidograph 3080-F Universal waterproof black India ink.

Hunt No. 22 or 22B pen nibs are the best universal points I have found. They give the artist freedom to draw thick and thin lines with one pen. Also, a coquille dip pen nib is great for very fine work.

Raphael No. 2 sable-type brushes are by far the best brushes I have found. If cleaned properly, this brush will give a razor-sharp point or spread out to blanket a larger area. The Windsor Newton No. 2 sable brush is almost as good and appears to be easier to find in most art stores, but it doesn't have the razor-fine point quality of the Raphael brush.

 GOLDEN NUGGET: The only place I have found the Raphael No. 2 brush is through the bookstore of the Joe Kubert School of Cartoon and Graphic Art, Inc., 37 Myrtle Avenue, Dover, NJ 07801.

 GOLDEN NUGGET: Air is the enemy of ink. Never work out of the original container. Pour out a little ink in another holder and quickly put the top back on the parent bottle. *Do not* pour the used ink back into the original bottle. You can use the exposed ink again if it hasn't been in the open air too long. Mark the date and which bottle it is on each container to avoid confusion.

BASIC DRAWING

The remainder of this chapter will contain a combination of concrete examples and assignments

for general cartooning. There are volumes of books already written that cover virtually every portion of the rest of this chapter. Many fine authors and artists have devoted entire manuals to just one element that we will cover in this unit. Some of those fine books will be listed in the reference section at the end of this book. I will acquaint you with the parts that have made the largest fundamental impression on me as a cartoonist. We will knife through the mountains of accumulated data and zero in on the central issues. Due to the scope of this text, we will study a combination of realistic and cartoonish rendering at the same time. Some portions of anatomy will be covered in other chapters.

To some, these initial exercises may appear on the surface to be simplistic and unnecessary. Nevertheless, it has been my experience from reviewing countless portfolios that students often fail to firmly grasp the basic principles and understructure of good cartooning. In various assignments, you will be required to do at least two extra examples on your own. Remember, somewhere else, in your class or another community, there is another student who may not have the same amount of natural talent as you. That student may live only to fulfill his or her dream of becoming a professional cartoonist. Do you think they are going to just do the minimum required, or are they going an extra mile? No one ever became the best by doing the least.

Our study will proceed in the following order:
The Four Basic Shapes
Heads and Faces
Jet Men, Spines, and Action Lines
The Body
Costumes and Props
Animals
Perspective, Foreshortening, Light Source, and Shading
Composition, Backgrounds, and Landscapes

THE FOUR BASIC SHAPES

Everything in our universe can be broken down into one of four basic shapes. As in Fig. 2-1, the circle (including ovals), square (including rectangles), triangle (including cones), and the cylinder make up our basic shapes. Take a look at the place where you are presently standing or sitting. Look briefly at the objects in that space. See if you can use your imagination to

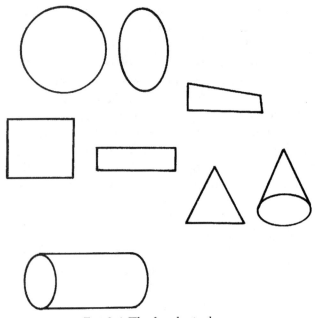

Fig. 2-1 *The four basic shapes*

break down any objects that are in your presence into their basic shapes. *If you can see something as a basic shape, you can draw it or cartoon it.* Cartooning is more than just artistic shorthand or symbolism. Cartooning is an abstraction or separation from reality. Sometimes it requires a realistic rendering and sometimes it takes the form of simple indication.

Assignment #2: Simple Shape Hunting

On the next page (*see* Fig. 2-2) are three identical photographs. As you can see, one picture is normal and on the others I have drawn an outline around each object's basic shape. Look through a magazine or book and choose an advertisement or picture. Make three photocopies of that page. Keep the first unmarred in the place of the original.

On the second copy, draw an outline around the basic shape of each object in your subject, just as I did in my example. In a margin or on the back of your paper, list how many circles, squares, triangles, and cylinders you find. Remember, an oval counts as a circle, a rectangle counts as a square, and a cone counts as a triangle.

On the third copy, draw an outline around shapes that are formed by objects intersecting and overlapping. Look carefully at my third picture. These shapes may not be obvious to you at first, but it is important that you see objects as shapes and

GUIDE TO CARTOONING

Fig. 2-2 (1) Photograph (2) Basic shapes (3) Intersecting shapes

their relationships to other objects. Seeing and understanding the function of a picture's background is essential to becoming a good cartoonist. Place these examples in your cartooning binder.

GOLDEN NUGGET: If you are having a little trouble identifying basic shapes, turn your subject matter upside down and study it again. For example, if your subject is a person's face, if you turn your picture upside down, the eyes are no longer seen as eyes; they can now be more easily viewed as diamond-shaped squares and circles. Another way of getting a new perspective is by looking at something in a mirror.

GOLDEN NUGGET: Another way of learning to separate objects into shapes is to cut out a one-inch square in the center of a piece of typing paper. Use the hole to isolate sections of your example and watch as objects suddenly emerge (presto) as shapes.

Designing Inky-Genie-Bot

Here is a character (Ill. 2-2) I designed for this book using variations of all four basic shapes. Character development will be covered in greater detail in later chapters. However, I feel it is impor-

tant to tell you at this point how I arrived at this design after many failed attempts.

You should begin learning today how to develop good, strong characters. Here is a peek at my thought processes. I started out with a germ of an idea, that I wanted to design a character who would utilize all four basic artistic shapes, and be something that could be used in all the various disciplines taught in this book. After thinking about it for a while, I decided that a robot would probably best meet the criteria listed above.

I started with the head and worked and reworked downward. (See Ill. 2-3.) With each sketch I tried to add and subtract something in the design. Never be hasty to call something finished. After numerous hours of drawing, the character began to emerge. There are already a million robot characters in the cartooning world today. I needed something that would set mine apart and give him unique personality traits. In the course of drawing the robot, I did a draft that had a lightning bolt coming out of his body trunk. It reminded me of a genie from Arabian mythology. Since I had already designed a character for this book that was an elderly male prospector, I thought it would be a good character twist or contrast to make the robot both a genie and a young girl. Any time you have two characters in a story that fill the same role, one of them is not needed. This is part of creating conflict, which we will cover in later chapters.

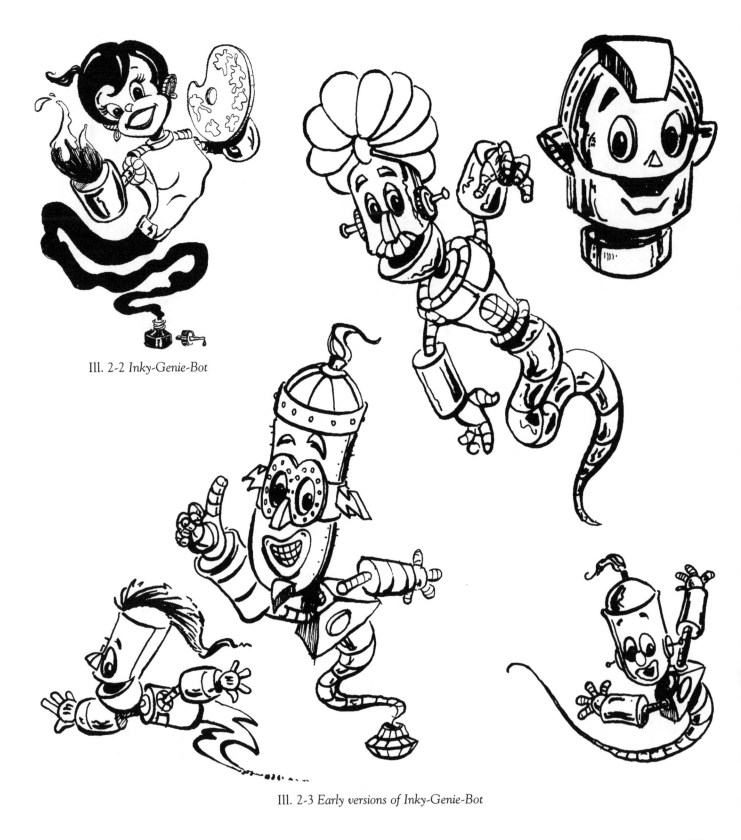

Ill. 2-2 Inky-Genie-Bot

Ill. 2-3 Early versions of Inky-Genie-Bot

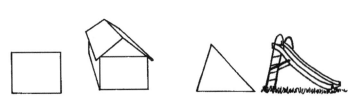

Fig. 2-3 Cartoons using basic shapes

I was looking for a way to tie the genie concept to the theme of this cartooning guide, so it hit me to have the genie come out of an inkwell instead of a lamp. My eldest son, Aaron, an excellent cartoonist in his own right, suggested putting an artist's brush and palette for the genie's hands.

I decided that this concept had some very interesting story and character design possibilities. I repeatedly asked myself how this character would look or work if it were used in animation, as a toy, in a movie, in a comic book, in a comic strip, or in a line of greeting cards. With every question came a readjustment. After numerous sketches, the character I call Inky-Genie-Bot was born.

The drawings in Fig. 2-3 are accompanied by their basic shapes.

HEADS AND FACES

People and animals come in all shapes and sizes. The two most expressive parts of humans or animals are their heads and hands, so let's begin with the head and facial features. We will draw faces in five views: the front view, ¾ view, side (profile) view, ¾ rear view, and the full rear view. The reason for this exercise is to teach you how to develop a character that you can draw more than once, in any position, and keep recognizable. This is the hardest thing to master in cartooning and the most important fundamental task to becoming a accomplished cartoonist in whatever area you work in. It is imperative that you completely understand the basic construction of a cartoon head, or you are doomed to be a rank amateur, forever limited in your professional growth.

Assignment #3: Basic Face Types

On four separate sheets of typing paper, draw two rows of five circles, about the size of twenty-five cent pieces. Feel free to use a quarter as a template. As you see I have done, use dotted lines to divide each circle into four pie slices. Look at the four sets of drawings here, read the description next to each sketch, and draw these four different type faces in your circles. Notice that all the faces are the same size and yet reflect different ages. Place these in your cartooning binder.

Since there is little difference between boy and girl infants, one row of circles will be sufficient.

Possibly the addition of a few eyelashes could denote a girl infant. I've known girl babies that had so little hair that their mothers taped hair bows to their head.

Front View

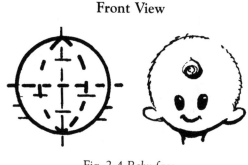

Fig. 2-4 Baby face

• Notice that in the face of a baby, all the elements (eyes, mouth, and ears) are smaller, below the middle horizontal dotted line, and bunched closely together.
• There is no nose or eyebrows indicated.
• The ears are rendered low on the sides of the head.
• Very little hair is shown.

¾ View

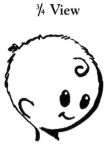

• Think of your circle as a round ball or globe of the earth. Following the vertical dotted line, place the facial elements as you see pictured above.
• Notice that only one ear is shown low on the rounded vertical line on the far left.
• No nose or eyebrows are present.

 GOLDEN NUGGET: Perspective in drawing gives the illusion of depth by making things that are closer appear bigger and things that are far away seem smaller. The right eye is closer to the viewer; therefore it should be slightly larger than the left eye.

GOLDEN NUGGET: *The ¾ view is the most dramatic of all the positions.* Watch an animated cartoon and take note of the frequent use of the ¾ view and side view. These two views are designed to bring you, the viewer, into the cartoon world with the characters, thereby aiding in the willful suspension of disbelief necessary for your brain to accept this abstraction of reality as real or normal. If a character looks at the viewer directly, except in a case of extreme dramatic effect, the illusion of the cartoon magic world is destroyed. The only character I know of to really succeed in looking at the audience and not destroying the illusion is Bugs Bunny. The wild and zany geniuses of animation at Warner Brothers Studios knew all the rules and triumphantly broke them.

Side View

• In this view only half the face is visible.
• One eye, half the mouth, and one ear are shown bunched closely together.
• Of course, there is no nose, no eyebrows, and very little hair.

¾ Rear View

• This view shows very little of the face except for a little cowlick hair in the upper portion of the head and one ear that follows the vertically rounded lines in the lower right half of the head.
• The back of its small neck is shown and positioned on the far left lower vertical line. Think of the neck as a cylinder shape.

Rear View

• The small cowlick is shown in the center of the upper portion of the head.
• Both ears hang on the side of the head in the lower hemisphere of the head.
• The neck is just above the extreme lower part of the bottom half of the head, and in the middle of the head.

These examples are of a boy and girl around the ages of eight to ten. Always keep in mind that whatever features you place on a character, those elements must be designed to look correct and pleasing in every view in which the character is drawn.

Front Views

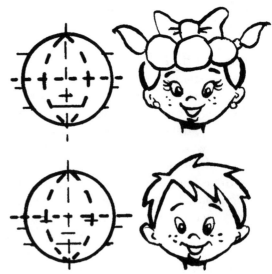

Fig. 2-5 *Girl and boy ages 8 to 10*

GUIDE TO CARTOONING

- The elements of the face are still below the halfway mark on the face, and are spread out a little.
- There is a small bump for a nose, a few freckles, and expressive, excited eyebrows.
- The ears are a little higher on the head.
- They both have plenty of hair.
- The girl has a few eyelashes, and her hair is longer.
- The addition of a hair bow and earrings help finish out the stereotypical girl.

¾ Views

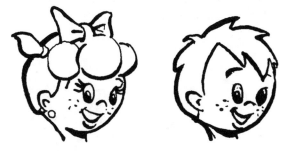

- Just as in the baby, only one ear is shown.
- The right eye is closer and slightly larger.
- The portion of the hair bow closest to the viewer is slightly larger. The bow and hair bangs reflect some *overlapping*, adding to the illusion of depth.
- The neck is small and angles from the back to the front, symbolizing innocence.
- A little lower lip is shown.

Side Views

- Only one eye, ear, half a mouth with lower lip, and one eyebrow are seen.

¾ Rear Views

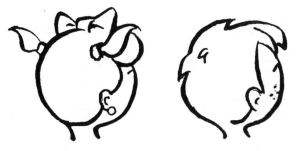

- Very little is seen of the face except one ear.
- The hair of the girl puffs up and overlaps the bottom of the bow.
- The boy has a cowlick and his neck is seen.

Rear Views

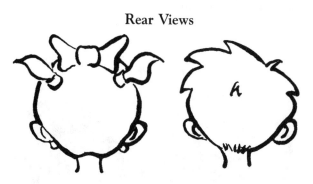

- Very little is seen except for hair, the bow, the boy's ears, and his neck.

These are examples of a teenage boy and girl.

Front Views

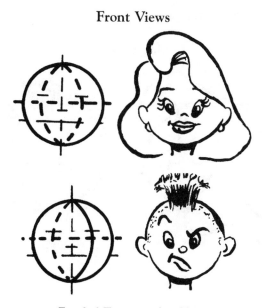

Fig. 2-6 Teenage girl and boy

- The elements of the face continue to spread outward.
- The center horizontal line divides the eyes in halves.
- The nose is a little more defined.
- The tops of the ears touch the bottom of the horizontal line.
- The mouths are more expressive and self-assured.
- The girl's lips are fuller and her eyelashes longer and thicker.
- The eyebrows show some moodiness and the girl's eyebrows appear shaped.
- Hair on teenagers often reflects a more adventurous fashion statement.

¾ Rear Views

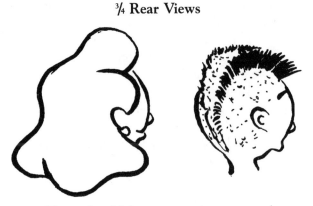

- There should be no surprises to you by now about how to see the character in all views.

¾ Views

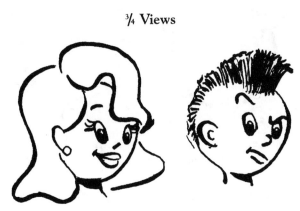

- The pattern continues.

Side Views

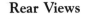

- The beat goes on.

Rear Views

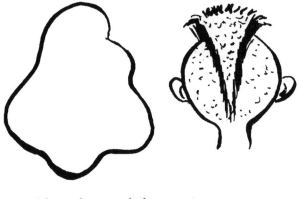

- The girl is mostly hair.
- The boy's head should be seen at a slight turn to show the sides of the mohawk.

Well, here is where *gravity* attacks: the adult male and female.

Front Views

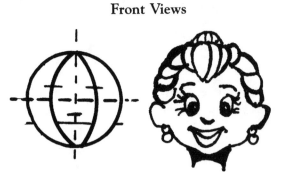

Fig. 2-7a *Adult woman*

GUIDE TO CARTOONING

Ears

Ears give character to a head but add little or nothing to the expression of the cartoon. Three letters of the alphabet can help you remember the ingredients of the ear's structure. They are C, C, Y, and U. As you see in Fig. 2-16, the two Cs make up the outer part of the ear. The Y is the portion that holds up the top of the ear, and the U is the dip at the top of the earlobe. In a cartoonish drawing, you can indicate the right ear with a simple C shape. If you like, add a stylized backward 6 in the right ear and in the left ear add a normal 6 for the interior of the ear.

Mouths and Teeth

Eyes are first in conveying expression; the mouth is second. The mouth expresses mood. In Fig. 2-17, you see the mouth is made of an upper lip and a lower lip. The upper lip has three parts: a central wedge and two wings. When rendering the mouth in normal light, the upper lip forms a natural shadow; therefore it is darker. Generally, the female's upper lip is drawn fuller than the male's. In profile, the upper lip is further forward than the lower, but not too far.

The lower lip has three parts: the center groove and two rounded lobes. The lower lip generally catches normal light, so it is lighter in color. It is

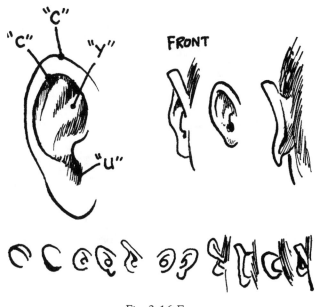

Fig. 2-16 *Ears*

shorter in length and fatter than the upper lip.

If you notice, most realistic portraits do not show teeth. It is very difficult to portray teeth in a believable manner without making the painting look overworked. Even most professional cartoonists get insecure when it comes to drawing teeth. Study and practice Fig. 2-17; these are a few ways to take care of a real problem.

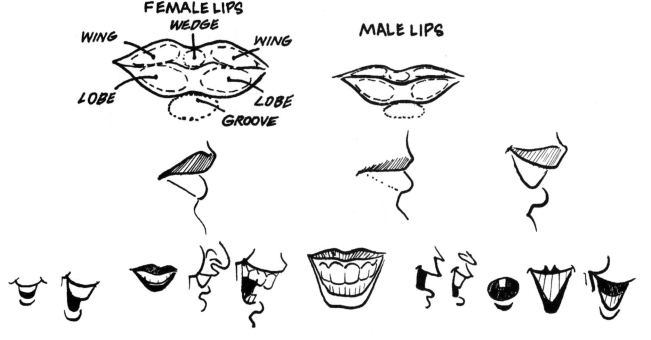

Fig. 2-17 *Lips and teeth*

Fig. 2-18 Chins and jaws

Fig. 2-19 Hair

Chins and Jaws

Look at Fig. 2-18 for some of the basic jaws and chins available. Chins contribute to the overall personality of the cartoon character. A strong, firm jaw/chin denotes a hero. A weak chin reflects a coward. In rendering handsome adult men, give them a strong chin. When rendering pretty females, the rule is that you shorten the distance between the lower lip and the chin.

Hair

Fig. 2-19 shows a few of the various hair styles you can use. *Static electricity* holds strands of hair together, forming groups called *locks* or *tufts*. These ribbon clusters of soft and pliable hair adhere to and defy gravity in three categories: 1) hair that rises and falls, 2) ringed clusters, and 3) swirls. Learn to see hair in group types and your rendering will improve.

Be sure to practice placing highlights where the light source strikes the hair. These highlights will add bounce and body to an otherwise flat, lifeless hairdo. Besides practicing these accents, look through magazines at hair styles and train your eyes to see the highlights so that you can correctly apply them. Later in this chapter we will discuss the importance and use of light source.

When working in black and white, hair coloring is indicated by the overall amount of black applied. A pen and brush work ideally for black hair, whereas a pen works best for blondes.

Assignment #6: Facial Expressions

Before leaving this very important section of study, it is vital that we pull all of these elements together to be sure that you understand the construction of facial expression. While body language counts as reinforcement, the majority of your character's true feelings and impact will rest on how well you communicate through your faces. Fig. 2-20 shows a series of faces that reflect certain moods. In your cartooning binder, on typing paper, use a quarter as a template to draw the shapes of heads. Redraw the faces I have drawn and then with the aid of a small mirror look at yourself making each expression. Draw your own countenance in a cartoon manner using the list of expressions. It is my understanding that most animators keep a mirror handy to help them work out desired expressions.

The list: happy, shock, content, sad, mad, laughing, in love, hurt, frightened, angelic, devilish, doubting, confident, sorrowful, nervous, singing, sick, wild, stubborn, cold, hot, yelling.

You may come up with a few more examples.

JET MEN, SPINES, AND ACTION LINES

Sometimes students draw cartoon characters that look like weird zombies. The only problem is that they aren't trying to draw weird zombies. A student starts by drawing an eye, then adds the nose, and another eye. The body unfolds one part at a time, resulting in a disproportionate, lifeless, and static cartoon. The caricatural principle of cartooning is to *control* distortion and exaggeration. Fig. 2-21 shows you that step one in cartooning deals with the head, and step two deals with the spine or line of action. Every human and animal has a skeletal spine that regulates the movement of the figure. This line of action is an extension of that spine which makes your character bend, swing, stretch, and twist with power.

The professional term for "stick man" is "jet man." Students sometimes bristle when I tell them to draw a "stick man." They act as if I'm asking them to ride a tricycle again. Nevertheless, using a jet man is the best way to breathe life into and work out anatomical bugs in a character. It helps you push the action to the necessary extreme before you've committed too much time to a pose. If the term "jet man" bothers you beyond reason, think of it as simplified anatomy.

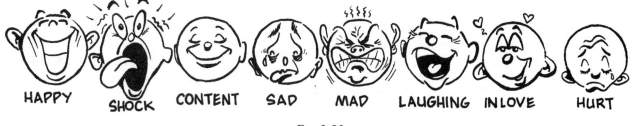

HAPPY SHOCK CONTENT SAD MAD LAUGHING IN LOVE HURT

Fig. 2-20

The Fundamentals of Cartooning Art

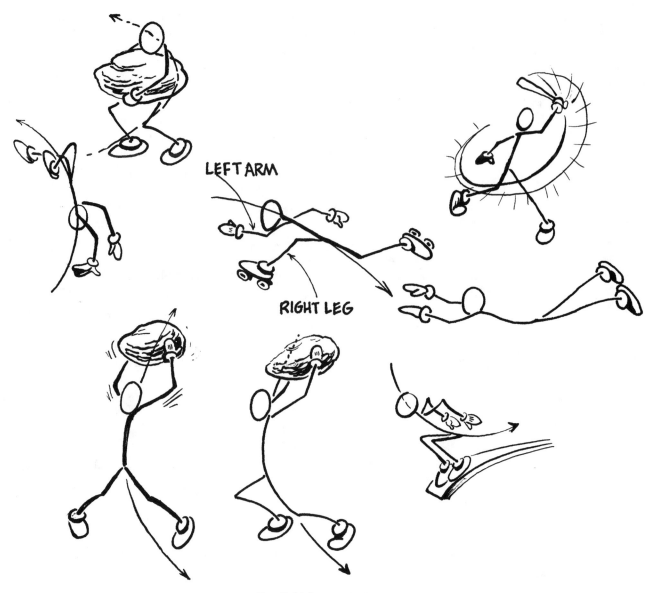

Fig. 2-21 *Jet men in action!*

 GOLDEN NUGGET: Early in my career I did some projects where I didn't take the extra time to get my preliminary drawing just the way it needed to be. I wrongly felt that I could fix these problems with paint as I went along. In the long run, it pays to push yourself to get your sketch as good as possible from the start. All of us look back over our past work and cringe at our lack of skill. Don't be discouraged, if you keep working at it you will get better. I would be worried if I looked back at some older work and didn't see any improvement.

 GOLDEN NUGGET: A simple thing to remember is that if your character is in motion, the legs and arms work in opposition. If the right leg is forward, the right arm swings backward. The left arm is swung forward, and the left leg is back. *Walking has been correctly defined as "controlled falling."*

Assignment #7: Jet Man

After practicing the examples of Fig. 2-21, draw at least three jet men in several poses. Remember to push the anatomy but don't forget that a line of action shouldn't have more than two bends in it. It should look realistic. That is, of course, except in the case of a snake or a tail.

THE BODY

The body consists of the flesh that covers the jet man and is broken down into three major parts: arms, legs, and torso. The height of a human has historically been measured by head sizes. As Fig. 2-22 shows, the realistic cartoon male is eight and a half heads tall.

During the time of Michelangelo (1475-1564), these ideal dimensions were established and became known as the "heroic proportions." The actual adult male is about seven and a half heads, crown to sole. The female size comes in at around six and a half to seven and a half. Look carefully at Fig. 2-22. Notice the horizontal and vertical measurements. You will need to refer back to Fig. 2-22 as we cover each body part.

There aren't very many bones in the body that you really need to be concerned with, so we will mostly deal with surface anatomy. The arms have, in essence, two long bones. The legs have two long bones each. That leaves the head, neck, rib cage, pelvis, hands, and feet. The jet man will suffice for the skeleton in most cases (Fig. 2-23). The flesh and muscles that hang on the skeleton make the major difference in character. Except for the height of the skeleton, all people are either anatomically male or female. Let's take a quick survey of the various body portions and look at a few ways to render them in a realistic and a cartoonish manner.

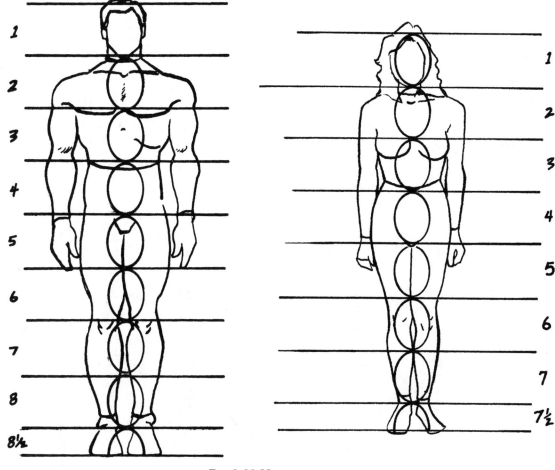

Fig. 2-22 Heroic proportions

The Fundamentals of Cartooning Art

43

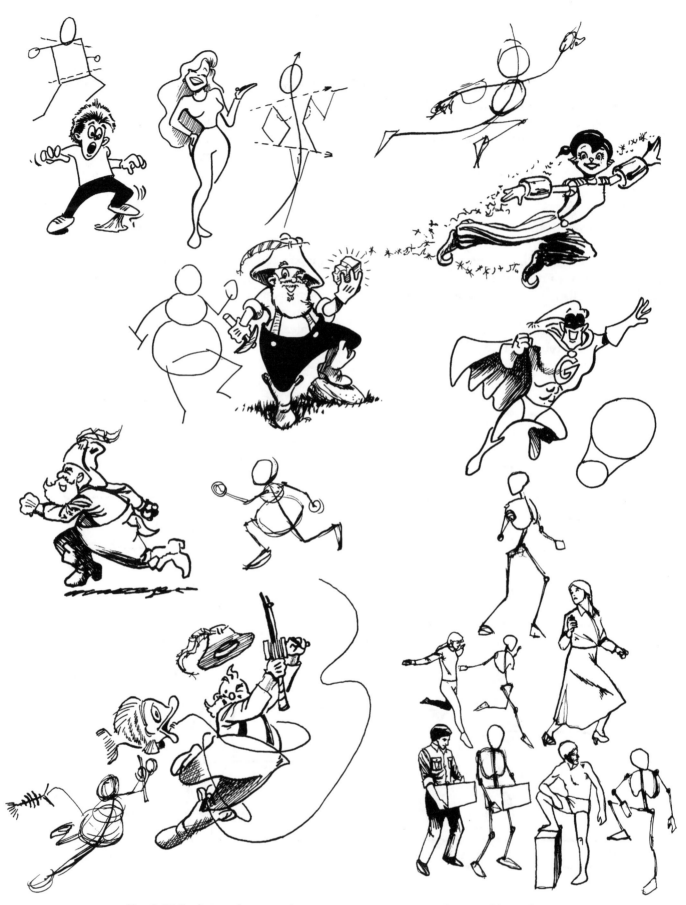

Fig. 2-23 Realistic and cartoon characters using jet men, action lines, and basic shapes

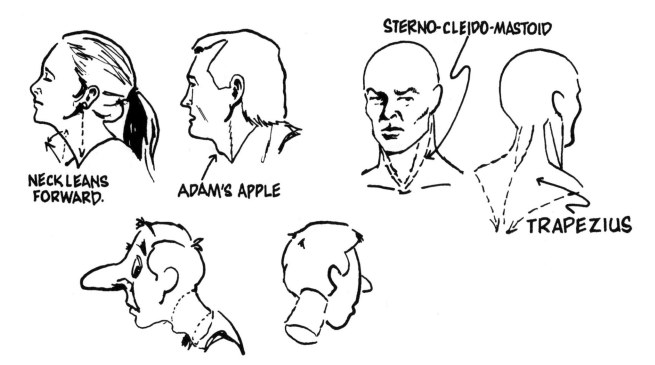

STERNO-CLEIDO-MASTOID

NECK LEANS
FORWARD.

ADAM'S APPLE

TRAPEZIUS

Fig. 2-24 *The neck*

Assignment #8: *The Body*

The following sections of body parts will have examples that accompany their explanations. Copy these examples in your notebook and add at least three of your own.

The Neck

From Fig. 2-24, you can see that there are only two main types of muscles that you should understand to form the neck cylinder. The (a) *sterno-cleido-mastoid* muscles, commonly called *bonnet strings,* extend forward from beneath the ears to the pit of the neck, forming a V shape. The others are the (b) *trapezius* muscles, which join the back of the neck to the shoulders.

Memorize and practice the following checkpoints in order to better reference the rendering of the neck.

• The neck always leans forward. Even when the head bends back, the neck protrudes forward.

• According to muscle tone, the trapezius muscles vary in size. Note the dotted trapezoid outline in Fig. 2-24.

• The "Adam's apple" is more evident in males; hence the Biblical reference.

• Lines add age, so when you're drawing a younger female, use them sparingly.

• Be sure to take the neck into consideration when drawing your jet men. Young artists have a tendency to want to jump from the head to the shoulders, thinking the neck will fit in somewhere down the line.

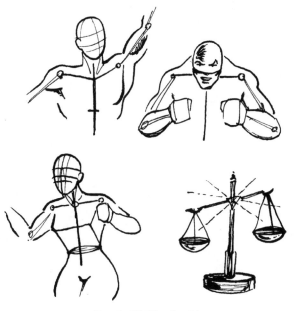

Fig. 2-25 *The shoulder*

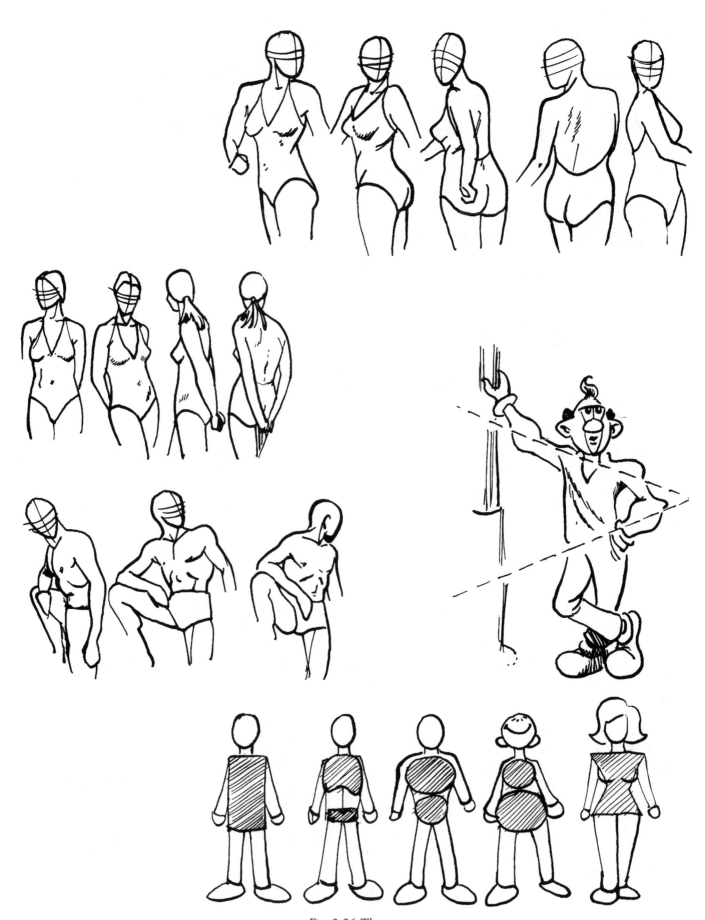

Fig. 2-26 The torso

The Shoulder

Here are some checkpoints for the shoulder:

• There isn't that much to portraying shoulders except that, as Fig. 2-25 shows, generally the female shoulder is smaller in width than the male's.

• Think of shoulders as a *T* shape, or as a set of weight scales.

• The shoulders serve to connect the arms and neck to the torso.

The Torso

Let's jump into the checkpoints:

• Look back at Fig. 2-22 and take note that the torso is three heads long from the shoulders to the crotch.

• In Fig. 2-26, the male is broader at the shoulder and more narrow at the hips than the female.

• Notice that when the weight of the body is shifted to one leg, the hip tilts up and the shoulder on the same side dips down.

• In the cartoonish department, you can accomplish the torso with a simple rectangle, or a rib cage and block pelvis, or a pear shape.

• The easiest way I've seen to sketch the female torso was in the Jack Hamm book *Drawing the Head and Figure*. He uses what he calls the "double triangle" to establish the hourglass female figure.

Arms

Arms can be drawn as extremely complex with all their bones, muscles, and tendons, or as simple as two rubbery tubes. Comic book superheroes today are often rendered in an overly grotesque and bulky manner, but thank goodness, arms can also be rendered in very simple ways, as in Fig. 2-27.

Here are some checkpoints for the arm:

• If you break the arm into its elementary shapes, it is a circle and two flexible cylinders connected by an elbow.

• Take a moment to review the arm back in Fig. 2-22. The arm is about three heads long.

• The elbow is almost even with the stomach navel.

Hands

In my research for this section, I found that through the years the number of cartoon fingers has varied from three to four. To the best of my knowl-

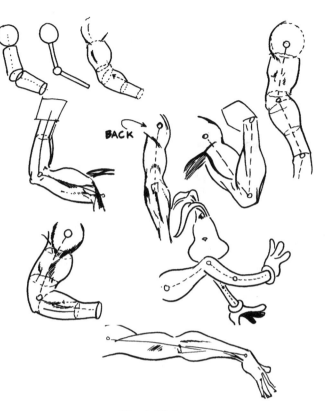

Fig. 2-27 Arms

edge, no one knows who first gave cartoon characters three fingers as opposed to four. It is commonly held that animation was the point of origin. The volume of drawings and the man hours involved forced animators to delete the ring finger, or third finger, on each hand, especially since the third finger virtually copies the movements of the middle finger. I had always heard that this phenomenon began with Disney, but the first evidence I found of this hand design was around 1914, in John Randolph Bray's character Colonel Heeza Liar. It also appeared to show up more in "funny animal" characters than cartoon humans. Winsor McCay, considered to be the father of American animation, used four fingers and a thumb on his characters.

Through the centuries, hands have been drawn differently to the point that each artistic period had its own styles. In the beginning of artistic history (before critics), hands were merely presented as evidence that the character was a human being. With time, the artist learned the necessity of using hands to dramatize the heart and soul of mankind.

Next to the face, hands afford the artist the most

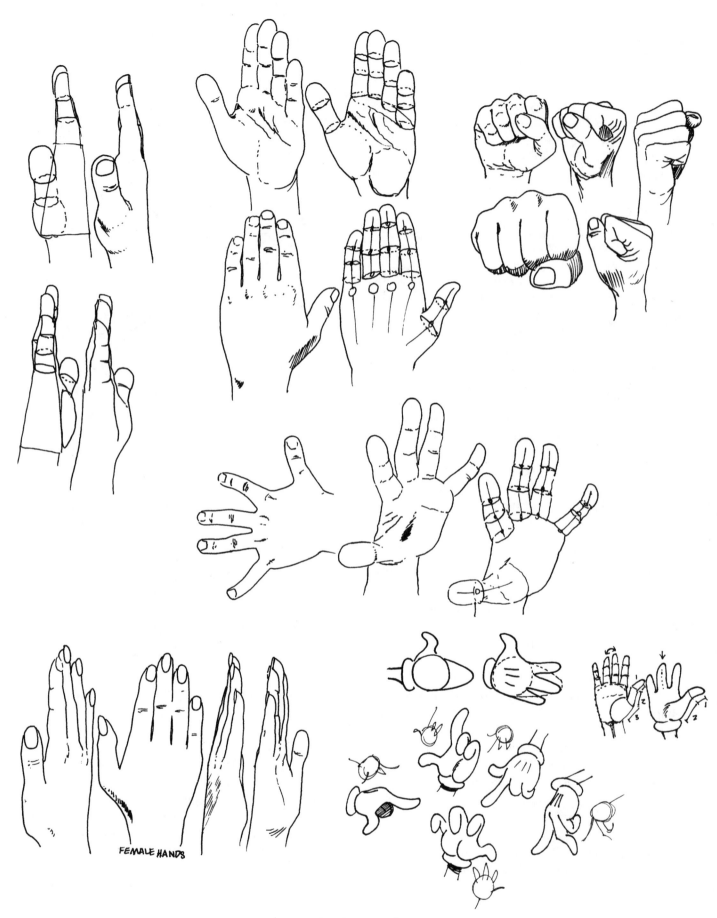

FEMALE HANDS

Fig. 2-28 Hands

opportunity for exaggerated expression and communication of ideas. Don't be discouraged; the hand is a struggle for any artist to learn to draw well. Some cartoonists learn to draw the hand in six or so poses and never draw the hand any other way. Study your own hands, look at photos, or take a look at how other artists represent them.

Checkpoints:
• Study Fig. 2-28. The hand basically filters down to rounded wedges and connected cylinders.
• The cartoon hand is a balloonish caricature of the real hand in that the thumb has only two bones instead of three, and there are few if any joints in the fingers.
• There is a real difference in the way that hands are drawn for women and men. The female hand is more graceful and tapered.
• The side view of the hand starts with a triangle for the palm.

Assignment #9: Hand Talk
As an addition to Assignment #8, draw hands that communicate the following emotions and posi-

tions. Use a combination of realistic and cartoonish male and female hands.

Shock, sympathy, anger, joy, physical hurt, emotional hurt, sadness, contentment, stop, holding object, holding paper, woman's hands, baby's hands, elderly person's hands, shaking hands with someone else, hands folded, and squeezing something.

Legs
Pictured in Fig. 2-29 is a varied assortment of legs. Like arms, the indication of legs can range from a set of rubberized tubes to a very complicated network of muscles and tendons.

Checkpoints:
• The leg can be considered as two long bones and a knee cap that joins them.
• The surface of the leg is seen as a larger cylinder that tapers from the hip down to the ankle.
• Look once again at Fig. 2-22. From the hip to the knee is two heads long and from the knee to the bottom of the feet is another two heads.
• Take note of the staggering of the leg in the front and side views.

Fig. 2-29 Legs

The Fundamentals of Cartooning Art

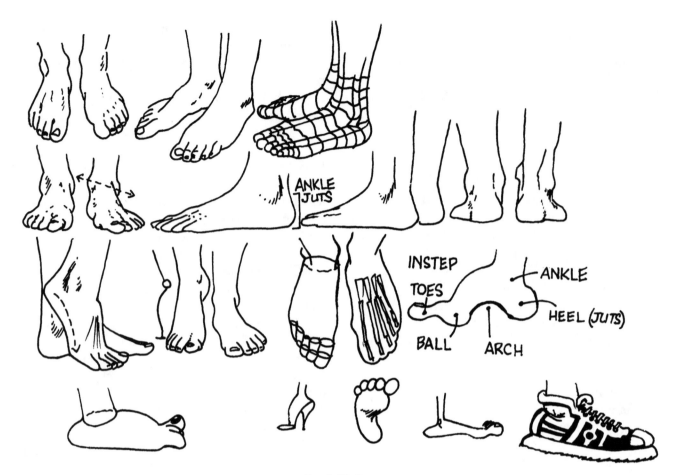

Fig. 2-30 Feet

The inner ankle is higher than the outer ankle.
- Small ankles are generally used when drawing the legs of women.
- Legs drawn further apart denote a heavier body.

The Foot

Well, we finally made it to the feet. Believable feet are difficult to draw. It is common for artists to exhaust themselves trying to get every muscle and eyelash just right, only to rush through the rendering of feet. While feet aren't nearly as expressive as hands, they are a dead giveaway for the amateur cartoonist.

Checkpoints:
- Notice in the side view of the foot that the heel juts out a little. This holds true even in very cartoony characters.
- The other ingredients to keep in mind when drawing the feet are the arch, the ball of the foot, the instep on top of the foot, and the toes.
- The foot bends at the toes and the ankle.

COSTUMES AND PROPS

Most art institutions you may attend will emphasize drawing the figure in the nude. However, they usually offer few or no courses that stress drawing figures with clothes on. This is odd to me because most professional assignments will call for clothed figures. I'm not saying that understanding the human form isn't necessary, but I do contend that it is more to your advantage to know how to draw draped figures. As Mark Twain once mused, "Naked people have little influence in society."

Costumes and props are imperative to the credibility and identification of your characters. Don't rely on your own knowledge of how a costume looks. Go to a local library. They usually have books that

FEUDAL ENGLAND
1400 A.D.

POSSIBLE
FUTURE

Fig. 2-31 Old and new costumes

Fig. 2-32 Cave man and his environment

show clothing styles throughout the ages. When I receive a new assignment I always spend a lot of time in the library looking at costume or historical reference books. Even if I'm doing a futuristic piece, old clothing can sometimes trigger inspiration. (Fig. 2-31) You may want to start a morgue file that you can fill with pictures of various kinds of clothing. As I mentioned earlier, Norman Rockwell had a large area in his studio filled with various costumes. Your research will also uncover other items that will aid in the believability of your cartoon. For example (Fig. 2-32), if you're drawing a prehistoric man, research would show not only his clothing, but also his dwelling, tools, weapons, environment, food, family, and enemies. Props or properties are essential to aid in delivering dynamic action and energy to your character and story. As often as possible, give your character a prop.

GOLDEN NUGGET: Props are an area where your artist's morgue harvesting will come in very handy. Retail stores mail out advertising pieces weekly that are filled with props. Flip through these papers and keep anything that you feel might help you later.

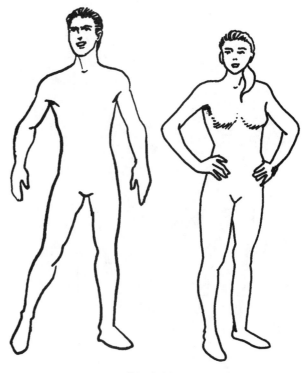

Fig. 2-33

Assignment #10: Clothes Make the Person

Draw a simple man or trace over the character I've provided. Choose two personalities from the following list of characters and render the appropriate costumes and props for their characteristics. Consult your local library for costume ideas if needed. You

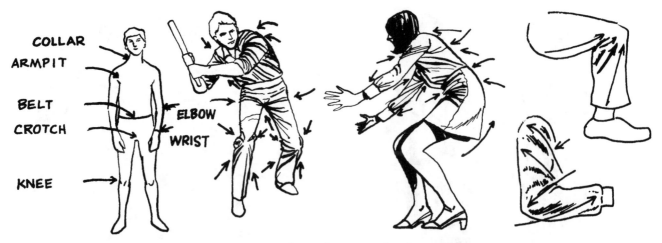

COLLAR
ARMPIT

BELT
CROTCH

KNEE

ELBOW

WRIST

Fig. 2-34 *Primary and secondary internal and external forces*

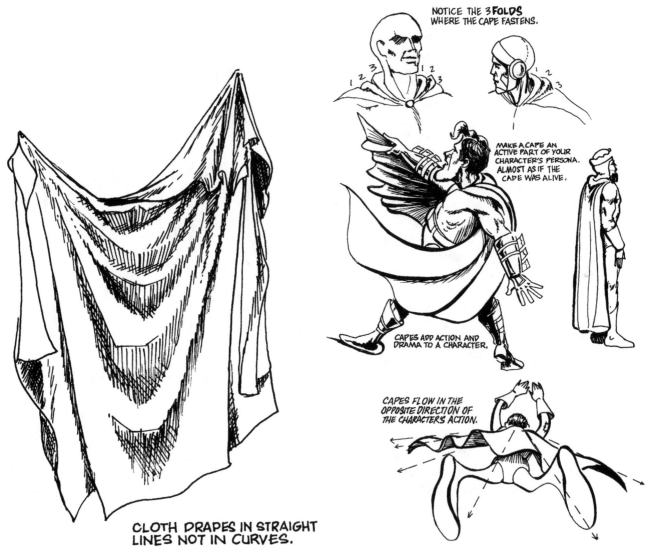

CLOTH DRAPES IN STRAIGHT
LINES NOT IN CURVES.

Fig. 2-35 *Hanging drapes*

NOTICE THE 3 **FOLDS**
WHERE THE CAPE FASTENS.

MAKE A CAPE AN
ACTIVE PART OF YOUR
CHARACTER'S PERSONA.
ALMOST AS IF THE
CAPE WAS ALIVE.

CAPES ADD ACTION AND
DRAMA TO A CHARACTER.

CAPES FLOW IN THE
OPPOSITE DIRECTION OF
THE CHARACTER'S ACTION.

Fig. 2-36 *Caped crusaders*

Fig. 2-37

can also collect clothing catalogs from retail and uniform clothing stores.

Police officer, chef, nurse, firefighter, tennis player, rodeo performer, clown, pirate, king, queen, lion tamer, farm worker, explorer.

Clothing: Wrinkles and Folds

Very often, students place wrinkles and folds in clothing because they know that they exist, but not how or why. It is important to grasp the internal and external forces on clothing to make your character believable. These internal and external forces demonstrate themselves in the form of wrinkles and folds. The following principles apply to realistic and cartoon inventions alike. All folds indent or protrude. The internal forces are the muscles and bones of the figure, and what I call the *fasten points*. The external forces are gravity, nature (wind and weather), and other objects. Notice Fig. 2-34: these lines indicate on a person where fasten points originate. *The primary fasten points are the armpits, the crotch, and a belt if the figure is wearing one.* The internal forces of the elbows and knees add to or delete the tension of these fastening points. The external forces generally contribute to stresses contrary to the internal forces.

Folds drape in straight or diagonal lines; they seldom drape in curves. The stronger the tension or twist on the fasten point, the more defined the fold. Fig. 2-34 shows some examples of internal and external forces on clothing. Be careful, it isn't hard to overdo wrinkles and folds.

Assignment #11: Wrinkles and Folds

Redraw or trace the cartoon mannequins in Fig. 2-37. Draw simple clothes on them. Give at least one of the characters a belt. Show the evidence of internal and external forces at work. Use a red pen or crayon on the fasten points, a blue pen or crayon on the primary internal force folds, and a green pen or crayon on the secondary external force folds.

ANIMALS

Before we advance to drawing the environment where your characters live, we must deal with the second most popular character type: the animal. Stop for a moment and think about how many cartoon characters are non-human. In fact, there are probably more famous cartoon animals than cartoon humans.

One of man's first attempts at animation was a boar (pig) that some believe was drawn about thirty thousand years ago on a cave wall in northern Spain. I suppose this means that wall graffiti isn't new either. Apparently, man has always told stories about animals that possessed human characteristics, but it wasn't until around 6 B.C. that Aesop first penned his fables.

The term for these humanized creatures used by fans and collectors today is "funny animals." Since the funny animal is the most often used type of animal in our world of cartooning, it is the kind we will explore in this section of study. The funny animals are abstract combinations of real animal and human attributes. Sometimes they walk on two legs, talk, reason, and use hands much like humans, and other times their humanity is sporadic.

In Fig. 2-38, you see the little donkey sidekick I created for the prospector in this book. Here are two versions of Li'l Donny Donkey. One has him walking on four legs and looking very animal-like. The other version has him more human in design. Of course,

Fig. 2-38 *Two versions of Li'l Donny Donkey*

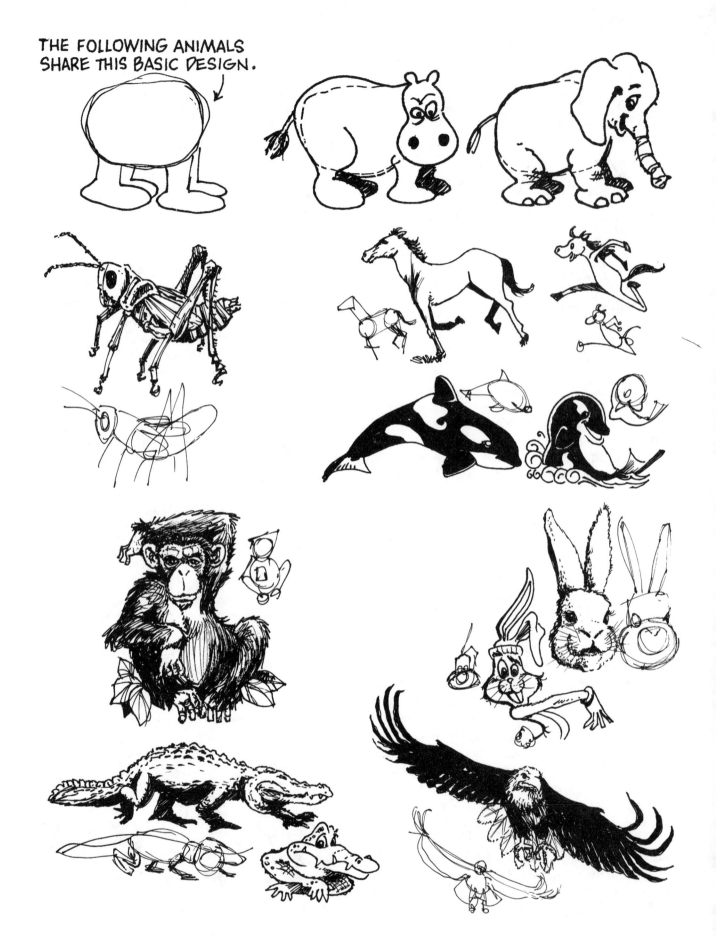

THE FOLLOWING ANIMALS SHARE THIS BASIC DESIGN.

Fig. 2-39 Real and cartoon animals

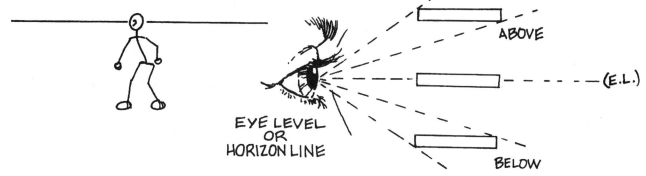

HORIZON LINE OR EYE LEVEL

EYE LEVEL
OR
HORIZON LINE

ABOVE

(E.L.)

BELOW

Fig. 2-40 *Perspective*

the great thing about cartoons is that anything is possible. I have included his understructures so that you can see how the different translations affect how he is put together.

There are more than 10,000 different mammals alone. This doesn't tap the multitudes of other species. For our purposes, I have selected a few from different animal groups. In fig. 2-39, I have included a drawing of the real animal, a cartoon version, and notes on their similar qualities. Don't be afraid to give your characters costumes and props.

Assignment #12: Animals

Choose two animals that are not drawn in Fig. 2-39. Draw or trace a realistic version of the animal and then draw a cartooned version of that animal.

PERSPECTIVE, FORESHORTENING, LIGHT SOURCE, AND SHADING

Well, we've covered the characters. Now it's time to jump into their environments. Perspective, foreshortening, light source, and shading are needed to make your drawings look 3-D instead of flat and lifeless.

Perspective

Perspective is easily explained. Objects closer to the viewer are bigger and things in the distance are smaller. One day while enjoying Pensacola Beach in Florida, I realized that the water tower was round and painted like a beach ball. I got my camera and directed my children to move between me and the tower. They were a few feet from me, and the tower

was a hundred or so yards away, and fifty or sixty feet tall. By moving their hands into position, it looked as if the children were holding the ball on top of the tower in their palms. That's perspective!

Horizon line and *vanishing point* are the two concepts that you must understand to be able to grasp perspective. Horizon, or eye level, is the horizontal line where the viewer sees the sky meet the earth. It runs from east to west. Vanishing point is a point on the horizon line where the outside edges of an object converge or would converge if the object was that long.

In Fig. 2-40, you have a front view and a side view demonstrating the eye level or horizon line. On the box above the eye level, you see its bottom and front. The box at eye level reveals only the front. Placing the box below the eye level exposes the front and the top of the box.

Fig. 2-41 shows *one point perspective*, where the object has one vanishing point. *Two point perspective* (Fig. 2-42) is where the object has two vanishing points. This is an area of cartooning when the four basic shapes (circle, triangle, cylinder, and rectangle) really come in handy.

It takes a lot of practice to become really good at drawing in perspective, so don't be discouraged.

Assignment #13: Perspective

In your cartooning binder, practice the drawings I did in Figures 2-40, 41, and 42. Draw one simple sketch that demonstrates one point perspective and another that reflects two point perspective. Do not erase your horizon line or vanishing point lines. Feel free to use a ruler or straight edge as aids.

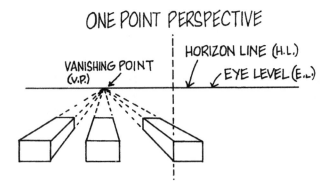

ONE POINT PERSPECTIVE

VANISHING POINT (V.P.)

HORIZON LINE (H.L.)

EYE LEVEL (E.L.)

Fig. 2-41 *One point perspective*

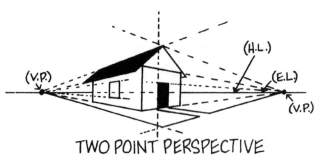

(V.P.)

(H.L.)

(E.L.)

(V.P.)

TWO POINT PERSPECTIVE

Fig. 2-42 *Two point perspective*

Foreshortening

Foreshortening and perspective are very similar. However, foreshortening is not as exact as perspective. Perspective can be plotted out mathematically and artistically. Foreshortening bends the rules to extremes for special effects purposes. It is the abstract enlarging of one object and the abstract shrinking of another to show the contrast in the relationship of the two objects. Cartooning really takes advantage of foreshortening to exaggerate and distort a character or concept to intensify its impact. Warner Bros. animated cartoons, especially ones that Tex Avery worked on, used foreshortening to it fullest potential and then some.

Tex Avery, best known for his short *Red Hot Riding Hood*, was instrumental in the development of Bugs Bunny, Chilly Willy, Daffy Duck, Porky Pig, and Droopy. His biography is listed in the resource appendix.

Assignment #14: Foreshortening

Create two examples of foreshortening after you've drawn my examples in Fig. 2-43.

Light Source and Shading

The next step to giving your cartoons dimensional life is showing the direction of light. It is best to use one source, such as the sun or a directional, artificial light. I've combined light and shade in this section because you really can't have one without the other. The principles of perspective play an important role in plotting where the highlights strike the surface of the object and where the shade and shadows fall.

I describe *shade* as the dark area "on" an object opposite the portion that light hits. *Shadow* is the dark area "around" or near the object where the light is blocked. An example of a shadow area is a table where the object rests. More and more cartoonists

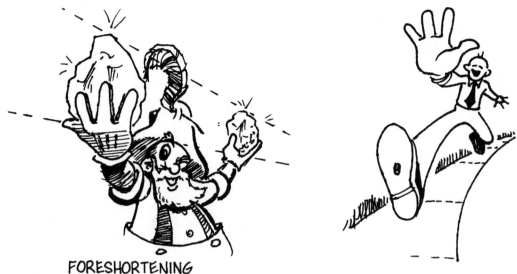

FORESHORTENING

Fig. 2-43 *Foreshortening*

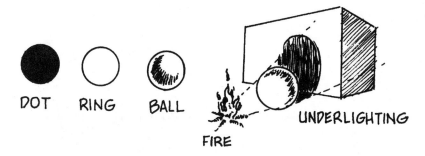
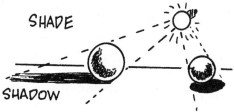

Fig. 2-44 Light source

and illustrators are using *under lighting* for dramatic effect. This is where the light source is below the object, such as the camp fire in Fig. 2-44. Often they use this effect indoors without identifying from where this under lighting source emanates.

 GOLDEN NUGGET: Notice the ball in Fig. 2-44. The shading doesn't touch the back edges of the ball. Light creeps around the ball and bounces up, striking the bottom in what's called *reflected light*.

Assignment #15: Dark Shadows

Draw five circles in a horizontal line about a half-inch in diameter and an inch apart. Number the balls 1-5. Using the sun as your light source, draw the sun in five locations as if it is rising and setting. Ball one's highlight, shade, and shadow should reflect just after sunrise. Ball two, 10:00 A.M. Ball three, noon. Ball four, 4:00 P.M. Ball five, just before sunset.

COMPOSITION, BACKGROUNDS, AND LANDSCAPES

Just as your characters need costumes and props, they also require a place to live. Each kind of cartooning we study in this book will have a section on the types of backgrounds that work the best. Nevertheless, we will now cover the basic elements of nature and manmade construction that are the essentials for good cartooning composition. The magic of good cartooning is to know what to put in a drawing to make a point, and what to leave out. I've seen cartoonists fill up a drawing with background because they are trying to make up for a weak joke.

Assignment #16: Composition, Backgrounds, and Landscapes

This assignment covers all of this section. As a portion is discussed and illustrated, create one drawing of your own version of that subject.

Composition and Layout

There are a few principles to remember when doing layout and composition. First, avoid being static. Look at Fig. 2-45 and take note of the good and bad basic layouts. Avoid putting your main idea in the dead center of the cartoon. Put it to either side, and above or below the center part of the panel. Rectangles are better than the static square. When planning your panel remember, if it's left up to you, use vertical panels for drawings that emphasize people, and horizontal panels for art that features landscape pictures.

Every picture or drawing needs a *focal point* (Fig. 2-46), or area where the reader's eyes go first. With practice and planning you will learn to plot this out so that your drawing will have its greatest impact.

Fig. 2-47 shows some Do's and Don'ts about panel composition:

• Never let a background tree or vertical object come between your main characters. Put the background object to one side and try to use it as part of your panel's border.

• Make sure that no background objects appear to come out of the character's body and that the background lines don't actually touch the main characters. When lines touch in a cartoon it communicates to the viewer that the objects are occupying the same space. Separating them adds depth and moves the background to its servant position.

• Have your characters looking within the

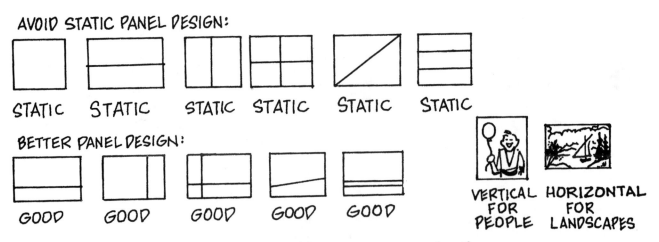

AVOID STATIC PANEL DESIGN:

STATIC STATIC STATIC STATIC STATIC STATIC

BETTER PANEL DESIGN:

GOOD GOOD GOOD GOOD GOOD

VERTICAL FOR PEOPLE HORIZONTAL FOR LANDSCAPES

Fig. 2-45 Take note of the compositions to use and avoid

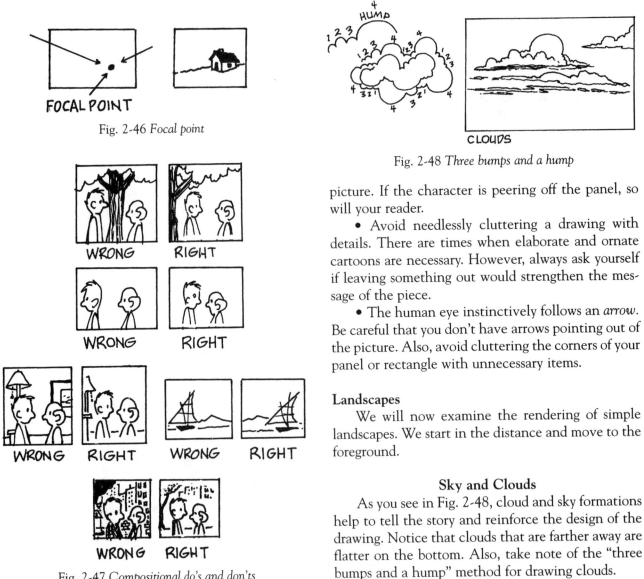

FOCAL POINT

Fig. 2-46 Focal point

WRONG RIGHT

WRONG RIGHT

WRONG RIGHT WRONG RIGHT

WRONG RIGHT

Fig. 2-47 Compositional do's and don'ts

HUMP

CLOUDS

Fig. 2-48 Three bumps and a hump

picture. If the character is peering off the panel, so will your reader.

• Avoid needlessly cluttering a drawing with details. There are times when elaborate and ornate cartoons are necessary. However, always ask yourself if leaving something out would strengthen the message of the piece.

• The human eye instinctively follows an *arrow*. Be careful that you don't have arrows pointing out of the picture. Also, avoid cluttering the corners of your panel or rectangle with unnecessary items.

Landscapes

We will now examine the rendering of simple landscapes. We start in the distance and move to the foreground.

Sky and Clouds

As you see in Fig. 2-48, cloud and sky formations help to tell the story and reinforce the design of the drawing. Notice that clouds that are farther away are flatter on the bottom. Also, take note of the "three bumps and a hump" method for drawing clouds.

Mountains

Mountains (Fig. 2-49) are rarely bump- or mound-shaped. Mountains are the result of erosion on rock formations, so mountains should come to peaks or points and not be rounded. Remember, what you're learning about is light source. Your mountains will look 3-D if you show light and shaded areas. The further mountains are set back in a drawing, the flatter" they should appear. Incidentally, the further away mountains are from the viewer, the lighter they appear in color.

Trees

Fig. 2-50 shows how to construct a basic tree. The largest portion of a tree is the trunk. Generally, the tree gets thinner as it climbs into the sky. Give your trees character by not making them two straight parallel lines. Add some personality and twist to your trees. Branches are drawn by making a series of V shapes. If you put a branch on the left side of the trunk, counterbalance it with a branch on the right side. It is better looking if the counterbalancing

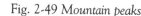
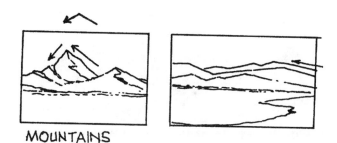

MOUNTAINS

Fig. 2-49 Mountain peaks

ROCKS

CLIFFS

Fig. 2-51 Rocks

branch is a little above or below the left branch. I have given you several examples of trees. Some trees have branches that angle down, others stick straight out, and others angle up. Some have thin leaves, while others have thick leaves or needles. Sometimes you can get away with a green "three bumps and a hump" cloud-like look. If the rest of your background has a lot of angles and action, simple straight trees may work best to give balance or contrast.

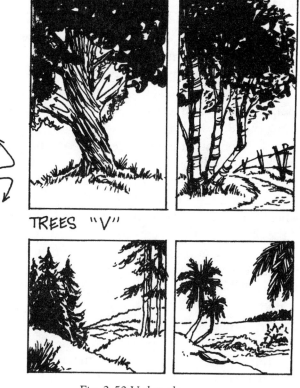

TREES "V"

Fig. 2-50 V-shaped trees

Rocks

Fig. 2-51 shows you the simple construction of rocks. A rock is a rock, whether it's the size of a mountain or a boulder or a pebble. Light source plays a big part in giving rocks the 3-D look. Rocks catch light on one side and show varying degrees of shade on different parts or chiseled portions of the rock.

CALM WATER WATERFALL

WAVES

Fig. 2-52 Water

Water

Look at Fig. 2-52. The important things to remember about water are (*a*) when it's calm, it rests flat or horizontal on the shoreline; (*b*) if water is on a slant, it will run with a current and possibly a waterfall; (*c*) weather plays an important part in the surface of water—the amount of wind, rain, or other outside forces will dictate the type of reflection the reader will see in the water; (*d*) you can view water waves as if they are small mountains. As noted in Fig. 2-52, stagger your wave peaks so they don't look so uniform.

Flowers and Grass

We close out our landscaping section with flowers and grass. There are so many different kinds of flowers, it could fill up numerous books. For our purposes, I have drawn a few flowers in Fig. 2-53 that show some easy ways to cartoon flowers. Along with the flowers are leaves and grasses.

FLOWERS AND LEAVES

Fig. 2-53 Flowers and grass

CONCLUSION

Well, we made it through this chapter of basic drawing. You will need to refer back to this chapter from time to time because all the other chapters are attached to this central hub, like spokes to a wheel.

Review Questions

1. What is a cartoon *morgue*?

2. In order to get his creative juices flowing, what did Norman Rockwell always draw first?

3. What is the difference between *plate* finished paper and *vellum* finished paper?

4. What are the four basic shapes used to cartoon?

5. What are the three parts of a nose and why is it drawn first after the basic shape of the head is sketched?

6. Using the face of a clock, explain the positioning of the reflective glints in the cartoon eyes.

7. Eyebrows are facial _____ _____.

8. Explain the letters *CCYU* as they relate to the construction of the human ear.

9. _____ _____ holds strands of hair together, forming groups called locks or tufts.

10. _____ _____ is the professional term used to mean "stick man."

11. The *line of action* is the _____ portion of the human anatomy.

12. What is the name of the first animated cartoon character to have a hand with only three fingers and a thumb?

13. What are the two forces that determine the wrinkles in clothing?

14. In perspective, the _____ _____ is a point on the horizon line where the outside edges converge or would converge if the object was that long.

15. What is the difference between one point perspective and two point perspective?

16. What is the difference between perspective and foreshortening?

17. What is the difference between *shade* and *shadow*?

18. The _____ _____ is the area of a cartoon where the reader's eyes go first.

CHAPTER THREE

GREETING CARDS

The greeting card industry likes to refer to itself as "the social expressions industry." This is a title that is more fact than brag. According to the Greeting Card Association, the average American receives thirty cards per year. Eight of those cards are in honor of a person's birthday. There are about ten million birthdays celebrated every day worldwide. Women are responsible for the purchase of 90 percent of all greeting cards. As far back as 1987, greeting cards accounted for 60 percent of all the mail delivered in the U.S.A. This year some eighty million graduates will receive cards; 25 percent of those will be humorous and 85 percent will contain money.

In 1995 alone, the U.S. social expressions industry made more than $6 billion for their efforts. The big three greeting card companies are Hallmark, American Greeting, and Gibson; there are close to fifteen hundred other greeting card publishers.

TYPES OF GREETING CARDS

There are two types of cards: seasonal and everyday. The seasonal cards are naturally oriented toward holidays. The most popular cards, in order, are Christmas, Valentine's Day, Easter, Mother's Day, and Father's Day. The everyday cards are sympathy, get well, birthday, or just to say "hi."

These cards are further divided into traditional and alternative (studio) cards. Traditional cards express a sincere message that one person wants to send to another, whereas the alternative cards tend to be humorous in nature. As early as the 1890s, satirical, or "vinegar," Valentines appeared in England. Some of these cards were very mean-spirited. This type of card was discouraged for about a hundred years because the card makers felt that cards should encourage people, not belittle them. Then, in the mid-1950s, free-lance artists living in small studio apartments in New York's Greenwich Village created alternative cards that became known as studio cards. These cards featured quirky, sophisticated, offbeat humor.

These days, greeting cards are almost everywhere, from greeting card specialty shops to small country gas stations. The industry has expanded to include other products such as oversized cards, postcards, stationery, notepads, gift booklets, gift enclosure cards, notecards, invitations, bridge and card tallies, napkins, and party paper products.

THE INDUSTRY AND THE CARTOONIST

Of all the areas of cartooning that will be discussed in this book, greeting cards afford the creative cartoonist the most potential for professional entry. The big three publishers have extensive staffs of in-house artists. However, as I mentioned before, there are still about fifteen hundred other publishers of cards that need hundreds of cartoonists and writers each year. Many smaller firms rely totally on freelance artists and/or writers.

COVER

INSIDE

Fig. 3-1

COVER

INSIDE CUT DOTTED LINE INSERT CASH

Fig. 3-2

Here are some qualifications that greeting card companies look for.

1) You need an education that includes the abilities to write the words and draw. In this business, the *art attracts,* but the *message sells* the card.

2) You need to have the ability to create fresh ideas. Card publishers are not only looking for people to work in the company's current styles, but they also need people who can create a new kind of profitable social expression.

3) You have to be able to write and/or draw in a manner that communicates the "you-to-me" feeling and appeal. The greeting card industry completely hinges on the "you-to-me" message of its products.

4) You must keep up with current trends. You can do this by studying the cards which are being sold now. Other ways are researching the greeting cards chapter in the current annual *Artist's and Graphic Designer's Market* book (see suggested reading list), writing the Greeting Card Association (see resource appendix), and writing the various greeting card companies to obtain their submission guidelines.

THE DIFFERENCES IN GREETING CARDS AND CARTOONS

The next time you are looking through the greeting card racks in a store, you will see a large assortment of humorous cartoon illustrated cards. Allow me to point out the subtle differences in a regular cartoon and a greeting card cartoon.

1) Greeting cards communicate a one-to-one, or "you-to-me," feeling, while a cartoon is aimed at a broader mass market. People buy cards so that the card can express what the purchaser wishes to say to someone else. Narrow audience gag cartoons only work in exclusive trade magazines aimed at a certain demographic group.

2) Cartoonists generally have a shorter deadline. As you will see in our section of study concerning comic strips, cartoonists are sometimes pressured by the "joke-a-day" grind. Greeting cards can afford more time to work and rework an idea.

3) Greeting cards have a softer look than cartoons. The lines are executed in a different way, and the col-

ors tend to be more on the pastel side. Remember, females buy 90 percent of the greeting cards sold.

4) Greeting cards are trendy and are not as time durable as cartoons. Many cartoons stay funny for decades. It may not seem like it on the surface, but greeting cards change with the times. Just think about it. Competition is fierce for shelf space in stores. Greeting card companies are constantly looking for something that will give them an edge over their very creative rivals. These companies closely monitor sales volume and quickly adjust in order to dull any competitor's new edge.

Assignment #1: Card Morgue
Start a new morgue file labeled "Greeting Cards." You only need be concerned about cards with a cartoon look. Go through your home and find some cards. You'd be surprised at the number of cards clogging up your sock drawer. Don't raid other people's personal stash without permission. Check with relatives and friends to acquire any cartoon cards they no longer want.

Assignment #2: Card Gazing
Go to a local store that carries greeting cards. It is always a good idea to notify any store personnel of your reason for being there. Look through the cards and write down a description of any funny cards that appeal to you. Look at the type of cartoon styles that seem to dominate the shelves. If financially possible, purchase one or two that are in a style you would like to learn and put them in your morgue.

Assignment #3: Design a Card
It is time for you to design a few cards. You are to design *two* cartoon cards for each of the following categories: birthday wishes, thank-you notes, just to say "hi," party invitations, get well soon, and graduation. Each of your cards must be accompanied by an envelope.

 GOLDEN NUGGET: No red envelopes. These envelopes are detested by the postal people because their electronic mail separators have a hard time reading black ink on red paper. Red Christmas card envelopes only serve to add to the headaches of that seasonal rush.

COVER

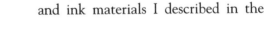

INSIDE

Fig. 3-3

Fig. 3-4

Assignment guidelines:

1) *Paper:* The thickness should be no less than index or poster board stock (2-ply Bristol board), in white or a pastel color. Each card should fold to the industry standard size of at least $4\frac{5}{8}$" x $7\frac{1}{2}$". You may choose another size if you can find an envelope to fit it. I always encourage creativity, but try to refrain from doing too many ornate pop-up panels.

2) *Message:* Remember, cards are directed from one person to another. If you have a hard time writing a gag, you may use a message from an already published card. If possible, try to alter the wording to make it your own message. Puns work well in greeting cards. Surprise seems to give the best punch for humor. The surprise card's front cover sets up the reader, and the inside gag line, or "kicker" as I call it, delivers the punch. Also, keep your messages and art aimed at a general audience, and don't use vulgarity or profanity. Your message doesn't have to be funny just because you are using cartoons to illustrate your point.

3) *Art:* Work in a cartoon style using the pencil and ink materials I described in the first chapter.

Color your cards with crayon, paint, watercolors, colored pencils, or dyes. Make the cartoon as close to current trends in the industry as you can.

 GOLDEN NUGGET: When my oldest son Aaron was about ten years old, he wanted to earn some extra money. I suggested he sell greeting cards that he designed. He got to work and drew about twelve original illustrations for all-occasion cards. He took these designs and walked through our neighborhood showing his art to anyone who would look at them. He assured them that he wasn't trying to get them to buy the cards, but rather, to give their opinions of their favorite six designs in order of preference. He recorded their choices and returned home. He tallied up the votes and drew cards based on the six most popular designs.

These all-occasion cards had cartoons on them without any written message. We had them photocopied on cream-colored paper. Next he hand colored each card with colored pencil. He put six different cards with cream-colored envelopes in small reclosable sandwich bags and sold them for three dollars per pack. They sold like crazy. He continued this business until he got sick of coloring them. As of this writing, people still call our house wanting to purchase his cards.

I feel you would be pleasantly surprised if you were to follow Aaron's example. These personally designed cards could make you some much needed cash. Each of his card packs cost roughly a dollar in materials. The rest is your time coloring, packaging, and selling your very own greeting cards. This might even make a good class or art club fund-raiser. Enterprising cartoonists seldom starve.

AARON BOHL-AGE 10 - GREETING CARD

Fig. 3-5 An all-occasion card designed by Aaron Bohl at age 10

HOW TO MAKE AND SELL CARDS

1) Take a sheet of typing paper ($8\frac{1}{2}$" x 11") and fold it in half, then fold it again so that the size is $5\frac{1}{2}$" x $4\frac{1}{4}$". Turn it toward you so that it opens like a book.

2) Draw and ink the cartoon so that it fits the front cover area. Keep it simple so that you don't have too much to color.

3) Decide what information you want to put on the back panel—you can sign it or write your name, or write the class or club name if it's a project. Be sure to include reorder information.

4) Open up the paper so it lies flat and copy it onto ivory or cream-colored paper—typing paper weight is fine.

5) Get matching envelopes from an office supply store or a print shop.

6) Get inexpensive reclosable sandwich bags.

7) Color the cards with colored pencils or crayons.

8) Put five or six cards and envelopes in each bag. You may want to include a simple label.

9) This should cost about a dollar a bag. Three to five dollars is a good asking price.

10) Sell them to friends, family, neighbors, and local retail stores.

Review Questions

1. What does the greeting card industry like to refer to itself as?

2. Name the big three greeting card companies.

3. What are the two basic types of greeting cards?

4. Where does the name "studio card" come from and what is it?

5. What basic message does a successful greeting card communicate?

6. Name two differences between a greeting card and a regular cartoon.

7. Why does the post office discourage the use of red envelopes?

CHAPTER FOUR

ILLUSTRATION

An illustration is a painting or drawing that accompanies the written part of a printed work. An illustration is most useful when it helps the reader understand the text. Of course, it may also serve to decorate or make the story more attractive. *Editorial* and *spot* illustrations are the two types of drawings used in books, magazines, and newspapers. Do not confuse editorial illustration with editorial cartoons. They can be one and the same, but not necessarily. Editorial illustration is art that illustrates a story in a book, magazine, or newspaper. An editorial cartoon is considered to be a meshing of message and art. Editorial cartoons are generally political in nature.

Spot illustrations are artistic renderings that are a half-page in size or smaller. They are used within story layouts as visual cues that accompany shorter articles, or as a way to break up larger articles into smaller chunks for readers.

When you're trying to come up with illustrations, think *action* even if the characters are just standing around. Illustration is a method of storytelling in itself.

THE INDUSTRY AND THE CARTOONIST

Don't fall for the Hollywood fairy tale that if you write or illustrate one book, you will be instantly famous and wealthy. It is slightly possible, but not likely. I've worked on nearly fifty books and I am neither famous nor rich, yet.

GOLDEN NUGGET: A person should be famous for what they are and not so much what they do. Become famous for helping others reach noble goals in life and success will never be a stranger in your home.

After greeting cards, the next best area for a cartoonist to explore is book, newspaper, and magazine illustration. There are thousands of book publishers who use free-lance artists. Most magazines need illustrations. Local newspapers may possibly need some editorial or spot illustrations. The local papers are a great place to begin, but they historically pay little or no money. To be honest, the wonderful feeling of seeing your work in print for the first time cannot be measured in mere dollars.

If your school has a newspaper, they may be open to your contributing cartoon illustrations for their stories. The main point is to start somewhere. I know artists who are always worried about how much they are going to get paid. There are times when money and ownership are legitimate considerations, but at this stage of your life, don't be overly concerned about money, or worried that someone is taking advantage of you. Your compensation, for now, should be the opportunity of communicating your ideas and talents to others. You are on a learning curve. Be willing to start in smaller markets and for little cash, but determine not to stay there.

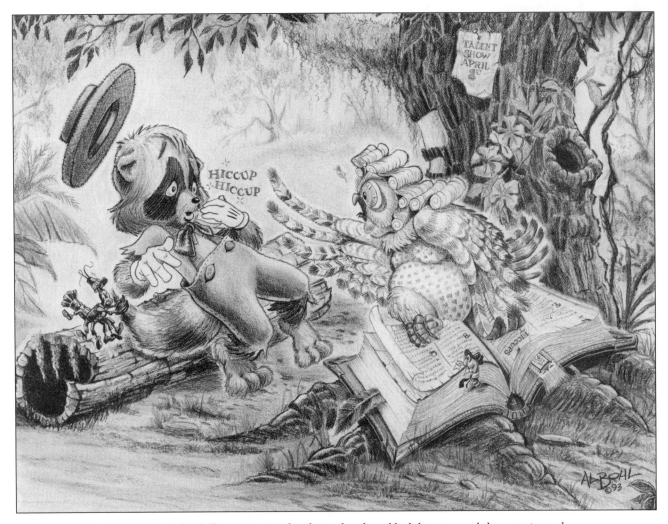

Fig. 4-1 *Children's book illustration in colored pencil with no black lines around the art—instead, a darker shade of the dominant color is used to soften effect*

Warning: you should be willing to work for free, but you should never have to pay someone to use your work. If someone wants you to pay them, something is very wrong.

Check with the print shops in your area; they may need a cartoonist from time to time. Also, check for small press book publishers. Doing work for a small press will build your portfolio and shows initiative, which might impress bigger publishers. Some publishers seem to be more impressed with cartoonists who can meet a deadline than those who can draw well.

Besides book and magazine illustrations, cartoon illustrators can also find work drawing for coloring books, and advertising.

ILLUSTRATION MATERIALS AND METHODS

Different types of illustrations require different materials and drawing styles. Let's take children's books, for example. Many cartoonists and editors feel that a black outline around a character makes the artwork too dark for children's literature, so they soften the art by using a darker shade of color to outline the character. An example would be a face that is flesh-colored. The outline around the face would be a darker red or maroon. Light blue pants would have a darker blue outline around the pants, instead of black. In recent years, there has been a trend in books aimed at pre-teens to use pencil art. To me it looks a little washed out, but if offered the assign-

Three TSVs burning into dust!

Fig. 4 -2 *Pen and ink illustration from one of my Zaanan books,* The Fatal Limit, *used by permission of Barbour and Company, Inc.*

"I was lured into an ambush!"

Fig. 4- 3 *Pen and ink illustration from one of my Zaanan books,* The Fatal Limit, *used by permission of Barbour and Company, Inc.*

ment I'd give them the best washed-out art I could.

In this book, we will not examine how to make production mechanicals for printing. That is an entire book unto itself and does not serve our purposes. However, the following is a brief explanation of different ways to add depth to your cartoons.

THE MAGIC OF OPTICAL MIXING

An *optical mix* is an artistic term that describes what the human eye does when two different colors are positioned next to each other: it tricks itself into blending those colors into a new color. If you place a blue dot next to a yellow dot, the human eye will blend these two separate colors into one green dot. The closer the dots are to each other, the darker the new color. The further the dots are apart from each other, the lighter the new color.

In order to print in *full color*, a printer has to take the original artwork and use photographic screens to separate different colors into small dots. Full-color printing is sometimes referred to as *four color*. Cyan (light blue), *magenta* (light red), *yellow*, and *black* are called *process colors*. They are what the printer uses to form all the colors of the rainbow and more. The printer lays down each color over the other, separated into dot patterns. Then the optical mixing of cyan, magenta, yellow, and black gives any colors desired.

Find a printer in your area who does four-color printing and ask if you can visit the company, or if they can send you examples of halftone screens and press sheets. Find a color separator and ask to see color keys and any other information they have.

Illustration

69

CROSS-HATCHING ILLUSTRATION

Fig. 4-4 *Cross-hatching method*

CROSS-HATCHING

When working in black and white, gray tones must be achieved to add depth to the art. One of these methods is the ancient technique of *cross-hatching*. The artist lays down individual lines parallel to each other, and then crosses back over the original set of lines from a new direction. The closer the lines are together, the darker the gray tone effect. Lines farther apart are lighter. Fig. 4-4 shows an example of cross-hatching.

STIPPLING

Stippling is a popular illustration method for adding gray areas to your cartoons. The artist takes his or her ink pen and makes a series of dots. The closer the dots are to each other, the darker the gray tone. Fig. 4-5 is an example of gray tones achieved by stippling.

BENDAY SCREENS

Benjamin Day (1838-1916) invented the Benday prefabricated pattern screen. These screens can be purchased in art stores or by mail order. The screens vary in patterns and gray value. Fig. 4-6 shows several screens in use. You purchase the screens on a sheet. Using an X-acto-blade knife, lightly cut out the desired shape. Lift the section of screen from its adhesive backing. After inking the art, and erasing any pencil marks, place the screen on the area to be shaded and cut off any excess. Burnish (rub over) the screen to make it stick to the art. Zipatone and Chartpak are two well-known brands of Benday screens.

Benday comes in a couple of different forms. One has the adhesive backing. The other, known as "rub down," is the kind that you place over an area of art and then rub onto the art surface. The screen transfers directly to the artwork.

The major problem cartoonists have with the Benday screen is when the art has to be reduced for printing. If the dots in the screen are too close together when they are first applied, the dots will mesh into a solid when reduced. Be sure that when the dots are applied, they are far enough apart so that reducing will not defeat the effect.

STIPPLING ILLUSTRATION

Fig. 4-5 *Stippling method*

GUIDE TO CARTOONING

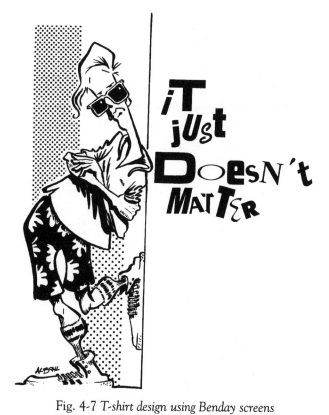

Fig. 4-6 Benday screens

Fig. 4-7 T-shirt design using Benday screens

DUO-SHADE

This method is rather expensive. It is most often used in editorial cartoons. Duo-shade is a specially treated paper which comes in a tracing vellum and a 2-ply paper board. You pencil and ink the image you want on the paper. Once the art is dry and pencil marks are erased, apply the two shading chemicals provided with the paper. The white cap solution reacts with the special paper to make a light shade of gray. The black cap solution reacts to produce a darker shade. First you paint the lighter screen. Be sure to wash the brush out thoroughly and dry it a little before painting with the dark solution. Don't mix the solutions. When purchasing Duo-shade paper and chemicals, be sure to get the kind that will reduce to the printing size you require.

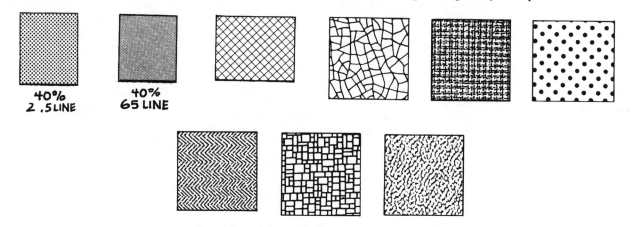

Fig. 4-8 Prefabricated adhesive patterned screens

Illustration

71

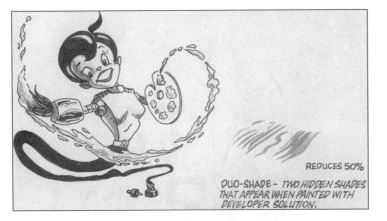

Fig. 4-9 *Duo-shade comes with specially treated paper and liquid developers*

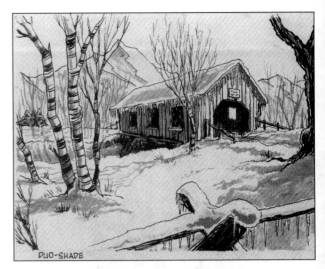

Fig. 4-10 *Duo- shade illustration*

Fig. 4-11 *Wash illustration using diluted inks*

GUIDE TO CARTOONING

Fig. 4-12 *Pappy and Donny illustration using wash*

WASHES

A *wash* is an effect where you dilute black ink with water to make it gray in color. Different amounts of water will generate varying densities of gray. Then you can paint the gray areas of your cartoon and let the printer photographically make your screens. This process is known as making *halftones*. The big problems with washes are that the gray is hard to control and the printer's screening process may break up some of your solid black lines.

TEXTURED PAPER AND CRAYONS

One final effect is the use of textured or pebble paper and crayons. Draw your cartoon on the textured paper. Then you rub the conté crayon over the pebble-board paper. Different degrees of pressure applied to the ridges of the paper breaks up the line into a natural screen or halftone. This method has been used very effectively for editorial cartoons in the past.

Assignment #1: Illustration Morgue

As you are working on this chapter, be sure to concentrate on morgue harvesting in the area of illustration. Have a separate morgue file for black and white cartoon illustrations and color illustra-

Fig. 4-13 *Lion illustration using conté crayon on textured paper*

tions. These files should not include comic strips or editorial cartoons. Try to become familiar with spot and editorial illustrations.

Assignment #2: Illustrated Trip

Take an hour or so and browse through a bookstore. Leaf through the various sections of books and magazines. Take notice of the different styles of

Illustration

73

cartooning. Be sure that you cover the children's, youth, and adult sections. Make note of any artist that you enjoy the most. Write down the artist's name and the name and address of the publisher. Write the cartoonist a short letter in care of the publisher. Most cartoonists will send a reply that you can share with your class. If you send a book or magazine that you wish them to autograph, be sure that you send a return envelope and enough postage to cover the cost of mailing it back. It isn't right to expect them to pay to return your book.

Assignment #3: Cartoonist Profile

Research and write a one- to two-page report on a well-known illustration cartoonist. Place it in your cartooning binder. Choose your own cartoonist to write about. Some well-known cartoon illustrators are: Jack Davis, Mort Drucker, Dr. Seuss, Maurice Sendak, Norman Rockwell, and William Joyce. There are many more, but this is a good sample of people that are easy to research. You can find articles on cartoonists by looking in the *Reader's Guide to Periodicals* in the library.

Assignment #4: Coloring Book Page

Every kind of cartooning demands a different approach. Coloring books are no exception. As you look at coloring books you will discover that the best books have one or two central characters that are boldly outlined. The interior features have thinner lines and no shading. Any background or landscaping is simplistic and open. Give the child colorist lots of room to stay within the lines. Fig. 4-14 is a reduced coloring page I have provided to give you an example of how a well-crafted page should look.

Your assignment is to choose between the following three scenarios and draw one 8¹/₂" x 11" inked black and white coloring book page.

Scenario 1: A young boy or girl is out walking a dog in a park setting. The dog has seen a cat and is chasing it. The child is fighting to hold onto the dog's leash.

Scenario 2: An animal of your choosing is raking autumn leaves which have fallen from a big oak tree.

Scenario 3: A circus clown is balancing himself on a tightrope with a stack of things in each hand. One hand has a fish in a sloshing fish bowl, an iced birthday cake, a roller skate, and a computer monitor. The other hand has a basketball, coffee pot,

Fig. 4-14 *Coloring book illustration*

accordion, and an umbrella.

Work to give one of these a lot of energy. Remember, give enough detail without overworking the art.

Assignment #5: Advertising Illustration

This assignment is to make a cartoon to draw attention to a full-page advertisement (see next page) for a new computer software program. Use any cartoon style you desire. Use one of the shading methods mentioned above. Photocopy the ad and insert your cartoon into it. Then photocopy the ad again and put it in your cartoon notebook.

The software is supposed to revolutionize home cooking. It contains a jillion cooking recipes, organizes grocery lists, and reminds the cook of needs. The grocery list will have an aisle-by-aisle diagram of the grocery stores in your area. All store specials will be faxed or e-mailed to your personal computer. This software will notify you of any sale price items you need. It will even compare different store prices on certain items.

It will inventory pots, pans, and utensils. It has answers for every cooking and measurement question imaginable. It will time thawing, cooking, and baking. It has a calendar for marking special occasions. It has the answer to every eating and entertaining etiquette question imaginable. If your computer has a modem, it will even fax your local grocery store with your list to be filled, pay with a credit card, and give delivery instructions.

This program truly earns the description, "The Greatest Software Program Since Sliced Bread!"

THE GREATEST SOFTWARE PROGRAM SINCE SLICED BREAD™!

*I*n today's wild and wacky work-a-day world, who has the time to put a family meal together? You've just worked eight hours, been a taxi service to soccer practice, piano lessons, and drum lessons, and took the pooch to the vet for its overdue shots. You've got a pile of clothes to wash the size of Mount Fuji, and it's just Tuesday.

To top it off, your mother-in-law is coming to dinner! Who cares? *WE DO!!!*

That's why we created

THE KITCHEN HELPER™!

An affordable software program that can pull your kitchen into order.

FEAST your eyes on these features fit for a king or queen!

- **COOKING RECIPES & KITCH-TIONARY**
 - A jillion and one time-tested favorites and room to add your own.
 - An answer for every cooking and measurement question you could imagine.
 - Etiquette answers for every question. What's right in 210 nations of the world.

- **GROCERY LIST**
 - An aisle-by-aisle diagram of the grocery stores in your area.

 - All store specials are faxed or e-mailed to your pc.
 - Price comparisons are now at the tip of your fingers.

- **KITCHEN ORGANIZER**
 - Inventories all pots, pans, and utensils.
 - Fax your grocery store your grocery list, pay with a credit card, and give delivery directions.
 - Family planner calendar.

SAVE $20! CALL FOR OUR SPECIAL $49.95 PRICE!
CALL 1 (800) 555-COOK! operator # 50

MASTERSOFTWARE™

Fig. 4-15 *Cartoon advertisement*

Assignment #6: Book Illustration

The following story, *The Fitful Slumber of Arlington Belmont,* is about a little boy whose hunger pains set him off on a wild adventure. As a boy I lived on a street named Arlington Place. The next street over was called Belmont. I call the boy in this short story Arlington Belmont as a contrast to his true adventurous personality, and as a tribute to my much-loved childhood neighborhood.

Most boys rarely think their names are tough enough to suit them. I used the derided nickname, Arlie Bela, in his dream because that is the nickname that school bullies would probably use to make fun of him.

Read the story several times. Pick out six exciting visual images that tell the story. Render one image in color on a piece of 2-ply Bristol board no larger than 11" x 17". It doesn't have to be the first image idea in the story. Use any kind of coloring material or format you desire. You may even work in black and white. This is the introductory image.

Draw the other five images in black and white, using any gray tone style you wish. These cartoons would be placed in the book, mixed with the type. Render them on 2-ply Bristol board no larger than 8½" x 11". Keep in mind that if you use the Benday adhesive screens, they must be the kind that will reduce and not clog.

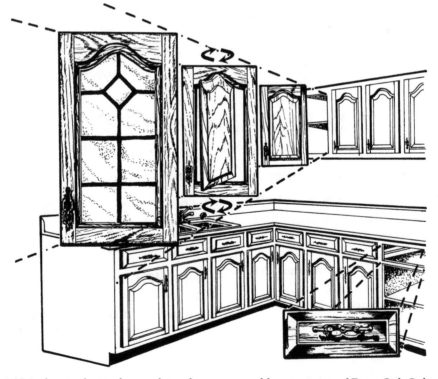

Fig. 4-16 *My first professional artwork in advertising; used by permission of Dura-Oak Cabinet Refacing Systems*

The Fitful Slumber of Arlington Belmont
by Al Bohl

The old wooden bed of Arlington Belmont wheezed and popped as he twisted and flopped in his dark lonely room. The tick and tock of his wind-up clock reminded him that he just couldn't sleep. He thought back on his day to see if maybe some way he had done something that bothered his mind. No, nothing was there that had hindered his prayers that he said before snuggling in bed.

Suddenly, Arlington heard a mumble, that felt more like a rumble, grumble from under his covers. He knew from this quake that he must be awake because his tummy yearned for a little ole snack. He slipped to the floor, gently squeaked open his door, and made sure that all was at ease. His little feet sneaked and the house didn't creak as he heeded the call of his master. Up high on a table sat a prized pizza that was able to send him drifting to La La Land. He ate every bite without the aid of a light and scurried right back to his room undetected. His bed didn't wheeze or pop, and he didn't twist or flop as he dozed into restful peace.

Thump, bump went his bed—bump, thump went his head as he forced open one heavy, tired eye. His little mind was reeling because from his floor to the ceiling stood a dinosaur dressed like a clown. "Arlie Bella," he said in a musical voice, that made Arlington realize that his only choice was to run as fast as his legs would allow. Arlington's feet hit the tile, and he fled for a mile before turning to see if he was alone.

The dinosaur said, "Hey, don't dash away, I've got something to say that's important to small creatures like you."

But Arlington's hunch was that he'd be the lunch of a monster who ate ten times a day. Arlington didn't turn back, and so hot on his tracks was the fiend dressed in funny bright clothes. From the top of his room dropped a hot air balloon with Arlington's name engraved on its basket. His room disappeared and he shook off his fears as he floated to the safety of height. However, not far below him zoomed a bi-plane up toward him with the dinosaur, a monkey, and bats. Arlington jumped at the notion, fell into an ocean, and was rescued by a red submarine. It dumped him on land where he climbed with his hands up a tree to see if he had escaped. To his utter dismay, his enemies weren't swayed, in fact, they had increased in their number.

Well, the tree had a vine so he made up his mind to swing his way clear of his trouble. He swang and he swung, and sang and he sung out a yodel like ole Tarzan would do. The crowd from behind also took to the vines as they cried, "Arlie Bella," together.

"Go away!" was his call as he slammed into a wall that had appeared right out of thin air. He fell and he fell as he yelled and he yelled as he fell and he fell even further. Following Arlington down was the dinosaur clown, and a throng of unusual animals. There was the monkey of course, and a loony-bin horse with a bird riding tall in the saddle; a wicked orange gator, a giraffe-sized potato, and an elephant bee dressed like a turtle.

Down through pink and blue clouds he screamed long and screamed loud till he fell on his bed where he started. Gathered around was the dinosaur clown and the animals, all dancing wildly. Arlington knew all was over so he pulled up his covers, and tried to wish them away. He barely could hear as the clown spoke in his ear words he would never forget. "Don't eat pizza so late or you'll always be bait for a nightmare instead of sweet dreams."

Arlington sat up in bed, wiped dream sweat from his head, and pondered the events of his slumber. A sly smile broke his stare as he decided to dare, and search for one more slice of that pizza.

The End

Assignment #7: Editorial Illustration for a News Article

As mentioned earlier, editorial illustration is different from editorial cartoons. Editorial illustrations headline a written story. They dress up and draw attention to the story. The following story, "Kick the Girl! Kick Her!," is designed to evoke emotion and concern among parents and encourage them to monitor the interests of their children. You may not agree with this article. As a cartoonist you may not have the luxury of illustrating things that always meet your personal ethical standards. I've turned down well-paying jobs before due to content. However, you need to illustrate this article because it has the makings of some powerful contrasting images.

Draw one illustration in black and white to fit an area of 7 3/4" wide and 5" deep. Render it on 2-ply

Illustration

77

Bristol board, using any gray toning method you want.

Kick the Girl! Kick Her!
by Al Bohl

I remember it well when my sister's boyfriend hooked up the game Pong to our family's color television set. We watched like cavemen seeing their first fire as the screen turned green and we manipulated a controller to play electronic ping pong. To be honest, I wasn't impressed with the game for long, and I don't remember playing it more than twice. However, someone must have liked it a lot because it spawned a gazillion-dollar entertainment industry. You can still play video games on your own television sets, but they are very, very different from Pong. You can also play games on your personal computer or you can travel to video arcades.

Recently, I took my boys to a local mall to let them spend five dollars each at the video arcade. The place was bulging with enthusiasts, mostly male, feeding twenty-five-cent tokens into these machines. My boys headed straight for a game that had been recently made into a live-action movie. We had just been to see it. The theater had been packed that afternoon, and the film wasn't too bad, I suppose. Somehow the video game seemed different. Watching my sons go one on one, hitting, kicking, and flipping a girl opponent made me feel ill at ease. Simulated blood flew as the 3-D characters pounded each other. I noticed one teenager watching over the shoulders of two others playing this game. He actually had a trance-like stare on his face. Without looking down, he took a paperback book from a bag and opened it. Sometimes he stopped unwrapping the book to twitch his fingers as if he were playing the game himself instead of just watching. The book looked to be about a hundred-page instructional guide showing how to improve oneself at playing the game.

I moved over to watch another "fun" game that had a title which said that *killing* was *instinctive*. As an experiment, I asked a young boy playing the game which character he was. With an almost zombie intonation, he identified himself as an ugly red beast with two heads and a very bad attitude.

I strolled through the arcade and counted about seventy individual games. Then I divided the games into the obvious categories of violent and non-violent. About half were violent in nature. I didn't include motorcycle, car racing, or sports-related games in this bracket. I surveyed the non-violent games to assess their attraction. Most of these games spit out tickets that the child could redeem for prizes. More than one boy had at least 2,500 tickets. One boy's prize appeared to be a combination of a radio and a flashlight. One of these non-violent games was a "children's" version of a roulette wheel like in a casino (I've never been in a casino, but I have seen one on television).

Suddenly, it hit me! I had taken my babies into a place that taught them the principles of *greed* and *violence*. They paid ten dollars for this crash course. I wasn't proud of myself as a parent. I felt that I had encouraged my sons to think it is possibly a good thing to gamble, and to resolve conflict with violence. Even more hideous, that violence toward women might be a necessary alternative.

Ultimately, my wife and I are responsible for the rearing of our children. We cannot always isolate them from the world, but we can endeavor to insulate them. I feel it is wrong to kick women and I think gambling is cancerous. I feel that playing some of these kinds of games could produce a time-delayed reaction or at least have a desensitizing effect. I decided to more closely monitor the activities of my own children. I would strive to give them other alternatives, and I rededicated myself to using my talents to bring to the children of the world entertainment that will teach them to value life and not destroy it.

Review Questions

1. What is a spot illustration?

2. What is an editorial illustration?

3. Explain the principle of an optical mix.

4. List the four process colors used in full-color printing.

5. What is the difference in the shading techniques of cross-hatching and stippling?

6. Who created the Benday prefabricated adhesive pattern screens?

7. What can be a problem with reproducing the shading technique of washes?

CHAPTER FIVE

HUMOR WRITING AND CARTOONING

There really isn't a specific date when the first cartoon was blended with humor. Since laughter is strictly a human trait, it probably dates back to the first person to pick up a smoldering stick from a fire and charcoal a mark on a rock or other object. It could have been a person accidentally scratching a mark on a cave wall with another rock. Who knows, except maybe his mother-in-law who told the guy to put that stick down and get a job.

"Where do you get your ideas?" This has to be one of the most-often-asked questions any cartoonist receives, second only to, "how does one learn to draw?" Most cartoonists are polite enough to smile and say as little as possible. This is because being funny on purpose and on a regular basis is hard, sometimes agonizing work. My hat is off to people like Charles Schulz. His *Peanuts* comic strip has been in the *daily* newspapers since 1951. Can you image how difficult it would be to remain funny every single day for almost half a century?

This is not a business for the faint of heart. However, it is not brain surgery either. Almost anyone can learn to be funny. In this chapter we will examine where to get ideas, making use of different types of humorous situations, and how to present them. This chapter is especially important because it will help you in every other chapter of this book.

You may be throwing up your hands and exclaiming, "I'm a cartoonist, not a writer!" It is true that some people are more gifted at writing than others. Nevertheless, you never know until you try. Besides, the success rate is better for people who can do both.

GAG TYPE: UNSEEN ELEMENT.

"OKAY! ON THE COUNT OF THREE WE'LL *SURPRISE* EM'!"

Fig. 5-1a

THE EIGHT TYPES OF GAGS

I will be using the word "gag" throughout this book to mean a laugh-provoking remark or act. Other words that I may use to denote a gag are punchline, caption, and kicker. Somehow, some way, everyone has a personal sense of humor. Granted, not everyone appreciates all kinds of humor. There are subjects in which I find very little, if any, humor. In my research, I found that there are many types of gag situations that a majority of people find consistently funny. I did my best to simplify these concepts into eight basic guidelines. Study these gag types to help you develop a "gag mind." Some of these gag types will overlap in concept.

1. *Unseen element:* The basic punchline or gag is unseen by one or more characters, while the reader and other characters know what is happening.

GAG TYPE: UNSEEN ELEMENT

"DON'T WORRY- MY PARENTS ARE SOUND SLEEPERS. THEY'VE NEVER CAUGHT ME **YET!**"

Fig. 5-1b

GAG TYPE: UNDERSTATEMENT

"I THINK THIS **SAUCE** MAYBE A TAD BIT **WARM.**"

Fig. 5-2a

GAG TYPE: UNDERSTATEMENT.

"OKAY, YOU'VE CONVINCED ME. THEY **FORGOT** US."

Fig. 5-2b

GAG TYPE: TURNER-OVER.

"LIKE THEY SAY - NOTHING VENTURED, NOTHING **SPRAINED!**"

Fig. 5-3a

GAG TYPE: TURNER-OVER.

"I KNOW I SHOULDN'T HAVE GONE BACK TO ROGER, BUT LIKE THEY SAY, **'HINDSIGHT IS 50-50.'**"

Fig. 5-3b

GAG TYPE: BIG AND SMALL

"YOU MISSED A SPOT."

Fig. 5-4a

GAGTYPE: BIG AND SMALL

"...SEE, PERFECT FIT! CAN
WE KEEP HIM?"
Fig. 5-4b

GAG TYPE: TRADE TALK

"I'M SORRY, BUT THAT MODEL REQUIRES AN ARCHEOLOGIST."
Fig. 5-6a

GAG TYPE: OLD VERSUS NEW.

EYGPTIAN TEENAGERS

Fig. 5-5a

GAG TYPE: TRADE TALK

Fig. 5-6b

GAG TYPE: OLD VERSUS NEW.

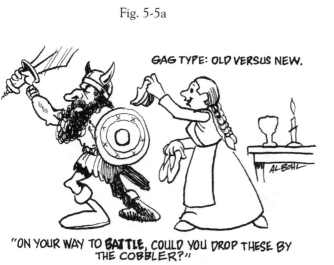

"ON YOUR WAY TO BATTLE, COULD YOU DROP THESE BY
THE COBBLER?"
Fig. 5-5b

GAG TYPE: CUSTOMARY HABITS

Fig. 5-7

"I'LL WASH, YOU TRY NOT TO BREAK."

Fig. 5-8a

" WELL, MY WILBUR WALKS AROUND WITH A CHIP ON HIS SHOULDER — *HIS HEAD!*"

Fig. 5-8b

2. *Understatement:* The scene in the cartoon is violent or reflects high energy action, but has a tame or understated caption. The speaker seems to ignore the problem. Most "understated" punchlines come in the form of a question.

3. *Turner-over:* A gag where the caption or visual image is twisted. By changing a word or two around, or altering the scene, the reader is caught unaware.

4. *Big and small:* The humor is derived from contrasting something gigantic with something tiny.

5. *Old versus new:* The humor comes from imposing our culture, sayings, customs, habits, and manners into another time in history. These gags tend to be more visually dependent.

6. *Trade talk:* Uses trade, shop, or technical jargon as the subject of humor. You can use gags that only "insiders" would understand. A good example is the computer industry; there are all kinds of magazines that are written to service hackers. Computer jargon is everywhere and ready, no, begging to be made into a cartoon. Every type of work has its own language that is known only to a select group. There are many trade magazines all over the world that look for this specialized gag type. These are more word-oriented gags.

7. *Customary habits:* These types of gags come from poking fun at *current* customs, habits, rituals, and sayings. Do not confuse this kind of humor with the old versus new type.

8. *Surprise ending captions:* The artwork for the cartoon is a static or calm visual. Most of the caption points one way, but the end of the gag has a surprise or new twist to it. Greeting cards make some of the best vehicles for this type of humor.

Assignment #1: Cartoon Searchlight

First, find at least one example in a magazine, newspaper, or greeting card that illustrates each of the eight gag types. Place the cartoon or a photocopy of the cartoon in your cartoon binder.

Second, look at a daily or Sunday comic strip section of a newspaper. Study each comic strip and label the gag concept the cartoonist used. Fold and keep in your cartoon class binder.

Assignment #2: Gags-R-Us

Write and illustrate one gag for a single panel cartoon using each of the eight gag types explained above. A *single panel* cartoon is where the action takes place in most of the panel without using word balloons, and the caption is written in the bottom portion of the panel. Each gag should fit on a separate sheet of typing paper. Do not start this assignment until you have read this entire chapter.

SEVENTEEN IDEA STARTERS

Just about everyone has a few original ideas for a cartoon. I recommend that you write out at least twenty-five ideas and then put them aside. Once you have a hundred more ideas written out, you may use half, a quarter, or less of them. But you will have a base of good, solid ideas.

Write out your idea on a 3" x 5" index card. In one sentence describe the situation and the characters involved. Then write out the punchline. Developing a gag mind is like exercising a muscle. The more you exercise the process of writing and drawing cartoons the better you will become. Set

quotas for yourself. The pros generate twelve to twenty gags a week. Starting out, a safe quota would be three to five a week. Many comic strip cartoonists that write their own material spent an entire day each week or a part of each day writing gags.

I've heard people who run races talk about hitting an invisible "wall" at some point during a race. In cartooning, the wall hits you. Speaking of walls, one cartoonist said that when he ran dry of funny ideas he would bang his head against a wall. This method is strongly discouraged! Few walls in modern homes are solid enough to help. (Ba-da-bing!) When you feel that you are drying up or you want to get your comedic energies flowing, use the following seventeen idea starters to rev up your engines.

1. *Be prepared—always carry a notebook.* In studying numerous professional cartoonists' work habits, they all shared this one common practice. Write down ideas that come to you, even at the strangest times. Record ideas that come from conversations, unusual actions, and everyday situations.

2. *Study other cartoons.* This is commonly called the *switch* method. It is practiced by virtually every cartoonist. Study a cartoon to see if a new "twist" will pop up in your mind. Looking at other people's cartoons should put you in a better frame of mind, and good ideas flow from good moods. It greases the gears of the gag mind. Personally, I like to read funny cartoons and stories before going to bed at night. I find it to be a relaxing sleep aid.

3. *Watch television.* Comedies, dramas, news, and commercials can often stimulate the gag mind into action. However, do not use this method as an excuse to neglect your other homework.

4. *Read.* Read the daily newspaper, magazines, the dictionary, *Roget's Thesaurus*, and books. I know that most news articles are negative. Nevertheless, conflict, drama, and difficulties are often the breeding grounds for choice humorous situations. The Bible, fairy tales, history books, and classics are full of humorous gems ready to be mined. Do not overestimate or underestimate the literacy of your audience. For example, many people may not know who Charles Dickens was. Avoid jokes that only a few people (insiders) would understand.

5. *Listen.* Listen to what people say, listen to the radio, but especially, listen to children. As Art Linkletter, a pioneer in 1950s television, used to say, "Kids say the darnedest things." Children have a unique gift for twisting and messing up grammar and trite expressions in the cutest ways.

6. *Use props.* Props such as computers, brooms, guns, feathers, knives, cooking pots, etc., can sometimes be enough to germinate an idea for a cartoon.

7. *Use animals.* The use of an animal like a turtle or dog in a human situation with an old cliché will twist or spark a great idea.

8. *Exercise.* Go for a walk. There have been times when I hit the wall in a story or a cartoon. A brisk walk helped clear the cobwebs away.

9. *Group ideas together.* Try to generate four to six gags that are alike before choosing one to draw. Reviewing these gags may spark another idea.

10. *Cool down.* Let gags "cool off." Set them aside overnight, or at least for a day or two if possible. Something funny at two o'clock in the morning may not be very humorous in the light of day.

11. *Don't worry about cartoon overkill.* No matter what someone might say, no cartoon situation has been done so many times that it is no longer funny. There will always be a market somewhere for a man on a deserted island. However, popular cartoon situations may make it difficult to interest an editor in wanting to use another man-on-a-deserted-island cartoon.

12. *Play act.* Imagine yourself as the star of a wild situation. Think of how you would react. See yourself in the old west, on a deserted island with a can of sweet peas, or as Romeo climbing up to Juliette's balcony.

13. *Think of doors.* Sometimes the size and shape of doors will ignite an idea. Even the words painted on a door may give you a flood of ideas for a cartoon. Think about doors for beauty salons, jails, restaurants, or businesses, just to name a few.

14. *Use sight gags.* These are non-captioned gags. Try to think of funny situations that don't require any caption. I recommend viewing the silent movies of Buster Keaton and Charlie Chaplin on videotape. I especially enjoy Buster's sight gags. And in doing historical research on famous cartoonists, I have been amazed at the number of them that were inspired by Charlie Chaplin.

15. *Use clichéd pictures.* These are cartoons that are almost generic in their situations. A hundred

different punchlines might fit with any of the following images: walking the dog, eating breakfast in bed, riding a bike, climbing a mountain, a school classroom, a person on crutches, a girl coming out of a party cake, a man on an island, a man and woman on an island, a man and mother-in-law on an island, prisoners chained in a dungeon, or prisoners digging an escape tunnel.

16. *Use non-literal clichéd ideas.* Every day, as we talk with other people, we use tons of trite expressions in an attempt to communicate or clarify our opinions. These clichés make great cartoons and the twisting of these clichés makes them even funnier. There are books in your local library or bookstores that contain nothing but clichés. Clichés are great for getting your gag mind working. An example of what I mean is the expression, "He's got a chip on his shoulder." It could be twisted to say, "He's out looking for a chip for his shoulder." Or, "She's looking for a shoulder to chip." Here is a good starter list:

"Why don't you mind your own business!" "Mind if I sleep on it?" "Honey, they're playing our song." "What does she see in him?" "It doesn't get any better than this!" "Under New Management." "The check is in the mail." "That's using your head." "Am I boring you?" "He's got a chip on his shoulder." "Look, no hands!" "Mind if I smoke?" "Is this seat taken?" "Dinner is served." "I'm tired of working for peanuts." "You are here."

17. *Use gag recipes.* Think of people, places, and props as ingredients you mix together to make a cartoon cake. Make up a list with three categories in separate columns. One column has only people, the second has places, and the last has props. As a stimulator for cartoon ideas, select a person at random from the first column. Match it with a randomly chosen location from the second column. Then look at the properties column. Maybe a germ of a humorous idea will come to your mind. Example: a sculptor in an attic with a vacuum cleaner. This mix might trigger an idea for a great cartoon. Here are a few ideas for starters:

PEOPLE	PLACES	PROPS
Astronaut	Igloo	Guitar
Barber	School classroom	Eye chart
Baby	Bridge	Hair wig
Dentist	Theater	Shoes
Old woman	Grocery store	Umbrella
Postal carrier	Grand Canyon	Fish bowl
Indian warrior	Restaurant	Fishing pole
Attorney	Sewer	Flashlight
Burglar	Mountain top	Bass drum

Assignment #3: Gag Pie

Go to the library and get a book of trite expressions. Add to the list of non-literal clichés. Next, add twenty people, places, and props to the gag recipe list.

CARTOON IDEA TEST

There are a few questions you should ask yourself about an idea before you go too far with it.

1. *Has it been done too many times?* As I stated before, no concept has been done for the last time. Nonetheless, editors can get weary of or sour on a certain type of cartoon. Some examples that most editors wish would go away are man on an island, man chained in a prison dungeon, and painter painting his thumb he holds up for measuring. I have done many paintings and I've never held my thumb up to anything. Also, they are sick of serial (cereal) killer jokes.

2. *Does the cartoon fit the right market?* Do a little research on a magazine or newspaper before sending a cartoon to them. A cooking cartoon may not fit a kung-fu magazine's format.

3. *Will someone read into your cartoon something racial, sexual, or satirical about a physically or mentally challenged person?*

4. *Is it too soon or too late?* Avoid making jokes that are too current or faddish. In the case of magazines, they work four months ahead of their publishing date. In January when you are thinking about the cold weather, magazines are thinking spring, baseball, and warm weather. Years ago teenagers decided it would be fun to run past people naked. They called it "streaking." It was a short-lived fad, and the only person I know of who cashed in on it was the singer Ray Stevens. He churned out a really funny song entitled "The Streak." By the time the ink streaks were dry on any streaking cartoons, though, everybody had their clothes back on.

CARTOON DESIGN TIPS

Okay, let's say you have some great cartoon ideas. Here are some tips to help make your cartoons work better.

1. The best cartoons and the most popular cartoons are the ones that have a "surprise twist" or an "unexpected" ending. Try to lead the readers in one direction, and then surprise them by doing the opposite of what they expect.

2. In our culture we read from the left to the right. Place the most humorous part of your cartoon on the right side of the panel.

3. Stay on the reader's side. Don't be mean-spirited and belittle the reader.

4. Remember, people love cartoons that deflate the super wealthy, the egotist, and the government. For hopefully obvious reasons, I wouldn't recommend doing jokes about the Internal Revenue Service.

5. When inking a cartoon, place the "darkest" area at the center of interest. The dark area will bring the reader into the picture and hold him there.

6. The shape of the border may possibly help sell a cartoon. If a cartoon is vertical or horizontal it may fit uniquely into a magazine's format.

7. Keep your cartoons simple. An overly ornate or elaborate drawing can kill the impact of the cartoon's message. Sometimes a cartoonist will subconsciously make a cartoon very busy because he isn't sure if the gag is funny enough.

8. Rules of thumb for framing the main characters of a cartoon:

Use long shots for cartoons that have a lot of people or mountains in them. Use medium shots for cartoons containing two or three people.

Use close-up shots for emphasis; mostly used in comic strips or multi-panel cartoons.

THE CARTOONIST MARKET

In time, you could develop into a really fine cartoonist. You may want to be a full-time or part-time cartoonist. In other chapters I discuss how to get into the business of comic strips, comic books, greeting cards, illustration, and animation. At this point I want to target the magazine market.

The bad news about gag cartoons for magazines is that there are fewer magazines using cartoons than there once were, and the average pay per cartoon isn't very high. However, this doesn't mean that there aren't people out making a good living or extra income selling cartoons to magazines.

Some of the following suggestions will apply to all markets.

WHERE TO FIND MARKETS

1. Browse bookstores, magazine racks, and newsstands.

2. Subscribe to different cartoon-related magazines like *Cartoonist Profiles* and *Cartoon World*.

3. Read the latest edition of the *Artist's and Graphic Designer's Market*. This book contains about 2500 markets available to you.

4. Advertise in a local paper for "idea people." You never know, there may be a very funny person living right down the street from you who can't draw, but has some truly great ideas. You might split any payment you receive with a gag man 50-50, 60-40, or 75-25 depending on who sends out the materials to the publishers.

5. Once you have found a market to send something to, you should put together a *submission package*. The submission package should contain:

A. A query letter: This is a letter that asks permission to send materials to the publisher. Editors are very busy, so keep your letter as short as possible and to the point. Be positive and don't put yourself down. Don't tell your life story. Don't tell them that God told you to send this letter. This implies that God is on your side, and if they reject you they are disobeying God. Editors see that ploy as a negative.

B. Request any restrictions as to size or format of the cartoons that they run in their magazines.

C. A stamped return query card is a good idea. An example of a query card is:

PLEASE CHECK AND RETURN:

DO YOU USE CARTOONS? YES___ NO___

CARTOONS ON ASSIGNMENT?

YES___ NO___

TYPE OF CARTOON NEEDED:

*GENERAL:*_____

SLANT OF MAGAZINE: _____

PAY: _____

REMARKS: _____

WILL YOU KEEP MY NAME ON FILE?

YES ___ _NO_ ___.

WILL YOU SEND A COPY OF YOUR

MAGAZINE? YES ___ _NO_ ___.

If the query card is returned with a positive response, then send the remainder of your submission package. This should include photocopies of your portfolio and/or the photocopies of the cartoons you wish to sell. I noticed a real change in editors' attitudes toward my work when I began sending them color photocopies of my work. Never, never, never send originals!

Cartoonists like to draw, but few enjoy self-promotion, so many cartoonists hope to find an agent to help them. I have never had an agent, but it has been my experience that if you want to get well known it is cheaper and a lot more effective if you sound your own trumpet. At best, waiting for a reply from a publisher takes a long time; having an agent just extends the wait. It would, however, be a good idea to have an attorney look over any contracts before you sign.

Always, always always send a self-addressed, stamped envelope with _everything_ you send out.

When you send out your cartoons to editors, never submit more than ten to fifteen.

When putting together a resumé, keep it to one page. Nobody reads any more than that.

REJECTION ISN'T A TERRIBLE WORD

To be a cartoonist you must have a healthy self-esteem and a thick hide. Mark my words, _you will be rejected,_ and probably many times. Dr. Seuss was rejected twenty-seven times before he got his first book, _And to Think That I Saw It on Mulberry Street,_ published. Everyone gets rejected, even the big-name pros. I have a file folder full of rejection letters. I am of the humble opinion that success too early in one's career is not really a good thing. Struggles and difficulties have a way of keeping life in the right perspective; they help you appreciate it more when you succeed. I have never enjoyed suffering, but I've never been foolish enough to hate it either.

CONCLUSION

Keep this chapter handy as you study all the other chapters of this book. Everyone hits the wall from time to time, and everyone gets rejected. Remember, you only truly fail in life when you cease to try.

Review Questions

1. List and define the eight different types of gags.

2. List and briefly define the seventeen idea starters.

3. What are the four questions you should ask yourself about your gag ideas?

4. What is the most popular gag ending?

5. Describe the reason you would use a long shot in a cartoon.

CHAPTER SIX

EDITORIAL AND POLITICAL CARTOONING AND CARICATURE

Of all the different kinds of cartooning, political or editorial cartooning tends to be, by nature, the most negative, cynical, and critical. If it is important for you to be loved by everyone, don't become an editorial cartoonist. Your job will be to draw cartoons that shock and instill fear, anger, amusement, inspiration, despair, and moral indignation. Your aim is to make people *think* and take action. If you think the people who are the object of your opinion should have thick hides, then you cannot be thin-skinned either. People of power do not always enjoyed being lampooned. Franklin D. Roosevelt made a hobby of collecting caricatures of himself, but remember he was president for almost two decades. I don't know if anyone in an editorial cartoon really likes to be the recipient of the poison pen, but one thing is for sure; they realize that you are nobody in politics until you've been the subject of one.

Of course, there are times, such as when a big peace treaty is signed, or on Christmas Day, that a positive message is allowed, but good news and tranquillity do not sell newspapers. I don't feel that I am being unfairly negative about editorial cartooning. I enjoy reading and drawing these types of cartoons, but I want you to understand from the start what separates this art form from all the others.

Call your local newspaper and see if they have an editorial cartoonist on staff. If so, ask him or her if you can visit them briefly to see how they work.

A vital portion of this chapter deals with the subject of caricature. The "Old Masters" considered themselves to be caricaturists long before the term "political cartoonist" came along. Of course, not every political cartoon has caricature in it, but you won't go far in the business if you can't draw a good likeness of whoever you're harpooning. Not all caricature in this chapter will relate to editorial cartooning. You will also learn how to do caricatures for fun and profit.

THE INDUSTRY AND THE CARTOONIST

I believe that as long as there are politicians, there will be political cartoonists. I don't know if they will always be in newspapers as we know them now, but there will be editorial cartoonists somewhere endeavoring to right wrongs.

Not too long after their explosion throughout the U.S. in around 1900, newspapers began to consolidate. That trend has continued to the present time, with fewer independent papers remaining and a downsizing to fewer papers in general. Television, radio, telephones, and computers have sped up the information highway to the point that newspapers are "old news" when they hit your door in the morning. Newspapers still serve a very valuable role in their individual communities but they are definitely in a real place of transition or identity crisis. This translates to fewer full-time jobs for cartoonists in local papers. Many local editorial cartoonists today have other jobs to support themselves. Newspaper syndicates have many highly professional cartoonists

and clip-art services that they promote to local papers. It is simpler to buy first-class cartoons from syndicates at a greatly reduced rate than to hire an artist and give that person a fair income with benefits. Nevertheless, I firmly believe that talent always has a way of surfacing if the talent is willing to pay the price of perseverance. Every full-time pro was at one time just like you, an amateur with talent and a dream.

There is only one way to break into the professional editorial cartooning business. You must do or have done cartoons for a newspaper. Most political cartoonists get their start with a high school or college newspaper. You need to know the pressure of a deadline and prove that you can handle criticism and feedback from editors. It would be rare for a syndicate to consider handling a cartoonist who hasn't worked professionally in the field for at least three years.

An editorial cartoonist is a crusader by nature who must draw a line in the sand, step over it, and encourage others to follow. You must have a political point of view without being self-righteous or unduly mean-spirited. *I've never heard of a famous editorial cartoonist who was politically indifferent.* An editorial cartoonist is a reporter first and an artist second. This means that the need for excellence of draftsmanship should give you an indication of just how good a reporter the cartoonist must be.

You have to be able to boil a subject down to its basic elements and you must have a genuine interest in political and social issues. A great political cartoonist will have a deep love and understanding of history and literature. A liberal arts degree from a university with an emphasis in journalism is a good start. A good diet of history, grammar, and literature is also recommended. A quick survey of editorial cartoons throughout history shows the constant usage of time-worn fables, symbolism, mythology, analogy, and allegory to drive home a message. I wonder how many times the human skull has been used, or how many times some politician has been depicted as Don Quixote sitting on a horse, fighting windmills. Here is a list of some other symbols and motifs used:

• Variations of the American flag. Sometimes the actual flag is used and other times it is in the background.
• The Statue of Liberty

Ill. 6-1 *I guess no one can feel like a real editorial cartoonist without drawing Uncle Sam at least once. Used by permission of the Evangelistic Association of New England.*

• The Trojan Horse
• Uncle Sam
• A human caricatured head on an animal's body
• Taxpayer money bag
• Republican elephant
• Democratic donkey
• The Earth
• The Grim Reaper
• Bald eagle
• Angels
• Demons
• War
• Anything Shakespearean
• Map of U.S.A.
• Slave chains
• Guns, guns, and more guns
• Sinking ships
• Life preservers
• Beggars and tramps
• The White House

I did editorial cartoons on a monthly freelance basis in the 1980s. As you can see here, I was allowed to do one using Uncle Sam. I happened to be attending a conference in Amsterdam, Holland. The conference had a daily newspaper. I submitted cartoons to the main editor, who told me that the conference paper didn't run cartoons, but his paper in America did. My first assignment was to illustrate how preachers

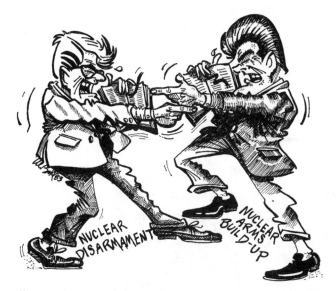

Ill. 6-2 *This is the first editorial cartoon I did. It's about how preachers can try to use the Bible to reinforce their personal views on nuclear disarmament. Used by permission of the Evangelistic Association of New England.*

used the Bible to back up their opposing personal feelings about nuclear weapons. Here are a few of my other cartoons.

I recommend looking at other editorial cartoons for reference. In particular, the book *Best Editorial Cartoons of the Year*, edited by Charles Brooks and published by Pelican Publishing Company (the publisher of this book), is a great source. This cartoon collection has come out every year since 1972.

FORMATS AND MATERIALS

You may draw your cartoons any size you like, but they will need to reduce to fit in an area of 5" x 7" when printed. Some people draw that size, but I draw either 10" x 14" or 7½" X 10½". If you are going to draw larger you must take this into consideration when choosing any special kinds of adhesive screens or treated boards. Some screens are so fine that they clog when reduced. Look in chapter four at the

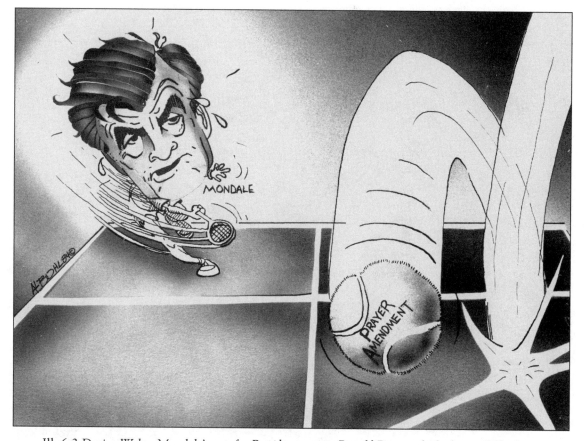

Ill. 6-3 *During Walter Mondale's run for President against Ronald Reagan, he had some difficulty making his stance known about a prayer amendment. I included it here because it is a cartoon done using an airbrush for shading. Used by permission of the Evangelistic Association of New England.*

Ill. 6-4 *The Presidential primaries are always times where a political party tries to destroy itself before it destroys its opponents. Used by permission of the Evangelistic Association of New England.*

LOUISIANA - THE STATE WE'RE IN!

Ill. 6-5 *Louisiana has gone gambling crazy. This is a statement about the volume of gambling available. Reprinted by permission of* The Times *of Shreveport, LA.*

OH NO! WE'RE MORPHING!

Fig. 6-1

section concerning materials for full explanations and examples of these screens. I use the same kind of paper, pencil, ink, pens, brushes, and Ames Guide that I use in my other cartoons. Many editorial cartoonists today use Duo-shade paper and developers. Others use the Benday or Zipatone adhesive screens. I have used airbrush before with excellent results. Some cross-hatching is still used but not to the extent of Thomas Nast. Fig. 6-2 shows the steps of how I develop an editorial cartoon.

Assignment #1: Morgues

There are three kinds of morgues that you need to gather for this chapter. 1) Collect a morgue of editorial cartoons that you like. You may wish to have individual folders for specific artists. 2) Collect images of props that you might use in an editorial cartoon. Examples: guns, airplanes, bombs, TV sets, eagles, the Statue of Liberty, etc. 3) Collect any caricatures you see in editorial cartoons or any magazines (if the magazine isn't yours, then photocopy it). *MAD* magazine specializes in caricatures.

Assignment #2: Editorialization Time

Draw five editorial cartoons. Read the entire chapter before doing these cartoons. Be sure that you include caricatures in your editorial cartoons. I encourage you to try using some adhesive screens if possible. You may pick any subject matter you like, but one should deal with a global problem like the environment, nuclear warfare, hunger, war, or something universal. Two should be concerning U.S. politics.

STEP I
THE CONCEPT:
THE TWO MAJOR U.S. POLITICAL
PARTIES DECLARE THAT
THEY ARE DIFFERENT, BUT
ARE THEY? I USE THE
WORD "MORPHING" MADE POPULAR
BY TV'S "POWER RANGERS" TO
ILLUSTRATE THE POINT.

IDEA # 1

STEP II PENCIL
THIS IDEA
JUST WASN'T
STRONG
ENOUGH.
THE PARTIES
MUST BE PULLING
APART.

IDEA # 2
STEP III PENCIL
THE TRIANGLE DESIGN LENDS TO
MAKING A STRONGER VISUAL IMPACT.
THE PARTIES ARE APPARENTLY BLENDING.
THE ELEPHANT TRUNK COULD HAVE BEEN
EXTENDED STRAIGHT OUT, BUT THAT
WOULD HAVE GIVEN A POSSIBLE SUBLIMINAL
MESSAGE THAT THEY WERE BLENDING TO
THE LEFT. AS IS, THEY ARE MORPHING TO
THE CENTER. THIS WAY BOTH SIDES OF
THE WORLDVIEWS ARE CHALLENGED.

OH NO! WE'RE MORPHING !

LETTERING STYLE

Fig. 6-2

Another should take on a state or local problem. Finally, tackle an issue within your school. Make photocopies of your work and paste them into a real newspaper so you can see how they would look in print.

CARICATURE

Getting a good likeness of a person isn't always easy, but with practice it isn't terribly hard either. The greatest thing in your favor is that everybody on the planet looks different from everyone else. Caricature is the exaggeration of a person's features that make him or her unique. When caricature first began to surface as an art form in the seventeenth century, it was used by the artist as a cruel insult to the person drawn. These "bad guys" were generally kings or politicians. The main difference in caricatures of today and those of yesteryear is that now they are more aimed at humorous exaggeration of a person's recognizable features than distortion of their worst features.

Physiognomy was a theory that a person's outward appearance was an indication of their inward character traits. A long, thin, crooked nose might indicate a certain deviance, and bushy eyebrows might equate innocence. Naturally, this theory is not true, but we still see its prejudice promoted through story books, television, and the movies.

The art of caricature has been a very positive thing in my life. Through the years I have flown by airplane a lot. I don't mind flying but I didn't enjoy sitting around airports until I started carrying a pad and pen along. I've made it a habit to look for the saddest person I can find in my gate area. I try to keep from being discovered, and I draw a caricature of the person. When I finish it, I give it to the person. I've always had an appreciative response. Many times this opens the door to draw others, and make new friends.

I recall going to a reunion of my wife's family. I took along my gear and drew caricatures of anyone who wanted one. It was a great ice breaker for me, and everyone loved the special attention.

One time I worked at a radio station spinning records. We were the new staff for a newly reformatted FM station. We occupied the same offices as an older AM sister station. Things were tense between the two stations for a while until one morning when I was on the five A.M. shift. I could see the other station's

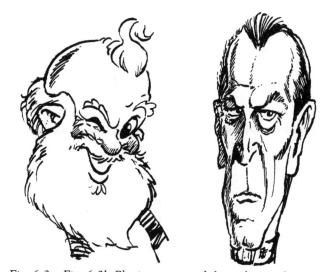

Fig. 6-3a, Fig. 6-3b *Physiognomy—a defunct theory of physical appearance revealing inner human personality*

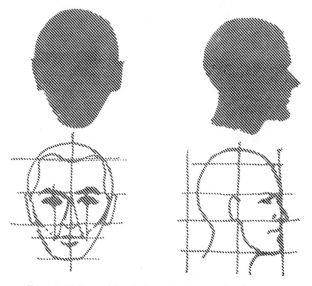

Fig. 6-4 *Normal head shape in front and side views*

DJ's profile through my window. During records I drew his caricature. I taped the cartoon to his window. He was so appreciative that you would have thought that I had given him a million dollars. In no time I was asked to draw everyone at both stations. Those caricatures served as one of the things that brought the two stations together as friends. I love being an artist!

HOW TO DRAW CARICATURES

It is most likely that Leonardo Da Vinci was the first artist to actually realize that the human body has

various points of relationship or comparison. Look back in the second chapter of this book at Fig. 2-22. This shows how the entire body relates to itself. Of course, these measurements are based on an average person, and none of us is average. However, you must realize that it is upon this principle of unique traits that all caricature is based. All four billion plus of us are exaggerations of the average or ideal person. In Fig. 6-4 you see a front view and a side view of a person's head. It is divided into grids with three basic hemispheres and location points. These heads don't look like anyone in particular, and that is exactly my intent. Study these heads and grids. Burn them into your mind. Every person that you caricature will be an exaggeration of these average heads. Now let's concentrate on every part of a person's head, and you will see how caricature is learned.

You are about to learn two kinds of caricature. One is for use in editorial cartoons and the other is for use in entertaining your friends and/or making money.

THE CARICATURE EYE

Every good caricaturist has to develop an "eye" for picking up on most outstanding traits. Don't think that you can do one or two caricatures and consider yourself proficient. It takes time and practice. Memorize the "average" face, attempt a few caricatures, and in no time you will find yourself seeing as you have never seen before. Caricature is like anything else; if you don't use it, you lose it.

The Shape of the Head

Just as we learned in the first chapter, all head types are broken down into the circle (oval), triangle (pear, with big part on top or bottom), square (rectangle), or cylinder. Use your memory and visualize the "average" head and grid over your subject's head. It wouldn't be a bad idea to photocopy my "average heads" so you can keep them handy for easy reference. This should establish the basic shape of your caricature. Look at your subject's forehead and jaw. Compared to the "average" head, how does your subject's forehead and jaw differ? Also in this examination, see where the hairline begins and how their hair style fits the person.

The Elements of the Face

Now, using the "average" facial grid, decide where the elements of your subject's face sit. The following sections show a lot of potential facial combinations. Learning this method takes time and practice, but it is essential to be a good caricaturist.

The Nose

The first thing to consider after the shape of the head is the nose. My first example is of the "average" nose; the rest are variations on that nose which make us all unique. Notice where your subject's nose fits in with the "average" nose portion of the grid. Your subject's nose may be small and wide, or longer and thinner. It may be turned up or down or crooked. I don't care what anyone may say, I bet most editorial cartoonists really missed Richard Nixon when he resigned. His face had such character that it must have been a pleasure to render.

The Eyes and Eyebrows

The next elements to zero in on are the eyes and eyebrows. See where the eyes of your subject sit on the grid. Next, exaggerate the shape of the eyes and any distinguishing traits of the eyebrows.

Lips and Mouths

Where does the subject's mouth and lips fall on the average grid? Look at these examples of mouths done in caricature.

Ears

Check out where the ears sit on the "average" face. Often, ears are covered by hair. When caricaturing a female, I generally put little earrings just to add a little more of a feminine look.

Wrinkles

Do not *overdo* the wrinkles, especially when drawing an older lady. Little crows' feet are enough for anyone under 130 years old.

Bodies

A person's body is not generally as important as his face, but in editorial cartooning it will help solidify the likeness of the subject. For editorial cartooning it is generally considered fine to exaggerate the shape or weight of a person's body. It may not be appreciated by a politician to be expressed in an unflattering manner, but that is the nature of editorial cartooning.

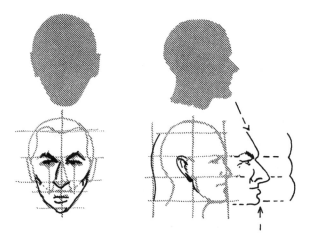
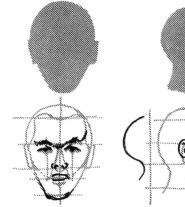
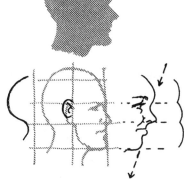

Fig. 6-5 *Here are twelve front and profile view faces. Notice how they vary from the normal face.*

In portraying the modern caricature for fun and profit, it isn't a good idea to draw an overweight person too heavy. And, he may be upset if you draw him too thin. So it's all right to draw him a little thicker at the waist. Keep the bodies for these caricatures small and simple.

CARICATURES FOR FUN AND PROFIT

Here are some tips for drawing caricatures for individuals and parties.

1. I draw on smooth white index paper, 110 lb., cut 8½" x 11".

2. I use a black Design pointed nib art marker #229-LF.

3. I have a piece of smooth ¼" plywood to use as a drawing surface.

4. I ask my subject what his favorite things to do are. Based on his answers I draw him doing one of those pastimes. I draw big heads and little bodies.

5. I always draw a profile. Profiles are easier because people seldom see themselves from the side. This makes the person a little less critical. It is easier and faster to draw just one eye, eyebrow, ear, and nostril. It is easier to exaggerate the forehead, nose, mouth, and chin. I position my subject where the part in his hair is toward me. I indicate some strands of hair, but I do not completely darken in the entire head of hair. Babies are difficult to capture unless you do them pretty much the same. Look closely at my examples. Children take extra practice because they

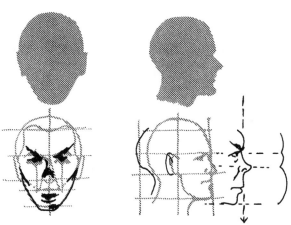

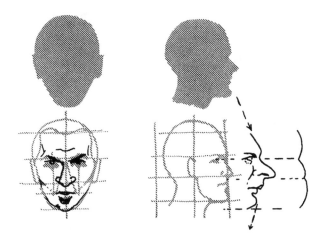

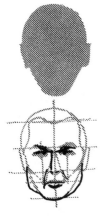
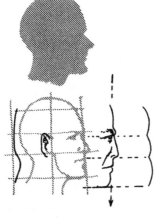
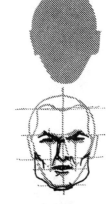
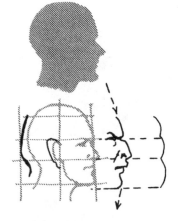

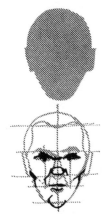
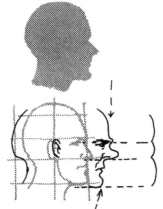
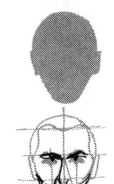
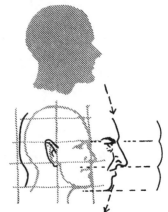

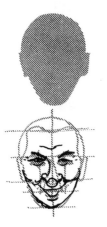
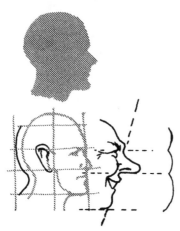
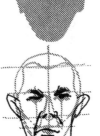
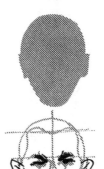
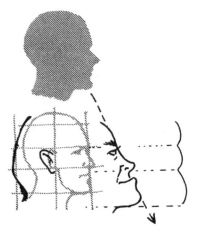

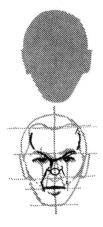
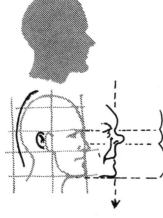
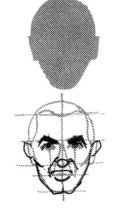
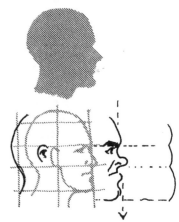

Fig. 6-5 Continued

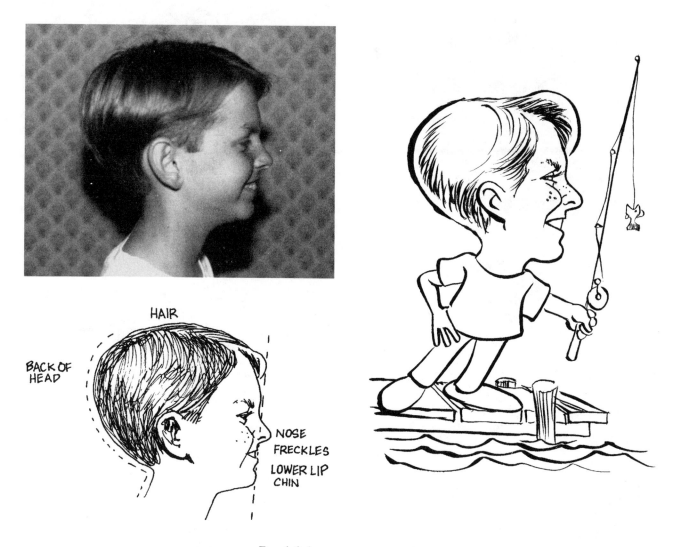

Fig. 6-6 Aaron, *a young teenager*

can start looking too old if you aren't careful. Try to get your subject to smile. This will encourage him to be more positive about your work.

6. I use as few lines as possible to draw their bodies. I don't get wrapped up in trying to draw individual fingers. As I mentioned before, if I'm drawing a person that weighs a lot, I make him thicker but I don't overemphasize his figures. I draw him using a prop of some kind.

7. I try to draw this caricature in two to three minutes maximum. The goal is to finish it in ninety seconds. I charge $5 per drawing, and I draw one image per sheet of paper. If I'm drawing for a party I charge by the hour. The amount charged varies depending on how many people will attend.

8. You can do caricatures at shopping malls, birthday/office/school parties, family reunions, and trade shows. At trade shows I generally rent an overhead projector and draw on clear transparencies. This way people can watch me draw on a screen and it serves to advertise to other possible patrons.

Assignment #3: Character Caricature

Do ten caricatures. Draw five in profile with big heads and little bodies, using your classmates, friends, or relatives. Next, do five more from the front or ¾ view like you would use in an editorial cartoon. Don't worry if it takes you a little while to capture a likeness. Of course, you can do more than the requirement, and you will need to do a lot more if you want to become good at it.

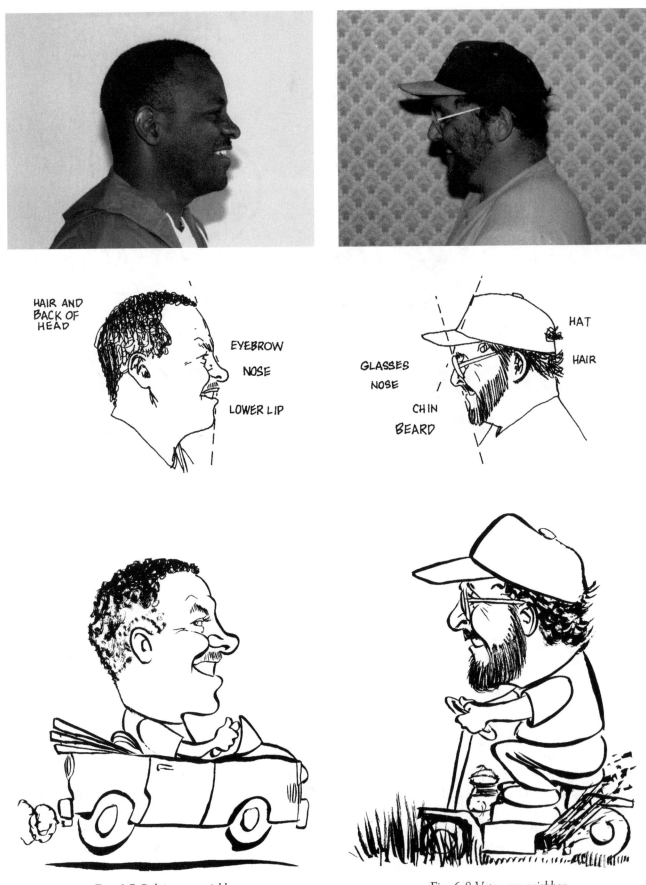

HAIR AND
BACK OF
HEAD

EYEBROW

NOSE

LOWER LIP

GLASSES

NOSE

CHIN

BEARD

HAT

HAIR

Fig. 6-7 *Calvin, my neighbor*

Fig. 6-8 *Veto, my neighbor*

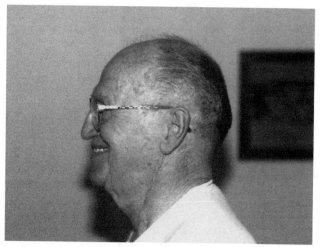

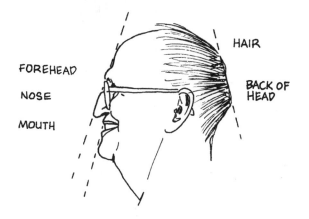

HAIR

BACK OF
HEAD

EYEBROWS

BEARD
NECK

FOREHEAD

NOSE

MOUTH

HAIR

BACK OF
HEAD

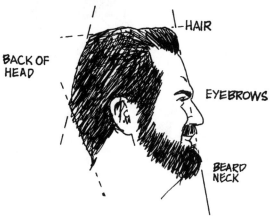

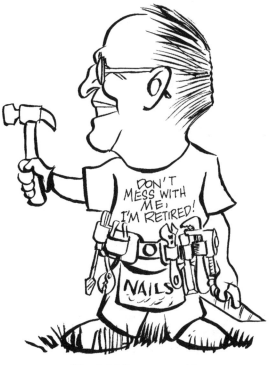

DON'T
MESS WITH
ME,
I'M RETIRED!

NAILS

Fig. 6-9 Jeff, my neighbor

Fig. 6-10 Jim, my neighbor

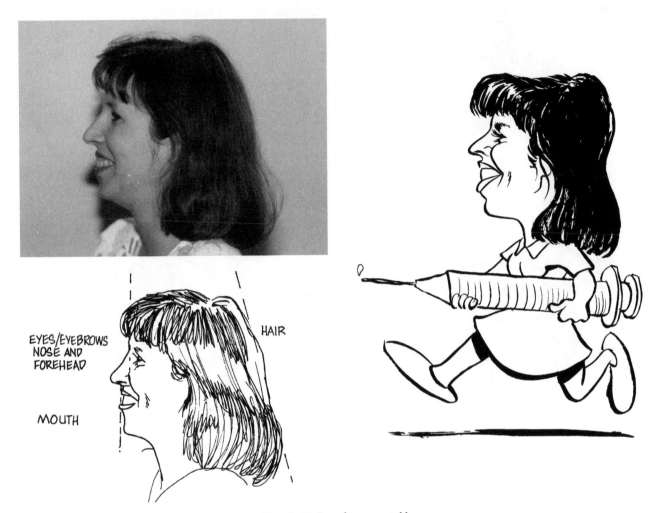

Fig. 6 -11 *Brenda, my neighbor*

Review Questions

1. What is the goal of an editorial cartoon as opposed to a regular funny cartoon?

2. In the 17th century, what was the term used for these artists before they were called political or editorial cartoonists?

3. In caricature, what is the one universal thing that is in the artist's favor?

4. Define the word caricature.

5. What is physiognomy?

6. What is meant by the term "caricature eye"?

7. Why is memorizing the "average" face important to the caricaturist?

CHAPTER SEVEN

ANIMATION

For decades we have enjoyed the world's greatest artistic magicians, performing their illusions through animation. Without a doubt, the most difficult form of cartooning known to man is the field of animation. All of the various forms of cartooning have gone through numerous adaptations as they have grown, but none can match animation's technical revolution. It appears that through the years, everyone who has been bitten by the animation bug has done something to advance the technological cause.

Most avenues of cartooning begin and end with the idea and the art. In animation, this is only the very beginning. As you will see in this chapter, animation takes a lot of preparation, planning, and patience. I have diligently prepared this chapter to show you how animation is done and what is needed to bring this art form to life without bogging you down in the nitty-gritty details.

Animation for motion pictures and television takes a lot of people, time, experience, and money. In addition to creating a character, writing a story, and knowing how to draw, you must also understand how to use cameras, light meters, lights; and how to draw hundreds or thousands of pieces of art, add sound, and edit everything together. At times during this chapter only, I will use the word "cartoon" to mean the same as an animated film or story.

In the recent past, most amateur animated cartoons were done by 16mm or Super 8mm cameras. The 16mm camera is expensive even if purchased used, and the film is cost-prohibitive. Sadly for amateur animators, the Super 8mm camera has been tossed aside by the general public due to the ease and accessibility of the home video camera. It is no longer an easy task to find Super 8mm cameras that have the single frame capability which is vital to produce animation. Most pawn shops do not take or sell Super 8 mm cameras anymore. It is even more difficult to find a photo shop that carries Super 8mm film. If the film is found, it is expensive to buy and have developed, especially if any lab work is required. It is also virtually impossible to find editing and sound equipment for the Super 8mm or the 16mm.

I placed two ads in a newspaper with a weekly readership of about 200,000. I received more than fifteen calls about Super 8mm cameras and projectors, and two calls concerning 16mm. I got a really good 16mm camera, projector, and film splicer for $75, but no one carries the film locally. I had a number of people give me Super 8mm cameras and projectors, but only one had the ability to do single frame action.

As of this writing, no companies have invented or seen any commercial potential in making a consumer-friendly video camera that can photograph multiple frames within one second. The only way to really marry videotape with animation is the Animation Controls Video Pencil Test System, created by John Lamb. This will be described in detail later in this chapter.

It has been suggested by some that teaching the old way of animation is outdated because of the

advent of computers. It is true that computers are becoming more and more of a necessity to the animation process. However, it is doubtful that very many individuals or school systems have a computer with the memory capability to generate, store, and play back enough animation to justify directing this chapter toward that end. Computer technology is advancing so fast that whatever program you purchase is soon outdated. The software industry seems to always be aiming their products at the newest upgraded system. Besides, even with a computer you would need to know all the things you will learn here anyway. This chapter will instruct you in the fun fundamentals and principles of animation that should translate to any person's or school's abilities, whatever they may be. Hopefully, you will come down with the animation virus, and you will be inspired to experiment on your own.

Assignment #1: Animated Hero and Morgue

Write a two-page report on one of the pioneers of the animation industry. Some suggestions to consider are Walt Disney, Tex Avery, Winsor McCay, Hanna-Barbera, or Dave, Lou, and Max Fleischer.

Collect any articles or information you can find that is connected to animation or animators for your Animation Morgue.

THE INDUSTRY AND THE CARTOONIST

Animation is not on the downward slide. In recent years it has broadened to include special effects for all kinds of movies, video and computer games, music videos, television programs, and commercials. From my research I have found that most animation studios prefer hiring unmarried people in their early twenties with an art degree. In the back of this book I have listed some universities or technical schools that specialize in preparing people for a career in animation. A degree is not necessary, but I feel it is wise because you will be competing with great artists who already have a degree.

Also, in today's marketplace, a healthy background in computers and computer graphics is paramount because that is the direction that the industry is going.

Animation offers so many different kinds of job opportunities. The following are some, *but not all*, of the positions that are available in classical animation alone.

Writer: The writer/creator is important because animation is essentially a storytelling medium.

Character designer and layout artist: These are the artists who develop the looks of the characters and the story.

Storyboard artist: They sketch out the story in comic strip fashion and pin the story to a large board so it can be checked.

Director: The director is the one who supervises every area of the animation production.

Animator: These are the artists who draw the key positions of the characters in motion.

Assistant animator: This important job is for artists who work with the animators, cleaning up the their drawings and overseeing the work of the breakdown artists and in-betweeners.

Breakdown artist: These artists "break down" the action within a scene and work behind the assistant animator.

In-betweener: In-betweeners add the number of drawings needed to finish the action started by the animators, assistant animators, and the breakdown artists.

Clean-up artist: These people make the final refinements to the art before it is inked, painted, and photographed.

Inker: An inker copies the art onto animation cels with ink.

Painters: These are artists who paint color onto the animation cel.

Background artist: These artists paint the background scenery that goes behind the animation.

The above-mentioned job descriptions are only a few of the areas available in animation. The public's appreciation of animation goes in cycles like everything else. I feel it is safe to say that animation is here to stay in one form or another. If this is a field you would like to work in, it would be smart to know as much as possible and make yourself as valuable as you can.

EARLY FORMS OF ANIMATION

The thaumatrope, phenakistoscope, and zoetrope are three primitive experiments from the early days of animation. Their usage will be fun and will help you better understand the basic principles of this art form.

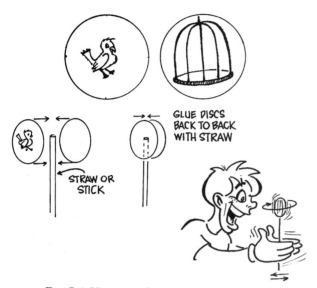

Fig. 7-1 *How to make and use a thaumatrope*

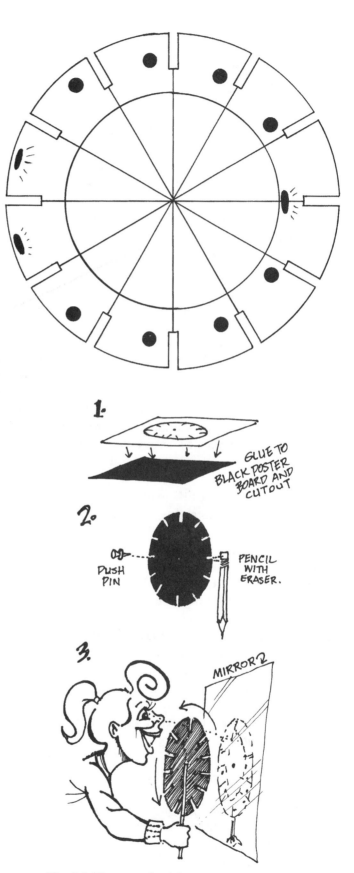

THE THAUMATROPE

Here is a pattern for making a thaumatrope, a cardboard disc with a picture on both sides. Follow the steps to make the device. Feel free to make your own design.

Supplies: white photocopying paper and Bristol or poster board; glue or adhesive tape; a small round wooden dowel stick or drinking straw; scissors or an X-acto knife.

Draw a bird in a circle and a cage in a circle, and glue onto white poster board or paper that is thicker than typing paper. Cut them out and glue them back to back with the straw or dowel in the middle. Place between your hands (palms together) and move back and forth, looking at the circle. Adjust the twirling speed until the cage and bird appear as one circle.

THE PHENAKISTOSCOPE

Follow the instructions and pattern to make one to show how the principles of animation work. Feel free to make your own design.

Supplies: white photocopying paper and black poster board (not construction paper); glue; a pencil with an eraser; push pin (tack); mirror; scissors or an X-acto knife.

Use your own discretion as to whether you wish to use a heavier dowel stick with washers, nut, and bolt, instead of a push pin and pencil with eraser.

Photocopy my bouncing ball disc at 200 percent and glue it to a piece of black poster board. After drying, cut out the design, and be sure to cut out the twelve slits.

Fig. 7-2 *How to make and use a phenakistoscope*

Push the pin (tack) through the center of the circle into the pencil eraser behind the circle. With the black portion toward you and both eyes open, look through the slits into a mirror and twirl the disc. Adjust your speed until the ball seems to bounce. You may need to add a little more light to make it easier to see.

THE ZOETROPE

This is a "wheel of life" from the 1830s. Use the provided pattern to make one.

Supplies: white photocopying paper and black poster board; glue and adhesive tape (to cover areas that are black it may look better to use black tape); pencil and eraser; push pin (tack); a button; scissors or an X-acto knife.

Photocopy Fig. 7-3 and Fig. 7-4 at 200 percent. Glue the disc and sides with slits to pieces of black poster board. After drying, cut out the disc and the sides.

Tape and glue the ends of the sides with slits together. The dotted section is for overlapping to adjust the fit. In order to make it fit you may have to overlap more than the dotted area. Be sure that you don't cover any slits.

Tape and glue the disc to the side with slits. Bend the fold tabs to add stability to the construction.

Push the tack through the center hole of the zoetrope, through a hole in the button, into the pencil eraser.

Cut out and tape the floating balloon animation strip together. Place into the zoetrope.

Be certain you have good lighting. With both eyes open, and looking through the slits, twirl the cylinder. Vary the speed and the balloon will appear to float up or down depending on which way you spin. Once you have the zoetrope you can use my template to create your own animation strips. Of course, if you use longer paper you wouldn't need to have the strip in two sections.

LET'S GET ANIMATED!

Perhaps by now you have gathered that animation is a very technical subject. At this point, it is more important for you to grasp the essence of animation than to be overloaded with information and become discouraged. Your assignments will come

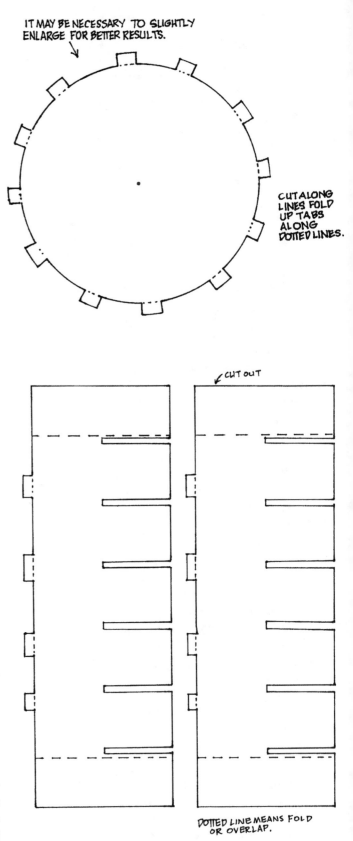

Fig. 7-3 Pattern to make a zoetrope

GUIDE TO CARTOONING

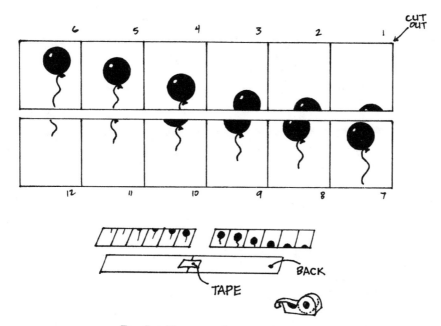

Fig. 7-4 *How to make a zoetrope*

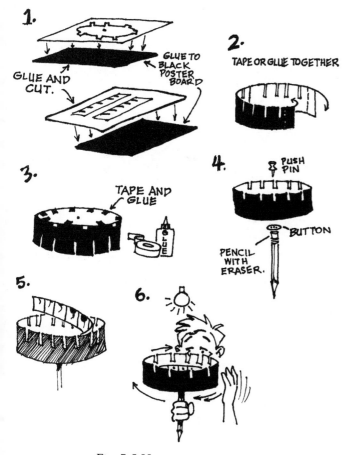

Fig. 7-5 *How to use a zoetrope*

with each section as it is covered. To begin with, let's take a brief overview of the different types of animation that are more or less available to you as a student.

Flipbooks: A flipbook is a picture that is drawn in sequence on each page of a pad of paper. One end of the pad is held securely in your hand as the other end is fanned from the back to the front. The drawings appear to move.

Non-photographic animation: This method is where you draw, paint, punch, or scratch an image directly onto blank film without having photographed the image.

Cel animation: A cel is a transparent cellulose acetate material on which art is drawn. This is used when only part of the artwork changes in a scene and the rest remains constant. The transparency of the cels allows for the overlapping of several layers to make one collective image to be photographed one frame at a time.

Stop-motion: Stop-motion animation is where an object (coffee cup, etc.), puppet, pliable clay object, cut-paper character, or pixilation (use of people as objects) is photographed with a camera, one frame at a time.

Time lapse photography: The compression of time by photographing one frame of film at a time at consistent intervals.

Computer animation: Animation that is accomplished using a computer software program.

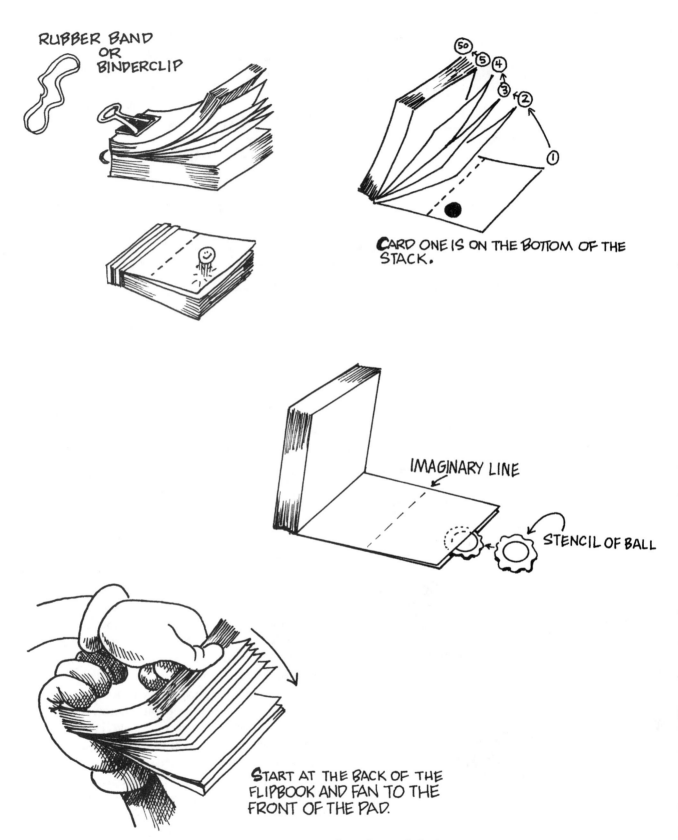

RUBBER BAND
OR
BINDERCLIP

50 5 4 3 2 1

CARD ONE IS ON THE BOTTOM OF THE STACK.

IMAGINARY LINE

STENCIL OF BALL

START AT THE BACK OF THE FLIPBOOK AND FAN TO THE FRONT OF THE PAD.

Fig. 7-6 How to make and use a flipbook

FLIPBOOKS (CAMERA-LESS ANIMATION)

Animation is a series of images that are altered slightly, and flashed separately in front of your eyes at a rate of speed that will translate as an illusion of connected movement. As I previously mentioned in the History of Animation section, this wonder known as animation is due to the theory of persistence of vision. The retina of the human eye grasps an image for a tenth of a second as it sends the image to the brain. If the eye is exposed to similar images at a speed fast enough to pile up on the retina, then the eye and the brain will superimpose the images on top of each other. The images then seem to move.

Persistence of vision works with another amazing characteristic of vision. It is called the *PHI phenomenon*. This means that the brain has the ability to understand these images as connected and related. The simple flipbook will teach you how these principles work, and be the basis for everything we will cover in this chapter. Flipbooks can be a lot of fun to make.

1. The Book to Flip

A flipbook (Fig. 7-6) is a pad of paper about fifty to one hundred pages thick. It varies in size. Some flipbook artists use 3" x 5" notepads or memo pads. I use 4" x 6" or 5" x 8" white medium-weight index cards. The 4" x 6" or 5" x 8" cards will work better for shooting with a video camera later. The 5" x 8" cards are a little difficult to work with as a regular flipbook.

Index cards are inexpensive to buy. You can purchase a pack of a hundred for about a dollar. They are easy to see through in normal light and almost transparent on a light table. They work well with pencil, ink, or paint. Also, you can align them without having to use the peg bar registration needed for cel animation. Make sure all the paper is aligned evenly and bound with a rubber band or a binder clip. Don't staple, tape, or glue one end until the book is finished.

Always work from the back to the front so that you can see the last image you drew through the paper on top. It is best to keep your artwork on the half of the pad that is opposite the binder. If you have the art move too close to the binding, it will be difficult to see as you flip through the book.

2. The Character and the Story

Animation is a storytelling art form. For our flip-books you need a character and a story to tell. Keep your character and story line *simple*. Your star is a ball, because it is best to avoid using sharp corners or angles. It can be a rubber ball, a steel ball bearing, a balloon, a bubble, a tomato, a bowling ball, a ring, a human head, or an egg. If you are going to use a steel ball, then you could make one template to use. If it is a rubber ball, then you would need several templates that would show the ball as round and in various phases of squashing.

Whatever you decide, make your templates or stencils in pencil, and then render them in ink. Think of what you want the object to do, and on a separate sketch pad make a simple storyboard of the plot. A *storyboard* is a series of drawings that is used to plan the action of a story line. The following basic principles of animation are necessary to learn in order to achieve fluidity of motion. Study people and things as they move in real life. Don't forget the photo references of Eadweard Muybridge.

Principle one: *overlapping action*—this means that different parts of the character's body and clothing arrive at a particular point at different times. Main actions are followed by lesser actions. In Fig. 7-7 the jetman's cape arrives after he lands. "Following through" with main and lesser motions makes your story and characters appear to flow. Animators practice body movements and facial expressions in a mirror. I have practiced facial and body movements in a mirror many times, making note of different sections of my body each time.

Principle two: *anticipation of action*—a character doesn't just jump or run, it leans opposite from the direction it intends to move. This is called a *delayed secondary reaction*. A character (as in Fig. 7-8) doesn't just jump; it must first coil in order to spring.

Principle three: *gravity and inertia*—inertia means that once an object is set in motion it will continue in that direction at a constant speed until acted upon by an outside source. Gravity gives a character or object weight. Also, gravity ensures that nothing moves at a constant speed. Your ball should show that motion includes acceleration and deceleration. Balls drawn close together read as slow motion, and are working against gravity. Balls drawn fewer and further apart show a faster pace by working with gravity (*see* Fig. 7-10). If you were riding a bicycle, you wouldn't start or stop at top speed. You start

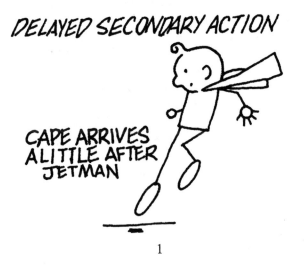

DELAYED SECONDARY ACTION

CAPE ARRIVES
A LITTLE AFTER
JETMAN

1

7

13

Fig. 7-7 Body and clothing arrive at different times.

slowly and build to maximum constant speed, and then slow to a stop. This is called *slow-in* and *slow-out*.

Principle four: *distortion in movement*—the faster an object moves, the more it appears to distort. If you are watching a dog run in a movie, he appears to be moving fast. If you looked at that film one frame at a time, the dog would be blurred. You can demonstrate the speed of your ball (*see* Fig. 7-9) in three ways: 1) by using more or fewer drawings in a cycle, 2) by stretching the object, and 3) by using accent marks or speed lines.

Principle five: *squash and stretch*—this enhances the motion of the object. Tex Avery's cartoons of the 1940s and the Steven Spielberg cartoons of the 1990s used the exaggeration of characters, stories, and action to magnify comedic potential.

These are exaggerations of shapes. The squashing and stretching of the character aids in making the overlapping and follow-through of characters more fluid and strengthens the action. The changing shape of the ball shows its speed, mass, and weight.

3. It's Movin' Time

Start out working lightly in pencil in case you have to erase. The speed an object moves is based on how much or little the object moves from frame (card) to frame. A baby step will read as slow movement and a giant leap will read as fast. Normal speed would require moving the object about an eighth of an inch (the width of a flat toothpick). Your goal is to have smooth, concise motion.

First, let's look at a *cycle*. Remember, a cycle is where an animated object begins and ends at the same position. A cycle can be a bouncing ball or a creature that is walking, running, or jumping. My example (*see* Fig. 7-11) is of a ball that starts on the left, bounces off the floor, hits the wall, bounces off the top of the frame, bounces off the floor again, strikes the top of the frame, and ends up back in the starting position. By tracing over these cards several times, arranging them in order, and fanning them, a cycle is established. Most professional animators do what is called *double framing* or *shooting on twos*. This is where the animator will photograph two shots of each drawing. This makes the animation flow a little better. You may want to double frame your flipbooks for the very same reason, but it is not really necessary for this course of study.

GUIDE TO CARTOONING

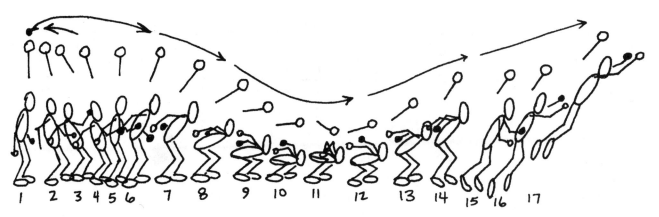

Fig. 7-8 Coiling and springing

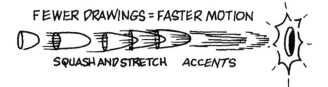

Fig. 7-9 Demonstrating speed

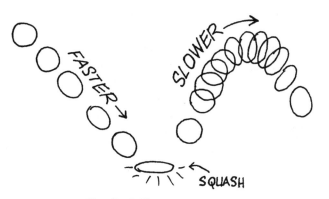

Fig. 7-10 Shape exaggeration

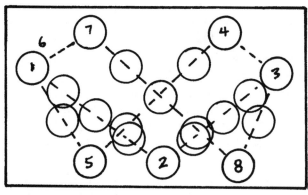

BOUNCING BALL CYCLE

Fig. 7-11

In the chapter dealing with the fundamentals of cartooning art, you learned the importance of under-structure and anatomy. Never is this more important than in animation, because you must design your characters to be able to bend, stretch, and move without changing in their look. You must also design it so that another artist can learn to draw the character just like you draw it. It wouldn't be a good thing to see several versions of a character in one film. I have seen this happen before in lower budget films.

Assignment #2: Follow the Bouncing Ball
Flipbook: Bouncing ball cycle #1

It's time to make your first flipbook. To keep it simple, make the ball solid steel. Count out fifty index cards, and on a separate card, draw a ball for a stencil. Trace the words "Ball Cycle #1" on the first five cards for a title. You can use a circle template, a penny, a small button, or a nickel to serve as your guide. Ink a line around your guide to make a stencil of a ball, but *don't* fill the circle with color to look solid. Cut out the stencil with scissors, leaving a lit-tle white space around the circular line. Put the first page over your stencil and trace it in pencil in the upper left portion.

Count out eight more cards. On card #9, trace the ball on the upper right side directly across from the first ball. In animation lingo, these drawings are known as *key drawings*. These key drawings represent the beginning and ending of the cycle. Number the cards on their backs to read as 1 through 9.

Take out card #5 and trace the ball in the lower center of the card. This drawing is called the *in-between*. So card #1 is a key drawing, #5 is the

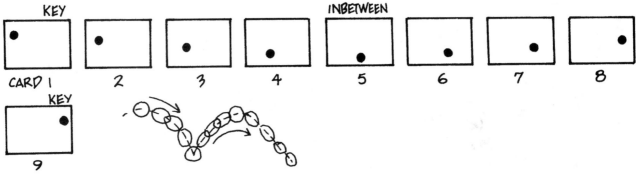

Fig. 7-12

in-between drawing, and #9 is the concluding key drawing. That leaves you three cards on either side of card #5. Using your guide, make cards #2, 3, and 4 have balls that equally fill in the space between cards #1 and 5. Then do the same on cards #6, 7, and 8.

Place the cards in order and fan the pages a few times. You should see the ball bounce from one side to another. If it works correctly, ink the line around the balls. Next, make four more sets of cards #1 through #9. Arrange them in order and you should have fifty inked cards moving in a cycle that repeats itself five times. Bind them securely and flip the pages. Film animation runs at twenty-four frames per second. You just drew fifty frames, meaning that your hard work would produce two seconds of film time. Professionals use the flipbook method to visually test their action sequences.

Flipbook: Bouncing ball cycle #2

Make another fifty-frame cycle using a circle. Call this flipbook "Ball Cycle #2." This time the ball can be a balloon, an egg, a rubber ball, a bomb that explodes, or any kind of ball you can imagine. Also, this time, add a few elements to add to the illusion of motion. Put a line for the ground. It can be on the spot that the ball hits on card #5 or above the line so it looks like the ball seems to be seen in perspective. Add a shadow that follows the progression of the ball. Feel free to add physical effects like accent marks when the ball strikes the earth, or motion lines trailing behind the ball as it nears the last cycle.

Create another stencil of a small cloud, a box, or a simple tree. Starting with the second set of nine cards, trace a second element beginning on the right side. By moving from the right to left it will appear to make the ball move faster or slower. A good rule

of thumb is that things far away move slower, and things up close move faster. Remember to do the entire fifty pages in pencil so that you can plan if the secondary elements are in front of the ball or behind it. End this flipbook cycle by having something happen to the ball. Let it explode, crack open, bounce out a door, window, or something.

Flipbook: Cycle #3

This time you choose your own character to move through another fifty frames. Keep it simple. Some suggestions are a flying bird, a man walking, a face changing, or an object changing into something entirely different. Make up your own title.

GOLDEN NUGGET: Instead of buying a card for that next birthday, Valentine's Day, or Christmas, make a flipbook for that special someone. He or she will love it!

NON-PHOTOGRAPHIC ANIMATION

This first step toward making animation on film doesn't require a camera, but this section of study may not be possible for you to do. I'm aware that not everyone lives near a larger city. I live in an area with a population of about 200,000, and it's hard for me to locate the various materials for this exercise. Look around your home or ask someone nearby. See if you can find any motion picture film. You never know, there may be some old, unused Super 8mm film lying around.

Call photo shops near you; they may have some film or *clear leader* in stock for sale. Leader is a portion of undeveloped film that is put at the beginning of a motion picture to aid in threading it through a

GUIDE TO CARTOONING

projector. Colored leader, even if it's white, *cannot* be made clear with bleach or scratched clear. You will find that 16mm clear leader is better because 8mm is so small to work with. Only in extremely rare situations would you be able to use 35mm film, due to the scarcity of 35mm projectors. However, a Super 8mm projector may be easier to locate. Ask around. Someone near you probably has an old Super 8mm projector in his attic gathering dust.

If you can only find undeveloped film, just dip it in bleach and rinse it with water. The photo-emulsion will go away, leaving a clear film. Once the film is washed and cloth dried, do not touch it again with your hands without wearing white cotton gloves. These cotton gloves can be bought at most drugstores. The oils in your skin could keep the ink from adhering to the film. Warning: *Be very careful with the bleach.* Don't splash it in your eyes, on your clothes, or on the floor. Wash it off your hands with soap and water as quickly as possible. A little bleach goes a long way, so it doesn't take much.

Making a Film Jig

A jig holds film steady to allow you to paint directly onto the non-photographed film. It helps to keep up with how many frames you've worked on. The jig can be a lightweight wooden plyboard, 8" x 4" for 8mm and 10" x 4" for 16mm. Glue a piece of Bristol board over the wood's surface. In the center of the Bristol board, use a ruler and hand draw a replica of a piece of film that runs the length of the jig. I have drawn you a little piece of 8mm and 16mm film at their actual sizes so you can use them as guides. Draw the sprocket holes on the left side of the film, and even draw the lines for box-like frames. This template is important because blank film has sprocket holes but no frame divider lines. The template is so that you can see the frame dividers through your film. Nail two small headless nails into the jig for registration. The nails must be able to fit through the sprocket holes. On both sides of the film template, glue two strips of thicker Bristol board. This will make a slot or jig for the film to fit in so that registration is tighter.

ASSIGNMENT #3
BOUNCING BALL TEMPLATE
No. 1

A JIG THAT HOLDS FILM

Fig. 7-13

Super 8mm film is projected at eighteen frames per second. That translates to about three inches per second. The eight-inch jig allows you to work on two seconds of film at a time.

The sprocket hole for 8mm film is located halfway between two frames. The art image is terribly small, measuring only about a quarter of an inch wide by three-sixteenths of an inch tall. You may need a magnifying glass and a very fine-tip ink pen.

The jig for 16mm needs to be about 10" x 4". The 16mm film is projected at twenty-four frames per second, which is seven inches long. Each frame divider of the film is lined up with the sprocket hole. The 16mm frame area is a little bigger than the 8mm, at $3/8$" x $5/16$".

Use a rich black, permanent, ultra-fine-tip ink pen. Make sure the ink will not smudge. There is no need to draw the frame dividers since your template shows them. It is the shutter in the projector that adds the black space between frames when the film is shown. You can use rich transparent paints or colored inks that dry permanently. Any paint that works on acetate film should work well. Professional animators use Cel-vinyl opaque water base paint. Cel-vinyl paint will not work for this method of animation because opaque paints, regardless of color, will project as black.

It's Time to Draw!

Skip about five or six feet of film so that you will have enough leader to thread the projector. Use another twenty-four inches to repeat a title. Just as with the flipbooks, you must decide what you are going to draw. It must be very simple. I recommend your working in double frame or on twos so that the film doesn't go by too fast.

Assignment #3: The Ball Returns
Camera-less Film #1

You should be seeing the bouncing ball cycle in your sleep by now, but let's use it again for our first section of film. Make one template on paper showing the ball in each position of travel. The template should fit the frame for the type of film you are working with. Place the template in the jig and use your pen to draw one ball per frame in the cycle. Repeat the cycle about five times at least. Let the ink dry thoroughly, thread it into a projector, and run it through.

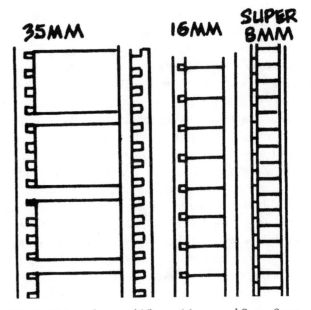

Fig. 7-14 *Actual sizes of 35mm, 16mm, and Super 8mm*

It will only last a couple of seconds so you don't need to worry about putting the film on reels.

Camera-less Film #2

For the next film you can create a template or draw freehand. Here are a few ideas: a dot growing larger and turning into a doughnut and then opening up again to clear film; a tree growing leaves and shedding them; a bomb exploding; a human face appearing one element at a time and changing expressions; a stick man (jet man) throwing a ball.

You may want to add color. I suggest large areas of color due to the small frames of the film. Even at eighteen or twenty-four frames per second, the colors will quickly blend.

VIDEO AND COMPUTER ANIMATION

As I mentioned earlier, 16mm and Super 8mm cameras, film, and editing equipment are difficult to find and expensive. This leaves us with computers and video.

Computers

Computer programs with animation capabilities are becoming more valuable to the cartoonist. While amateur programs are not too costly, they do require a powerful computer with a lot of memory. Even a small duration of animation takes up a lot of space on a computer. Every program you purchase will have

instructions designed specifically for your computer. Couple those instructions with what is taught in this book, and you should do fine. The traditional animation stand and camera are being replaced by computer-oriented equipment like the Canon RE-650 Video Visualizer. The way computers are becoming commonplace in this industry, it shouldn't be very long before everything works better and costs less.

Video Cameras

Every year video camcorder companies create and delete equipment. There are no home video camcorders that have the ability to capture the single frame stop-action needed to make smooth lyrical motion. Believe me, I've thoroughly researched this. There are a few camcorders that can do very limited animation. Two features are required for using your family's home video camera. You must have a unit that has a *flying erase head* feature and you must have a remote control device. The flying erase head is an internal editing feature. After you tape something and stop the camera, the flying erase head feature rewinds back to the last image. When you start videotaping again, there is no glitch or break in the flow of action. The remote control device is important so that you don't have to touch the camera and accidentally move it. Check around your class or with friends and relatives; perhaps someone has a camera with these two features.

I own an older Panasonic camera. It has the flying erase head and a remote control pause button. I have done numerous experiments with this camera. To get my home video camera to record a half-second of animation, I have to let the camera roll exactly three seconds. This means I can shoot two frames per second. Remember, animation requires at least twelve frames per second to generate fluid motion. If I play back what I taped in the play/fast forward mode, I can get a sense of animation. I know that this may not be the ideal way that you would like to watch your films, but it isn't a bad way to start.

My friend Harold Buchholz and his wife Diane use a Sony CCD-V8AF camcorder. They have found that by clicking the shutter as quickly as possible, they can get a reasonably good flow of motion. So experiment with what you can find.

The Canon L2 is an 8mm home video camera that does some limited animation. They are *very*

expensive, and they are not considered broadcast quality. In other words, the video would not look good if you tried to air it on television. Besides, for a little more money you could purchase an entire Animation Controls Video Pencil Test System. My research has shown that very few salespeople in stores know much about the animation potential of video cameras, so you will have to do your own research and experimentation.

Two real advantages that video has over film is that you can view it instantly instead of having to mail it off for developing, and videotape is cheaper to buy. Most home video cameras come with (or you can purchase) the necessary cables to hook it up to a television set. This would be a good way for you to watch what you're taping as it happens. This could be important to do because not all viewfinders (the camera eye-piece) are lined up with what the actual lens shoots.

Animation Controls Video Pencil Test System AC-200

The only videotape equipment that truly works for animation is the Animation Controls Video Pencil Test System AC-200. It has been around since 1977, and it was developed by John Lamb. In 1979 Mr. Lamb received an Academy Award for inventing it. It is currently being used by animation studios, interactive game developers, special effects houses, schools, and universities throughout the world. Mr. Lamb is also the president and chairman of the board of Bobtown Productions, an animation company.

Professional animators use the pencil test system to check their animation for mistakes before taking the next step. A growing number of school systems use it to teach animation classes. The system consists of a VCR, controller, monitor (TV), video camera, zoom lens, and video cables. They have various packages available. The system is available for regular VHS, S-VHS (super VHS), color video components, and black and white video components. Most better quality camcorders will work with the system. It does reverse playback, freeze frame, and manual frame advance/reverse. It converts video's thirty frames per second to the film industry standard of twenty-four frames per second. It is perfect for videotaping your flipbooks, stop motion paper cut-outs, 3-D objects, pixilation, and cel animation. As of this writing the

Fig. 7-15 *The Animation Controls Video Pencil Test System AC-200, used by permission of Animation Controls, Inc.*

system varies in cost from about $3500 to $5200. You can receive more information by contacting John Lamb at Animation Controls, Inc., 425 S. Horne, Oceanside, CA 92054, phone number (619) 722-4540. Schools should ask about a discount.

Camera Tripods (animation stands)

You do not need to invest in an animation stand; a sturdy camera tripod will do fine. It would be a good idea to find a way to make the tripod stationary so that it doesn't move. This can be done by putting clay or tape on the ends of its legs. You may wish to make a wooden triangle, or drill three indentions into a panel of wood and place the legs there to make them more secure. You want to stay at least three to four feet away from the subject being shot.

Lights

Most camcorders work fine under available light, but you can add a few quartz light bulbs or 60-watt household bulbs if you like. The 60-watt bulb doesn't shine as consistently as the quartz. In a world of total motion, we don't really notice the variation in the brightness of electric lights. But animation snips fractions of light, and the differences in intensity become apparent when the film is played back.

If you are shooting flat animation and you need additional lighting, use two lights set up at forty-five-degree angles on opposite sides from each other. The shooting of 3-D objects requires three lights. You need a light in front of the object, one to the side to soften shadows, and one aimed behind the object and in front of the background to avoid making the picture look flat.

Sound

When using a video camera to do stop action work, the microphone for sound on the camera is a *useless* device. In fact, the only sound you will record

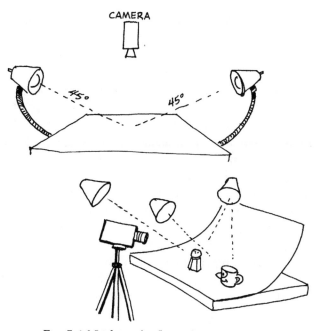

Fig. 7-16 *Lighting for flat and 3-D animation*

is probably your own voice saying "go" and "stop" a hundred times. Sound recording isn't easy to do. At best you could experiment and add a musical track by using a VCR to edit the music and video onto another tape. This kind of sound editing is called *random sync*. It would work all right for experimentation, but it is very difficult to keep the sound and picture running together. I think you'd be surprised how sound can overpower your art. This course of study does not require that you add sound. When animation is produced for broadcast, the voices are recorded first so that the animators can draw the characters to fit the sound. Fig. 7-17 shows a pronunciation chart which gives the various positions the mouth has to make in order to simulate the illusion of speech. As I said at first, animation is very technical.

Assignment #4: *Video Flipbooks*

If your school doesn't have the Animation Controls Video Pencil Test System, try to acquire a

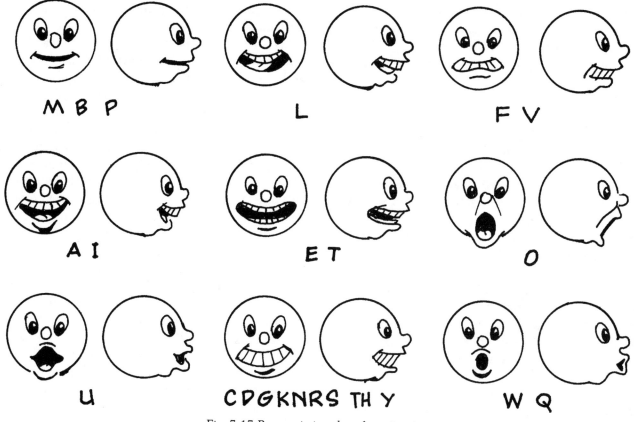

Fig. 7-17 *Pronunciation chart for animation*

video camera that has the flying erase head and remote control device. Videotape the flipbooks that you have already done for this chapter. Unbind your flipbooks and find something you can lean the cards against individually. Place a strip of tape above and beside the first card so that the other cards can be lined up in the same position. Do a test to see how long it takes your camcorder to begin taping after the pause button is released. Test it by clicking it from pause to record as fast as you can. Try it at one second, at two seconds, at three seconds, etc. Find out the shortest time available. Once you have established a pattern, shoot your flipbooks. Let the tape run for ten seconds on the title card. Once finished, rewind the tape in a VCR and play it back. You may have to run it in the play/ fast forward mode to really see any fluid motion. It should surprise you how much you will have fun and learn at the same time.

Time Lapse Video

Before going on to the other kinds of animation, let's look at the time lapse effect that many less expensive camcorders provide. It will be in the video camera's instructional manual if it is a feature. Time lapse occurs by the camera clicking one frame or one second of video at established intervals. Some cameras allow for one second of video every minute, others one second every five or ten minutes. Remember, a video battery only lasts about two hours without recharging.

Assignment #5: Great Timing!

(This assignment is optional because you may not be able to acquire a home video camera with this feature.)

Place your camera on a tripod in a corner of your art class. Make up a title card with credit information, and videotape it for about twenty seconds. More than one title credit could be incorporated into the time lapse effect by having different people hold a small segment of information. Set the time lapse device to work according to your manual. Tape your class period, and end with a closing card for twenty seconds.

Next you may wish to tape your class each day for a week. And the next time you travel on an extended trip by car, set up the camcorder with its time lapse setting. It will enhance the fond memory of the trip. Don't forget family meals or reunions.

Warning: Stay near your camcorder at all times to protect against theft or breakage.

Stop-Motion Animation

This section will teach principles that will apply to the animation of objects such as coffee cups and pencils. It will also cover puppets, clay, cut paper characters, and pixilation. Actually, all photographed animation could fall under the heading of stop-motion. These types of animation can be somewhat of a blessing and a curse. The blessing is that clay, puppets, objects, cut paper, and pixilation can be as spontaneous as a stage play. The curse is that once you start shooting it is hard and sometimes impossible to repeat an action. (This section assumes that your school has the Animation Controls Video Pencil Test System AC-200, a home video camera, or a 16mm or Super 8mm camera.)

3-D Objects

Of all the different types of animation available, 3-D objects are the simplest to work with. Look around your home or classroom for objects to use. Coffee cups, a book, pencils, or erasers make good characters. Anything that has several things in a box or package is especially good. A box of matches, a box of crayons, a kitchen drawer filled with knives and forks, or related items like towels, electric hairdryers, brushes, and a bag of makeup all make for delightful storytelling. This type of animation is great because you don't have to draw anything to get started.

Warning: *Don't get in a hurry!* Animation takes time and a lot of planning and thinking. Always have a title or test card that says which shot this is and any changes that may have been added or subtracted. The test or title card can be on an index card or regular notebook paper. Make sure your camera is at least three or four feet away from the center of action. Do a test by shooting the objects moving around a tabletop. This is done by altering their positions a little between takes. Check out your work to see if you're moving too much or if you have enough lighting. If you add lights, have one shining on the front of the object, one to the side to soften the shadows made by the first light, and one shining between the object and the background. If you change camera positions, check your lighting to make sure it is consistent with your last shot.

Assignment #6: Objectivity

Determine which objects you'd like to use. Select two but not more than three for this exercise. Develop a short story or scene for your objects to act out. Make a title card and shoot at least ten seconds of it before shooting any animation. Check your objects, camera, focus, and lighting. Okay, shoot. Make the film one minute in length.

Pixilation

Pixilation is different from working with 3-D objects in that humans become the object to be animated. This is achieved by making a person move around while they remain in the same pose. When I was younger, there was a television commercial for a gasoline company where a person sat on the highway and moved as if he were driving a car. This was done by the person scooting up a little between each shot. The result was a man driving an imaginary car down the road. If planned correctly, a person could appear to do amazing and impossible feats.

Assignment #7: Pixie Dust

Keeping your camera stationary, find a few volunteers in your art class to be your subjects. Have one seated on the floor, another standing on one foot, a couple of people standing like statues, and someone else jumping up. Have each student move forward a half step in different directions. When played back, the jumper should appear to float around the room, the statues will look like stone sliding along, the person on one foot is skating, and the seated guy is driving an imaginary car along the floor. Have them move over objects like desks and tables. Done correctly, pixilation is delightful fun.

Toys, Puppets, and Clay

Toys and dolls can be difficult to work with. Their feet are generally too small, making it hard to keep them in position or change their poses without knocking them over. They also have a fixed look on their face.

Normally, when we hear the word "puppet," we think of string-controlled marionettes or the kind worn on the hand. For animation, a jointed toy could be considered a puppet, or a face made out of fruit. Draw a few cartoon mouths, eyes, and eyebrows in different positions on paper. Lightly glue them to the

puppet's face. This will allow them to seem as if they move their mouths or change expressions. Whatever color you use on the outside of the paper eye or mouth, continue it on the sides so that white won't show around the art.

Clay in stop-action animation has been around a long time. Will Vinton is considered a master of clay animation. Art Clokey's "Gumby" TV show has entertained millions of fans for years. A couple of problems to be aware of when working with clay are:

• Clay used for sculpting or pottery has a tendency to dry out under lights. Add petroleum jelly or find a type of clay that has oil already added.

• It is difficult to return clay to its original form once it has been moved. This makes it hard to back up the scene to redo a shot. Clay has to be wrapped around a bendable wire frame or a metal skeletal armature. Cels and flipbooks can be shot again and again, but clay is a one-time shoot.

• Clay requires a good size base or larger feet to keep it standing stable.

Assignment #8: Clay Magic

Do a short one- or two-minute film using a combination of clay, toy, and a puppet. Create a puppet out of clay or anything. Cover a poseable toy figure with a blob of clay. Using animation, have the puppet touch the mound of clay with a magic wand. Start at the top of the blob and pinch off a little portion. Carefully lift the entire blob of clay. Spread the portion of clay you pinched off the top of the blob out to form a thin sheet of clay. Be sure it is directly covering where the blob originally sat. Replace the blob on top of the sheet of clay. The effect will look like a pool of liquid forming under the blob. Continue this process and the toy inside the clay will be revealed. The bottom will spread as if it is melting. After this is done, feel free to produce your own scenario with different characters in a short subject film.

Cut Paper Animation

Cut-out paper animation has been around a long time. It is the distant cousin of the old silhouette or shadow puppet films from the late 1800s. The camera has to be set up vertically, just like for cel animation. Cut-outs are separate pieces put together to form one character. For example, a man can be made up of a cartoon body trunk, several identical heads

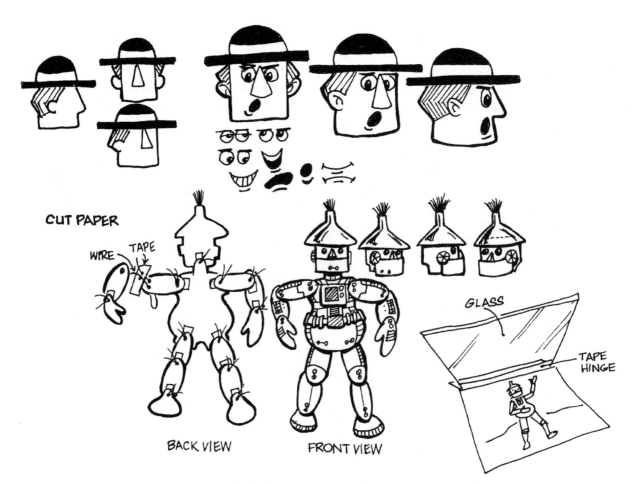

CUT PAPER

WIRE TAPE

BACK VIEW

FRONT VIEW

GLASS

TAPE
HINGE

Fig. 7-18 *Cut paper character for animation*

showing different angles, several arms, and several sets of legs. The heads can have different interchangeable facial expressions. These can be held together with small wires and tape. The character is animated by using tweezers to slightly move or replace the different parts of the body between shots.

Cut-out animation is very difficult to accomplish. The movements have a tendency to be somewhat jerky. Instead of shooting double frames, it may work better to shoot three frames of each set-up. It is also recommended that you put a thin sheet of glass over the art to keep it from curling or moving. Tape one side of the glass to your base so it can lift like a hinged door. *Be very careful* when you lift the glass so that static electricity doesn't move your cut-outs. You may want to add a little rubber cement to the back of the character. Once it dries it will aid in keeping the cut-out in registration.

INK EDGES SO THAT
WHITE DOESN'T SHOW.

Fig. 7-19

Assignment #9: Cut-Ups

Draw a simple cartoon head in the frontal view without facial elements. Next, draw several pairs of eyes and eyebrows that are alike but in different

poses, and cut them out. Draw a series of mouths using the pronunciation chart found in the Sound portion of this chapter. Pick a couple of easy words to say, like, "Hello Mom." Give the head hair and make a separated cut-out of a hat. Using the various separate elements together, have the head say, "Hello Mom," and then have his hat float away. Use his facial expressions to express his surprise at the hat leaving. Since this is a silent film you can show a comic strip speech balloon of the words, "Hello Mom."

CEL ANIMATION

In the beginning of animation, the characters were drawn on the same piece of paper as the background and the foreground. This meant that the next frame had to be completely redrawn. Cel animation was developed so that everything that moved could be drawn on a separate piece of clear acetate and placed over the stationary drawings. This meant that whatever didn't actually move in the shot didn't need to be redrawn. Just think, let's say that an animated motion picture requires five layers of cels for one frame, and animation runs at twenty-four frames per second, on a film that runs for ninety minutes. That's 120 cels for *one second* of film; 7,200 cels for *one minute* of film; and 648,000 cels for *ninety minutes* of film. We're talking a lot of work, but with cel animation you only have to draw whatever moves in the scene. Thank goodness animation studios have hundreds of people working on a movie.

Cels

A regular animation cel is 10½" x 13" x .005" thick. You can purchase them without registration peg holes or with the holes punched to fit the Acme or Oxberry peg bars. Oxberry pegs are mostly used in the eastern half of America, and Acme in the west. I have no idea why. Unless you intend to use the Acme or Oxberry peg bars for registration, I recommend getting the unpunched kind. Most art supply stores *will not* have animation cels in stock. It is best to order them from a company like Cartoon Color, Inc., at 9024 Lindblade Street, Culver City, CA 90232-2584. I'm sure there are other places that supply animators, but this is the only place with which I'm familiar.

If you purchase the standard-size animation cels,

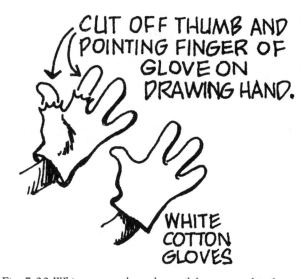

Fig. 7-20 *White cotton gloves keep oil from your skin from damaging the cel surface*

you have to use animation bond paper or tracing vellum the same size. For the purposes of this course I recommend your going to an office supply store in your area and getting 8½" x 11" clear transparencies and using regular typing paper. The animation cels and the transparencies cost about the same, but the animation bond paper costs a lot more than typing paper. You will have to get a two- or three-hole puncher to make your own registration peg bar. I prefer punching the holes to fit in a regular three-ring binder.

Wear *white cotton gloves* whenever you touch these transparencies so that you won't get oil from your hands on them; this would prevent ink and paint from sticking to them. You can cut off the thumb and index finger of the glove on the hand you write with.

Peg Bar Registration

You can make your own peg bar by taking a thin piece of wood, such as you would use for a baseboard. Get a piece of wooden dowel that is slightly smaller than the hole made by your cel puncher. Don't have the dowels be so small that the cel can move around. Cut the dowels where they will stick up out of the baseboard about half an inch. With a drill, make holes in the baseboard and glue in the dowels. Punch your cels and typing paper so that they will fit in your homemade peg board.

THREE HOLE PUNCH TWO HOLE PUNCH

HOMEMADE *PEG BAR REGISTRATION*.

Fig. 7-21

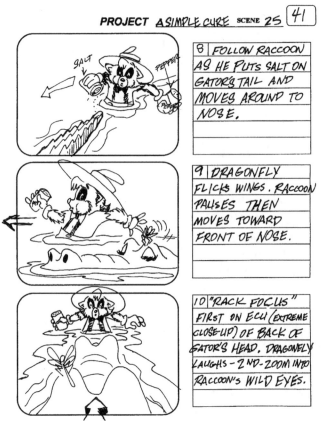

8 FOLLOW RACCOON AS HE PUTS SALT ON GATOR'S TAIL AND MOVES AROUND TO NOSE.

9 DRAGONFLY FLICKS WINGS. RACCOON PAUSES THEN MOVES TOWARD FRONT OF NOSE.

10 "RACK FOCUS" FIRST ON ECU (EXTREME CLOSE-UP) OF BACK OF GATOR'S HEAD. DRAGONFLY LAUGHS - 2ND-ZOOM INTO RACCOON'S WILD EYES.

Fig. 7-22 Here is a storyboard in the television format

Planning and Preparation

Let's go through the steps you take to do animation using cels:

Step one: The story and storyboards

Storyboards are the only way to visualize your story and trim anything that isn't needed to tell it. Storyboards are small sketches that look like a comic strip with the words and directions captioned directly below it. During the storyboarding process, think through the timing of the action. This will help you determine the length of your story, and make any changes needed.

Step two: Drawing the story on paper

Now that you have worked out the story and the timing of each scene, it is time to draw it on your paper. A *light table* is vital to making your job easier. You can make your own. Find or buy a piece of clear glass about 1½-feet square. Pile up some books, lean the glass on them, and put a reading lamp (60-watt bulb) so that it shines up through the glass. If the light is too bright, cover the glass with tracing paper. Draw your first key drawing and label it "1-A" in the upper left corner. Any more cels that go on top of the "A" cel will read "1-B1," "1-B2," etc. This may seem like a pain at the time, but you could get up into hundreds of cels before you know it. One accidental spill would change

your mind forever about not labeling. At the animation studios they use the Animation Controls Video Pencil Test System mentioned earlier to be sure that they are on track with their action. Live-action motion pictures are edited together after all the scenes are shot. Animation is different in that most of the editing is done in the drawing stage.

Backgrounds can be drawn or painted on a cel or any kind of paper you like. Some backgrounds are done on long sheets of paper so that the characters can move a longer distance. The long background slightly moves in the opposite direction from the direction that the character moves. The animator saves time by drawing the action needed for a walk or run cycle. The cycle is photographed over and over while only the panoramic background crawls by one frame at a time.

Step three: Tracing onto cels

Once the story is completely drawn and checked, it is time to transfer it to the cels. Take cel "1-A" and

PROJECT _____ SCENE _____

Fig. 7-23 _Make copies of this page to do your own storyboards_

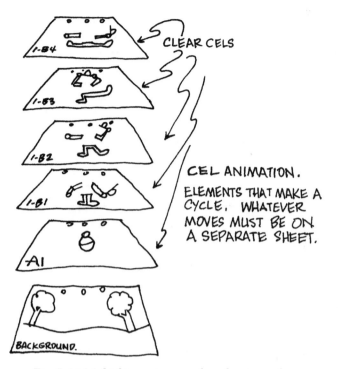

"CLEAR CELS"

CEL ANIMATION.
ELEMENTS THAT MAKE A CYCLE. WHATEVER MOVES MUST BE ON A SEPARATE SHEET.

1-B4
1-B3
1-B2
1-B1
A1
BACKGROUND.

Fig. 7-24 *Multiple transparent cels make up one frame*

SCROLL PAN BACKGROUND- MOVES OPPOSITE CHARACTER'S MOTION.

Fig. 7-25 *Background scroll of paper*

The Exposure Sheet

Title: *THE GENTLEMAN TRAVELER* Sheet No. __6__

Scene: __1 - INTRO OF MAIN CHARACTER__ FPS __24__

ACTION	FRAME NUMBER	CEL NUMBER					BACKGROUND	CAMERA
		A	B	C	D	E		
MAN TIPPING HAT/JUMPING	1	A1	B1				HOLD BKG	HOLD
	2							
	3		B2					
	4							
	5		B3					
	6							
	7		B4					
	8							
	9							
	10							
	11							
	12							
	13							
	14							
	15							
	16							
CLOSE UP MAN'S FACE	17	A2	B1	C1				ZOOM IN SLOWLY.
	18							
	19		B2					
	20							
	21							
	22							
	23		B3					
	24							

(REPEAT CYCLE)

Fig. 7-26 *This exposure sheet shows cels layered three deep on top of a background. The camera holds and moves in slowly. The camera shoots double frame or two times on each cel.*

put it on the peg bar. Wearing white cotton gloves, lay a sheet of cel acetate over "1-A" and trace the art using ink. A Rapidograph with a #3 or #4 nib works good. I'd use a #4 nib if you're working with Super 8mm; 8mm is so small that a finer nib might not show up when projected. Remember, I said "trace," not "redraw." All your drawing and redrawing should be done on paper. Number each cel just as you did the papers.

Step four: Painting the cels

After all the cels are dry, you must paint the cels with opaque paint. Cels are painted on the back of the art. Felt tip markers or dyes are not solid enough to block out the background; Cel-vinyl cartoon colors are perfect for coloring cels. Apply opaque white to characters that are not colored or you will see the background showing through. The black lines should be covered so that no clear will show through. You can easily scrape off any paint you get outside the outline without messing up the black line. Cels and transparencies come with tissue paper between each sheet. Store the cels with the tissue still in place for protection.

Step five: The exposure sheet

Up until now I haven't mentioned using an exposure sheet because we have worked on single layer artwork. Exposure sheets are *vital* to any animation that has to be planned. Fig. 7-27 is an example for you to redraw and photocopy. Pros have a column for sound, but sound is not part of this course. *Dope sheet* is the trade name for exposure sheet. I do not know where this term originated. This sheet serves as a reminder of the action of the scene, the frames that have several layers of cels, the duration of film time for the cels, on which background, and what the camera should be photographing. The sheet should be marked any time the camera pans, zooms in and out, or highlights a certain part of the frame. Once this is all worked out it is time to shoot the cels with the camera.

The Exposure Sheet

Title: _____ Sheet No. _____

Scene: _____ FPS _____

ACTION	FRAME NUMBER	CEL NUMBER					BACKGROUND	CAMERA
		A	B	C	D	E		

Fig. 7-27

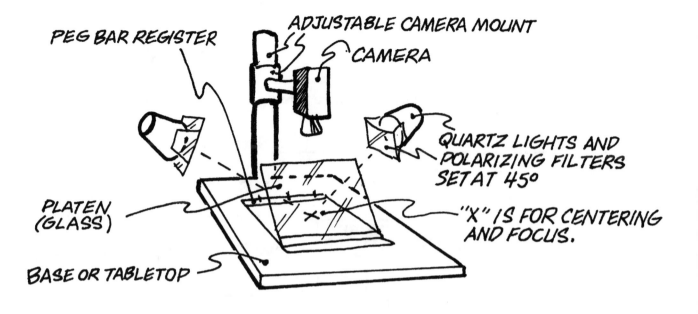

PEG BAR REGISTER

ADJUSTABLE CAMERA MOUNT

CAMERA

QUARTZ LIGHTS AND POLARIZING FILTERS SET AT 45°

PLATEN (GLASS)

"X" IS FOR CENTERING AND FOCUS.

BASE OR TABLETOP

ANIMATION STAND FOR FLAT ARTWORK

Fig. 7-28

Step six: Photographing the cels

Set up your animation stand. Make a checklist of things to do for each shot. Here is an example list:

1. Load camera with film.

2. Set up camera and clean lens.

3. Set up stand or tripod. Be sure the glass cover that you lay over the cels to be shot is clean.

4. Adjust the lights. Reposition if there is a reflection on the glass or add polarization filters if needed. You can purchase polarization filter material to add to a makeshift frame attached to the lights. Don't get the polarization stuff too close to the light or it will melt. You need to add a polarization filter lens to the camera also.

5. Set up the cels to be shot in the first frame. Check your exposure sheet to see which shot has the most layers of cels. Add clear cels so that every shot has the same amount of layers. This will insure that your film maintains a consistent look. Even though the cels are clear, they do take on a gray shade when layered.

6. Check your camera, lights, light meter, exposure sheet, and artwork. If everything is okay, move your hands out of the way and shoot.

After the first frame is shot, carefully repeat your actions for each frame until the film is done. Don't rush yourself. Check off each frame on your exposure sheet *after* it is shot. This way you won't lose your place if you are interrupted. Take frequent breaks.

Assignment #10: *The Face*

For your first cel assignment, you will make a face appear one or two lines at a time. Make a title or test cel and shoot ten seconds' worth. Draw a complete picture of a cartoon face on animation bond paper. Next, trace it with ink onto a cel, shooting one line at a time until the picture is complete except for the pupils of the eyes. This done by putting your penciled drawing on the peg bars attached to the animation stand. Place a sheet of cel acetate on top of the drawn picture. Ink a line or two, perhaps in different areas. Put a blank sheet of paper between the art and the cel. Shoot a double frame shot, and remove the blank sheet. Draw a little more on the cel, replace the blank sheet, and shoot. Do this until the face is finished. Don't put an end title because your film is not complete.

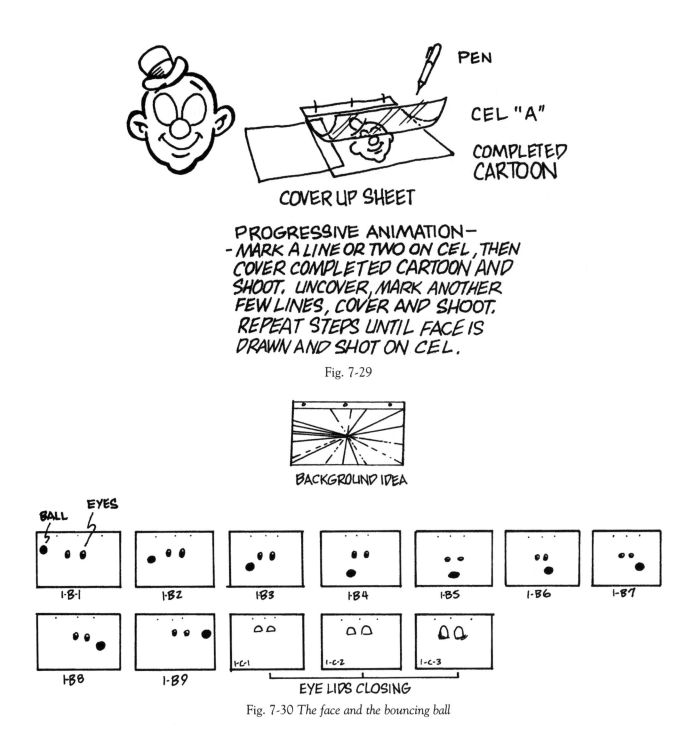

COVER UP SHEET

PEN

CEL "A"

COMPLETED CARTOON

PROGRESSIVE ANIMATION—
— MARK A LINE OR TWO ON CEL, THEN
COVER COMPLETED CARTOON AND
SHOOT. UNCOVER, MARK ANOTHER
FEW LINES, COVER AND SHOOT.
REPEAT STEPS UNTIL FACE IS
DRAWN AND SHOT ON CEL.

Fig. 7-29

BACKGROUND IDEA

BALL EYES

1-B-1 1-B2 1-B3 1-B4 1-B5 1-B6 1-B7

1-B8 1-B9 1-C-1 1-C-2 1-C-3

EYE LIDS CLOSING

Fig. 7-30 *The face and the bouncing ball*

Assignment #11: Face Painting, Background, and the Revenge of the Ball

Make the face white or a color by painting on the back of the cel. On a separate paper with peg bar holes, make a background. Make it as colorful as you like. The background can be done with dyes, crayons, watercolor, or anything you choose. Finally, pull out your bouncing ball cycle. Draw the ball on a series of cels in the various positions needed to form the cycle. You only have to draw the cycle once since you can use it over and over again. On this series of cels, also draw the pupils of the eyes so that they follow the ball as it bounces. Paint the ball white or any color that would stand out against your background. Do three more cels to make the face close his eyes.

Take about three seconds' worth of frames to

introduce the background, and then shoot one cel at a time of the ball making its cycle while the face's eyes follow. Repeat this cycle at least eight to ten times. To break up the predictability of the cycle, shoot it where the ball will go behind his head once or twice. A few extra cels need to be done with eye pupils for when the ball goes behind the face's back. Once the cycle has gone by the last time close his eyes, and show a end title cel.

CONCLUSION

We have just scratched the surface in exploring the fundamentals of the magic of animation. It is a subject that you could devote your whole life to and never stop learning. Take what you've learned here and go get animated!

Review Questions

1. Define the word "cycle" as it relates to animation.

2. Describe the difference between full animation and limited animation.

3. List and define the five principles of animation.

4. What is meant by the term *double framing* or *shooting on twos*?

5. What is the name of the man who won an Academy Award in 1979 for his invention of the Visual Pencil Test System?

6. From the pronunciation chart illustrated in this chapter, draw a cartoon head saying the words, "Hello Mom."

7. What is the trade name for an exposure sheet?

8. What is a key drawing?

9. What is an in-between drawing?

10. Film that is 16mm runs at twenty-four frames per second. Super 8mm runs at _____ frames per second, and video runs at _____ frames per second.

CHAPTER EIGHT

COMIC STRIPS

After the firm establishment of the magazine and the newspaper in American culture, the editorial or political cartoon spawned a new baby, the comic strip. While we still have the editorial cartoon, it has never been able to grab the hearts of the world quite like the comic strip. This is probably because the comic strip is meant to entertain with humor, and the editorial cartoon is designed to make you think.

Comic strips, or the "funnies" as they are commonly called, reigned as king of entertainment before the arrival of movies, comic books, radio, or television. They were an important means of mass communication, influencing attitudes, highlighting social problems, and adding words and phrases to our vocabulary.

Today, more than a hundred million Americans happily enter the bordered world of the comic strip on a regular basis. Three-fourths of this number say that they have been faithful followers since their twelfth birthday. Comic characters are among the most recognizable personalities in the world, and products bearing their likenesses make billions of dollars.

A comic strip is simply defined as a picture that communicates an idea or tells a story. Some people use the term "comic strip" when referring to comic books, animation, editorial cartoons, illustration, caricature, and magazine cartoons. In this chapter, I consider the comic strip to mean a series of panels featuring a regular cast of characters communicating through speech balloons that is published in a news-

paper. There are, however, some cartoons that could be considered comic strips that defy this description.

Assignment #1: Comic Strip Artist Profile

Pick a comic strip artist of your choice to research. You can use the *Reader's Guide to Periodicals* in the library to locate articles about comic strip artists. Write a one- to two-page paper on his or her life. Put it in your cartooning notebook.

Assignment #2: Comic Strip Morgue

Pick your favorite comic strip in the newspaper. Photocopy or cut it out for two straight weeks. You should have ten dailies and two Sunday strips (if it is in the Sunday paper) for your morgue. You may continue this for a longer duration if you like. If you're really serious about comic strips, pick several different strips to harvest. Study this sampling to see if the cartoonist varies the gag types and if the strips have any subject continuity.

Glue the strips to typing paper and label the various gag types used.

THE INDUSTRY AND THE CARTOONIST

I meet people all the time who want to write and draw comic strips professionally. The truth is that of all the areas of cartooning explored in this book, the newspaper comic strip is the most difficult field to enter. It is not impossible, but it certainly is not easy. But the daily newspaper isn't the only place where

comic strips can be found; advertising affords numerous avenues for the use of the comic strip to promote a product or industry. Some advertising strips have several connected panels and others are single panel cartoons. High school and college newspapers are also great learning grounds.

Since the daily newspapers are where most strip cartoonists want to end up, I'll explain how that industry works. One of your assignments for this chapter will be to create a comic strip. Let's say that you feel your idea is good enough to be in the big leagues. There are a couple of directions you could go to get your strip published in the newspaper.

First, you could self-publish. You are in complete control of the strip and completely responsible for getting it into the papers, collecting payment from the papers, writing/drawing the strip, and keeping it in the papers. This is like pushing a giant rock up a high mountain. It has been done, but it is the exception to the rule. As long as you are just trying to get your strip into a school or local paper, you can handle it fine—although you might be surprised to learn how difficult it could be to get your local paper to carry your strip.

Secondly, you could use a *syndicate*. A syndicate is a broker or agency representing the cartoonist to newspapers of all sizes. The syndicate is responsible for representing you to the various newspapers and for promoting and distributing your strip. They are the "middlemen" between the cartoonist and the papers or other avenues of merchandising. The newspapers pay from $5 to $200 per feature per week for the territorial rights to run your strip in their paper. That money is generally split fifty/fifty after the syndicate takes out their expenses. The more papers you are in, the more newspapers have to pay to run your strip, and the more likely you will get merchandising deals. Syndication is a good news and bad news business. I'll start with the bad news.

Assignment #3: Syndicate Guidelines

Write a letter to a syndicate asking them to send you their submissions guidelines for newspaper comic strips. Include a self-addressed, stamped envelope (SASE) so they can return it to you with no cost to them. You can get the syndicate's name and address by picking a name from a comic strip in the newspaper. The newspaper will have the address for the syn-

dicate, or your local library will have it in their reference section. You can also look in *Editor and Publisher Magazine* or *Cartoonist Profiles*.

THE BAD NEWS ABOUT SYNDICATION

Every year syndicates receive anywhere from 4,000 to 10,000 comic strip submissions from hopeful cartoonists. Each syndicate accepts between two to eight new strips. About 70 percent of the submissions are quickly rejected. Fifteen percent are asked to rework the strip, and of that number, 5 percent are offered contracts.

Many syndicates find many of their new properties from people who are already doing one strip, but want to start a second or third feature (I hate when they do that). Syndicates also seek out artists who have become well-known through books or magazines. They find other cartoonists by enticing talent away from other syndicates.

There are fewer newspapers today than ever, and those are being threatened with extinction by the speed of the electronic media. Many comic strip sections of the papers are relegated to just one page, and readers are very loyal to the strips that are already in the paper. For you to get in means that some strip has to come out.

Also, your competitors are numerous and their submissions are improving in quality and professionalism.

THE GOOD NEWS ABOUT SYNDICATION

Virtually every syndicate releases new comics each year from unknown talent. There are approximately three hundred syndicates, most releasing about three new strips a year. This calls for a lot of fresh new talent. Even though the submissions are improving, I have read and heard that only about 2 percent of all submissions are any good. Many of the 4,000 to 10,000 annual submissions are comic strips that have been rejected before and have been reworked.

The newspaper may not be able to compete with the late-breaking news of television and radio, but it is not ready to become petrified tabloids either. Every submission gets reviewed. They know that the cartoonist is sending his strip to other syndicates at the

same time. They don't want to miss the next *Peanuts*. Just because one syndicate doesn't like your idea doesn't mean that everybody will feel the same way. Plus, there is no VIP treatment. It doesn't matter who you know, or who you are; only the best comic strips are selected. Syndicates are in this business for profit, not favoritism.

BIG OR LITTLE SYNDICATES

As mentioned above, there are about three hundred syndicates. Some are very large and others are small to medium in size. For more information, see the suggested reading list in the resource appendix at the back of this book.

LARGE SYNDICATES

The good part about a large syndicate is that they have bigger staffs (editorial and sales) and more money to launch your strip. Many of these have a sales force that makes personal calls on newspapers. These syndicates have more experience with negotiating the possible licensing and merchandising agreements for the characters in your strip; and they are probably in a better position to distribute and promote your strip.

The bad part about a larger syndicate is that they receive more submissions than the smaller ones, making an increase in editorial burden. And, the larger the syndicate, the more likely that they already have a comic strip in their stable that is similar to yours. I spoke with a syndicate person about my strip idea and they said they were looking at *three* submissions like mine at that same time. Also, due to launching new strips, older strips may not get the attention they need.

SMALL SYNDICATES

The positive thing about a smaller syndicate is that they may be able to give each submission more personal attention, although the ratio of editors to submissions in large and small syndicates may be the same. Smaller syndicates may be more open to unknown talent, and they may show more patience with a strip that has a slow start. Due to their size, they may not have a strip that is anything like yours.

The biggest negative about a smaller syndicate is that they have a smaller staff. They do a lot of their selling over the phone or through the mail. This means that they may not have as much clout with the newspapers as the bigger guys. Their experience with licensing and merchandising may be limited, and their distribution and promotion may not be as effective.

THREE INGREDIENTS OF A SUCCESSFUL COMIC STRIP CARTOONIST

1) *Talent:* You must be a talented writer and cartoonist. Don't kid yourself—if you can draw, you can learn to write. You may not want to write, but it could double your pay. Remember, you must be your best, because you are competing with the best. If all you can submit is a half-hearted submission, then don't be shocked if you get a whole-hearted rejection.

2) *Determination:* It has been said that the success of a person is measured by what it takes to discourage him or her. When you say, "I can't!" you really mean, "I won't!"

3) *Know-how:* No one ever fails quite like the ignorant. You must study cartooning, cartoonists, and other comic strips, and you must learn how to write as well as draw. To be honest, syndicates are not really looking for young, inexperienced talent. I know that there are exceptions to this statement, but there is a difference between being inexperienced and being unknown. They need someone who has lived awhile, someone who has been inflated and deflated by life more than once. Again, let me encourage you to study the great film comedians like Charlie Chaplin, Buster Keaton, and Red Skelton.

MY PERSONAL COMIC STRIP STORY

Yes, I have created a comic strip, and yes, it has been rejected, and rejected, and rejected, and rejected. My first case of comic strip fever struck while I was in college. The intramural sports department hired me to take over their advertising. I created a character to be used on flyers and brochures. In addition to the flyers, each week I wrote and drew a comic strip for the school paper. The character was named Rah-Rah. It was neither male nor female. We even had a mascot costume made to be worn around campus. The program was very successful for the two

Fig. 8-1 *This is a photo of my costumed character, Rah-Rah, with a bearded me and my oldest son Aaron (age 2). We introduced Rah at a birthday party in his honor. Used by permission of Louisiana State University in Shreveport, Louisiana.*

Fig. 8-2 *A Rah-Rah comic strip that advertised upcoming intramural events in the weekly school newspaper; used by permission of Louisiana State University in Shreveport, Louisiana.*

years I worked on it. I really enjoyed doing that simple comic strip. I liked the fact that I got to create an alternate world where I was writer, producer, director, and actors.

After graduation I did a few comic strips for advertising clients. One night as I was watching television, I saw a Steve Martin comedy skit. He played an anthropologist who had discovered an island near the California coast where a group of hippies lived in seclusion from the outside world. It was a very funny skit that gave me a germ of an idea. It made me wonder what nursing homes will be like in the future when old hippies start to live there. The Big Band era will be replaced with acid rock 'n' roll music. They'll protest by chaining their wheelchairs and walkers to the doors of the administration office. I looked in the local newspaper and didn't see any strips about nursing homes. I did research on the demographics of elderly people and felt confident that I had a great idea. I still feel it is a great idea, but my interests have turned more to books, movies, and television than comic strips. Regardless, my idea is perfect to serve as an example of how to create a comic strip.

COMIC STRIP DEVELOPMENT

How many times have you looked in a newspaper and said that you could draw better than the cartoonist in the paper? Don't feel smug, every artist has said this, including the cartoonist you are currently judging in the paper. In comic strips, *writing* is more important than art. Today, strips are printed too small in the daily papers for much art to exist.

Character is the main ingredient in the successful comic strip. A strip should have *three* to *six* major characters. A single panel concept can have only one or two, or an unlimited number of non-continuing characters. The characters should be fully developed with recognizable personalities. The best humor comes out of true-to-life, open-ended situations with believable characters. Even characters like Garfield or Snoopy are believable because they use thought balloons to speak.

The one thread of advice that I've seen woven through every book or magazine concerning comic strips is: *write what you know!* In choosing your setting and characters for your strip, choose something you already know about or are interested in. I couldn't write a strip about a hardware store because I don't know anything about that business. My personal background afforded me a healthy knowledge about old people.

THE SETTING

Every strip needs a setting or place for the characters to live. Choose your setting wisely, because you may have to live there the rest of your life. The

GOLDENVIEW MANOR-FRONT

Fig. 8-3

best premise or setting is something simple but not single. You need an open-ended situational river for your characters to flow and develop in, not a pool and stagnant situation. I felt that a nursing home could act as a hub for a wheel of activities radiating in and out of the home.

I call my strip *Goldenview Manor*. The title was originally *Havenly Manor*, but everyone read it as *Heavenly Manor*. Goldenview is a better title since the strip is written from the viewpoint of people in their "golden" years.

RESEARCH YOUR IDEA

Once I decided that I thought that the strip idea had promise, I started my research. I contacted people who worked in nursing care facilities. I read articles and books on the demographics of older people. I studied their problems (especially their problems) and their forms of entertainment. I tried to categorize the seniors into different groups so that readers of the strip could see someone they know in at least one or two of my characters. *Never have two characters just alike.* You need characters that will have *conflict*. The more the conflict, the more the potential for humor. There is no comedic value in two people that happily agree with each other.

One major flaw in my concept is the way syndicates view the strips they select for their stable. Demographically, senior adults are already avid newspaper readers. Syndicates are looking for *new* comic strips that will bring *new* readers to the newspapers and away from the television set. Senior adults enjoy comic strips, and it doesn't matter to them that the main character is a wishy-washy kid with a round head. Most syndicates are also negative about new strips that have animals for main characters and about soap-opera-type serials.

CHARACTERS

Now that I had my setting, it was time to fill it up with interesting characters. This required major and minor roles. Take the time to really develop your actors, because they serve as an ongoing source of material for your jokes. You need characters that people can love and other personas that they love to hate. There are three words that rule supreme in story-telling or jokes: *know your characters*.

Major Roles for the Comic Strip
Goldenview Manor

GROVER AND MAXINE FINCH

Fig. 8-4

Grover and Maxine Finch (the married couple)

Grover is a retired corporate executive. He is a caricature of an impersonal, negative, hard-nosed, I'm-always-right CEO (Chief Executive Officer). To him, no one has ever worked as hard as he. All young people are lazy and going to the dogs. He reads the paper or watches TV constantly, and no decisions made by the nursing care administration, or the federal government, or the media are *ever* any good.

Maxine is the villain of the home. She is a snooty, educated, socialite name-dropper. She is sassy, brassy, bossy, and very insecure. She thinks she is the big hen in the pecking order of the other blue-haired chickadees. Even when she is nice she has a sarcastic edge. She thrives on gossip and carbohydrates. She doesn't know how to truly communicate with her husband, her own grown children, her grandchildren, or any of the other residents. Her life is sad and would be worthy of pity if she just knew when to hush her mouth.

PEARL AND ORALLEE

Fig. 8-5

Oral Lee and Pearl (the false teeth)

In talking with nursing care professionals, they all said that an animal would not be a good character for the strip, since pets are not allowed in nursing homes. But false teeth are very common among senior adults, and for some reason, they are a non-offensive, humorous subject. My research revealed some really funny stories about teeth that are always missing, as if they are alive and trying to escape.

Until I started trying to write gags for the teeth I never knew there were so many words that could be used or misused about dental things. They quickly became my personal favorite characters. They afforded me the opportunity to use puns. These two sets of false teeth are hopelessly in love. They leave a lasting *impression* on any conversation they *sink their bicuspids* into. Though they *live glass to mouth*, they still really get around.

Marcus Twine (the storyteller)

I have always enjoyed talking to older people. When I was a little boy, I would wake up early and drink coffee with my mom. Then I'd scoot over to the home of the Christians, a retired pastor and his wife. I'd drink a cup of coffee and visit with them. I finished out my morning rounds of coffee drinking and visiting with the MacNaughtens, another elderly couple. In the afternoons, I'd go see other neighbors like Clevy and Mrs. Pace. I dearly loved those older

MARCUS TWINE

Fig. 8-6

people, and especially enjoyed the stories they told of their lives. I still enjoy a good cup or two or three or four or more of coffee with good conversation.

In some ways I see my dad in Mr. Twine. As long as I can remember, he has always held me spellbound by his ability to tell his life's story. I am grateful that my children have been able to hear his wisdom. Except for World War II, he never traveled very far, but the tales of his life are magic. I feel that I learned to develop stories at the feet of a master.

In honor of these wonderful people I created a great storyteller, Marcus Twine. He obtained widespread acclaim as a humorous novelist and lecturer. He is aggressively pursued by literary, documentary types for interviews. Mr. Twine, a close fictitious cousin to Mark Twain, gives me the opportunity to impart philosophical observations in a humorous manner. He survived seven wives, all of whom he loved passionately.

SKY

Fig. 8-7

THE INTERCOM

Fig. 8-8

Sky (the hippy)

This is the character that started it all. Instead of filling up a home with old hippies, I settled for one rebel-with-a-cause. He, of course, is very different from all the other characters thus far. When Sky was in his fifties he attended the rock music festival, Woodstock. It was a time of great transformation for him as he found his true identity in life. His plain vanilla *chaos* became psychedelic *cosmos*. He is now the oldest living hippy. He never speaks out loud; all his comments are written on protest signs. This character gives me the occasion to make pointed and pointless social commentary.

The Intercom (big brother is watching)

Probably before reading this book you never noticed how often your life is interrupted by a voice from an intercom. In schools, amusement parks, hospitals, airports, bus stations, and even car dealerships, intercoms see all and, sometimes painfully, tell all. This character isn't unique to me. The television show "M*A*S*H" used this faceless force quite effectively.

While this character isn't really a major star in the strip, I knew it would help spice up comedic situations.

Supporting Roles

Every major star needs a subservient character for support. They need a "straight man" to supply the gag, or a "foil" who makes the star's joke backfire. These characters are not used as often as the main troops, but they still need to be as well-defined as the main roles.

MISS TRUDY

Fig. 8-9

Miss Trudy (the widow)

Her main function is to pour icy cold water on the fiery personality of Maxine Finch. Trudy is a gentle soul. She never gets in a tizzy. She patiently listens to the bragging and opinions of Maxine. Her words are few, yet pointed, when Maxine needs reeling in. She would be open to finding another Mr. Right, because she dearly misses her late husband.

Fig. 8-10

MISS FANNIE

Fig. 8-11

Red (the widower)

Life kind of goes on around Red. He is very quiet and slow, so I contrast his character with the hustle and bustle of a shopping mall. Philosophically, he represents the greater expanse of human history, when things changed very little from one generation to the next. The mall stands for the ever-accelerating industrial revolution where *new* is better, or so it boasts. Things don't happen to Red, they happen in his midst. He appears to sleep a lot, making him almost invisible to a world spinning too fast to notice a gentle giant of deep-seated compassion.

Miss Fannie (the spinster)

The truly liberated woman, she is mentally sharp and quick-tempered. Fannie never married. She worked hard all her life. It wasn't that she didn't want to get married or that no one ever asked her, she just never found anyone who measured up to her high standards. Nothing ruffles her feathers like a nurse, doctor, salesperson, or administrator who tries to patronize her.

JOKE BOOKS

Once you have worked out the bugs in your characters, you need a notebook with dividers to record jokes for your creations. Each star needs his or her own dressing room. I like dividers with pockets, so I can drop in ideas that I jot down while I'm away from

my studio. If you know your characters really well, and they are truly designed to conflict with each other, then humor will emerge from their personalities. Write out as much of the joke as will be needed to trigger your memory later.

I suggest you read the chapter on gag writing again to remind you of the eight basic gag types and the seventeen idea starters. You will never reach the point where you won't need to refresh yourself with the basics.

The following are examples of joke ideas I wrote down in my joke books for my characters.

Maxine and Grover: They receive a bumper sticker in the mail from their daughter, whose kids are undisciplined demons. The bumper sticker says, "I (heart symbol) my grandkids!" Maxine muses, "Only distance can make the heart grow fonder!"

Marcus Twine: A reporter asks Marcus if he believes in reincarnation. Marcus wisely puffs his cigar and answers, "Every carnation has but one chance to bloom and to bless."

The False Teeth: Oral Lee is dropped in his water glass sideways. He gurgles, "Was it something I said?"

Miss Fannie, Marcus Twine, and the Chaplain: The three are on the front porch of Goldenview Manor watching a steady rain. Miss Fannie, on the far left of panel, asks the chaplain, "Say, chaplain, can't *you* do something about this rain?" The chaplain, in obvious clergy costume, stands speechless in the middle. Marcus Twine, on the far right of the next panel, says, "Woman, he's in sales, not management!"

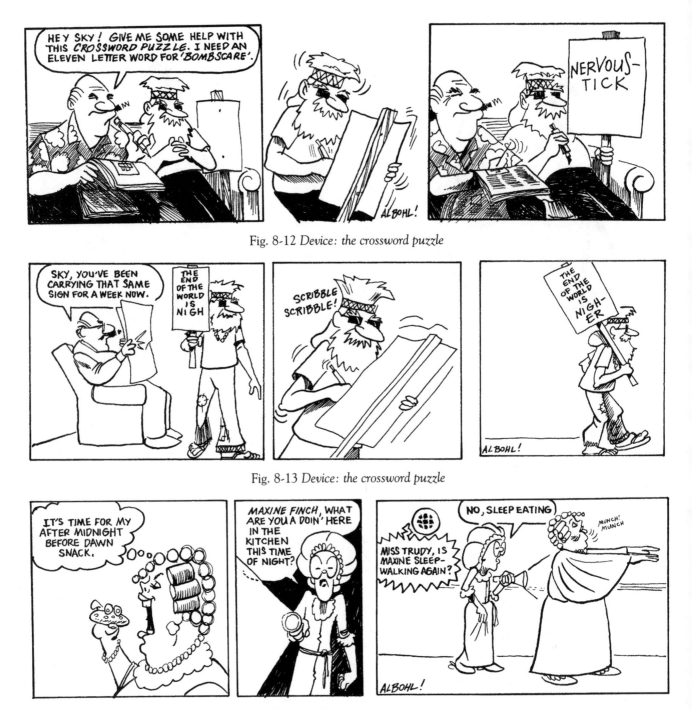

Fig. 8-12 *Device: the crossword puzzle*

Fig. 8-13 *Device: the crossword puzzle*

Fig. 8-14 *Device: Maxine's diet*

DEVICE

The two elements that every successful comic strip has are strong, well-rounded characters and extremely clever devices. A *device* is a situational well where the cartoonist returns over and over to drink. Every cartoonist that lasts very long makes use of the device. The guru of devices is Charles Schulz.

He has repeatedly used at least twelve devices to make *Peanuts* what it is today. Some of these situations are Linus's blanket, Lucy's psychiatry booth, Snoopy's dog house, The Red Baron, kicking the football, baseball games, and the Great Pumpkin.

In my strip I developed several devices that can be revisited again and again.

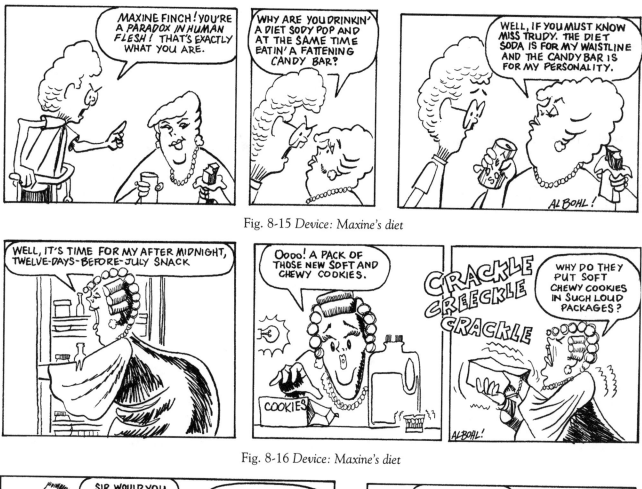

Fig. 8-15 *Device: Maxine's diet*

Fig. 8-16 *Device: Maxine's diet*

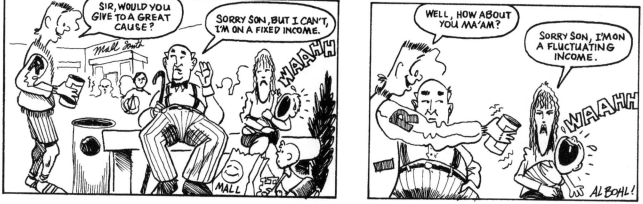

Fig. 8-17 *Device: Red at the mall*

1) The crossword puzzle: Grover likes to do crossword puzzles in the newspaper but they give him trouble. He asks Sky for help. Sky gives the comedic twist as he scribbles an answer on a fresh protest sign.

2) Maxine's diets: Maxine can't stay on a diet because she has always rewarded herself with food. Many funny situations find her standing in front of an open refrigerator snacking in the middle of the night.

3) The mall: This hangout for Red affords a constant source of gags.

4) Grandkids: Many older people think that today's parents aren't hard enough on their children. Naturally, Maxine's grandkids are little devils and Miss Trudy's are perfect angels.

Fig. 8-18 *Device: Grandkids*

Fig. 8-19 *Device: Grown children*

Fig. 8-20 *Device: Philosophy*

5) Philosophy: As I mentioned in the character section, literary, documentary types seek out Marcus Twine to hear his skewed views.

6) The beauty salon: This salon is in the nursing home; it's the perfect place for the spreading of juicy gossip.

7) Three Sunday strip devices (these would rotate):

a) "You know you're getting old when . . ." This is part of the title panel of the Sunday strip. I would encourage readers to submit (giving them credit) funny answers to finish this scenario. People want to feel like they're part of your strip. This device would make a great series of coffee table books.

Fig. 8-21 *Device: Philosophy*

Fig. 8-22 *Device: Beauty salon*

Fig. 8-23 *Device: Aging*

b) "Happy Birthday!" The title panel would wish birthday greetings to readers who are now over a hundred years old. This would also be sent in by readers or relatives. I would do a caricature of the recipient from a submitted photo.

c) "Did you know?" This would use the title panel to spotlight a senior adult who made an accomplishment after reaching retirement age. An example would be Colonel Sanders, who founded the Kentucky Fried Chicken restaurants after the age of sixty-five.

8) The television: This is another way to poke good-natured fun at a source of modern entertainment and irritation. Grover is so addicted to

Comic Strips

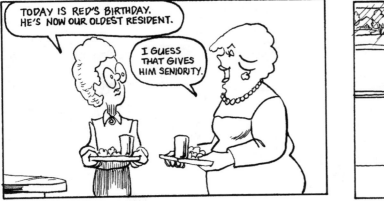

Fig. 8-24 *Device: Aging*

Fig. 8-25 *Device: Big government*

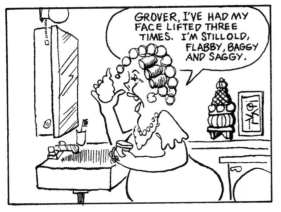
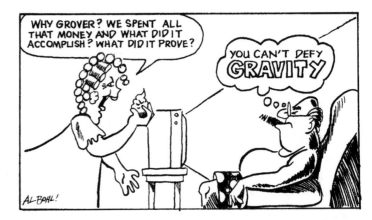

Fig. 8-26 *Device: Aging*

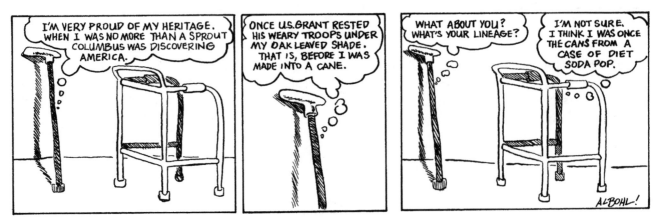

Fig. 8-27 *Device: Objects*

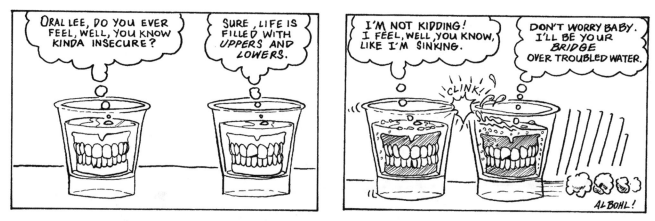

Fig. 8-28 Device: *Teeth puns*

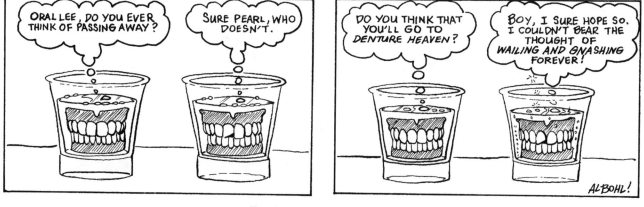

Fig. 8-29 Device: *Teeth puns*

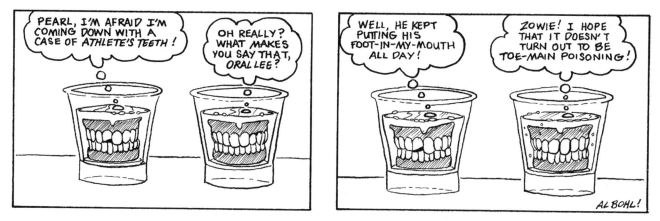

Fig. 8-30 Device: *Teeth puns*

TV that he feels that they can hear him when he tries to tell them his opinion. This device exposes the reality that television and life can be an illusion.

9) Illnesses and cures: Sickness, real or imagined, poses inner conflict that is ripe for the picking of joke material. Old-fashioned cures also make for great gags.

TOPIC IDEAS FOR GAGS

I unearthed all kinds of topics that would work great for jokes within the realm of my characters and devices. Here is a list of a few: holidays, Social Security, hearing, seeing, digestion, hair color, music, the news media, talk radio, sports, TV commercials, travel, memories, weather, the Great Depression, home remedies, wives' tales, politics,

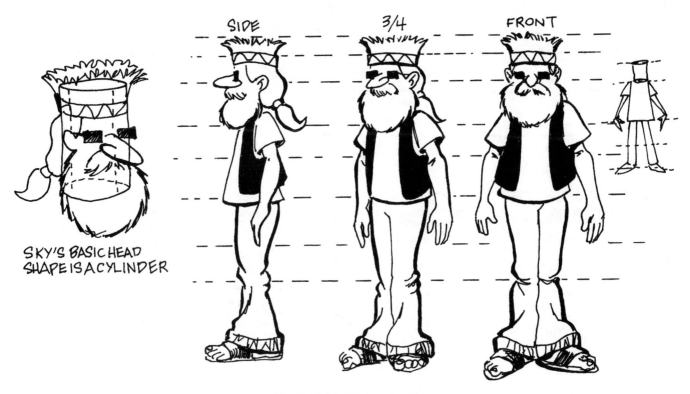

SIDE 3/4 FRONT

SKY'S BASIC HEAD
SHAPE IS A CYLINDER

Fig. 8-31 *Model sheet for Sky*

room temperature, movies, gossip, medicine, and exercise.

DESIGNING YOUR CHARACTERS

Take a moment and look at the characters I designed for *Goldenview Manor*. Except for the teeth, they are all old, but they are not alike. Give your strip an overall artistic style, but give all your characters diverse, contrasting looks. In the future, when the strip's readers would be introduced to the grown children and grandchildren of the Finches, they would see a resemblance. Their son would look like a young Grover, and their daughter, bless her heart, like Maxine. Think of the TV show "The Simpsons." They all look different and yet alike.

Draw your characters over and over again. Sketch them from every angle in the front, ³⁄₄, side, rear ³⁄₄, and rear views. This will help define the anatomy and basic look of each individual. At first your characters will probably appear very detailed. As you draw, try to simplify the character to as few lines as possible.

GOLDEN NUGGET: Ornate art can kill a good idea, and it cannot improve a weak one.

Drape your characters in clothes that reinforce their personality. Maxine has her beads and earrings; Marcus has his cigar, white suit, and necktie; and Sky has his bell-bottom jeans, head band, beard, shade glasses, and vest.

Give them props that can build and release their personalities. Grover has his TV and newspaper, the teeth have their glasses of water, Sky has his protest signs, and Red has his oak cane.

COMIC STRIP TOOLS AND MATERIALS

In the fundamental drawing chapter, I gave you some suggestions on materials to use in drawing. Let's go over them again and see how they fit into this type of cartooning. I have added a few more items.

PAPER

You can sketch on any paper you like. When I am creating a character, I draw on a big tablet (18" x 24") so I can draw the image, move over, and draw it again and again, making changes each time. For working out scenes, I work on regular size and weight typing paper. The actual paper for the finished comic strip is on 2-ply plate Bristol board. Plate is the smooth surface and can be purchased in larger sheets. If you are going to use a light table or box to transfer your rough sketches to the final art board, you may want to use a 1-ply Bristol board. The board is cut into strips measuring 14" x 5". The inked border around the art is 13" x 4". The finished comic strip will be reduced 50 percent for publishing.

PENCIL

I use an HB pencil lead in a 0.5mm mechanical pencil. I detest having to sharpen pencils, and normal pencils don't work as well for lettering.

Some cartoonists don't like to erase. They draw with a non-reproducing blue pencil. This blue pen or pencil doesn't photograph when the strip is made ready for reproduction. I have had trouble when I tried to combine the use of blue pencil for art and HB pencil for lettering. The HB and the blue pencils smeared when I tried to erase the normal pencil lead.

INK

For inking the artwork, I use Higgins Black Magic India Ink. I don't use Black Magic ink for lettering because it has a problem with clogging in rapidograph (reservoir) pens. I use Universal 3080 Koh-i-noor Rapidograph ink. However, just about any permanent black ink should work.

PENS

For art I use a number 22 B Hunt pen nib and a coquille pen nib in a pen holder. With practice, you can get a good thin-to-thick line with a lot of personality. Remember, I said with "practice." You can't push a dip pen, you must drag it.

For lettering, I use a Rapidograph technical pen with number 2, 3, or 4 points. The 3 and 4 points are for the sound effect words. Some letterists use a Speedball B-5 or B-6 dip pen for lettering. This is too slow and inconsistent for me. Before long, computers will probably take over the lettering chores completely.

The panel's borders are done using a Rapidograph pen with a number 3 point. Due to the fact that the strip is reduced, a number 1 pen point doesn't print well; it breaks up the lines and drops out.

BRUSHES

I use a number 2 or 3 Windsor Newton or Raphael brush for inking. Always be careful to wash the brush after each use with soap and warm water. Ink will ruin a brush in short order if it isn't cleaned properly.

LETTERING EQUIPMENT

To make lettering more readable, an Ames Guide is used to draw *lines* to write your letters and *gutters* to separate the rows of words. A *T-square* and a straight-edged board or table top are needed to use with the Ames Guide. Never have your lettering come within an eighth of an inch of any border on the top, bottom, or sides of the panels. A safe number to set your guide dial is *4* for comic strip work.

As a time saver, some comic strip artists make up a permanent guide of inked lines and gutters that they put under their 1-ply art board. They lay these on a light table so the permanent guide can be easily seen through the 1-ply art board, and then do their lettering without having to draw the lines for lettering.

TRANSFERRING EQUIPMENT

Many cartoonists prefer to draw their rough drawings on a separate sheet of paper and then transfer it to a final art board. Transferring can be done in several different ways:

1) You can use a window in your home. Tape your rough sketch to the glass. Next, tape your 1-ply Bristol art board over the rough. The light from the sun will serve to make it easier to see through the layers of boards. Redraw with pencil and ink.

2) You can make or purchase a light board (*see* Fig. 8-37). This will make it easier since it is tiring to stand by a window and draw.

3) You can purchase a type of opaque projector that stands on or is attached to a table. The Art-o-graph is the most commonly known projector used by artists. This is on the expensive side. I have one in my studio which I use on a *daily* basis. The greatest

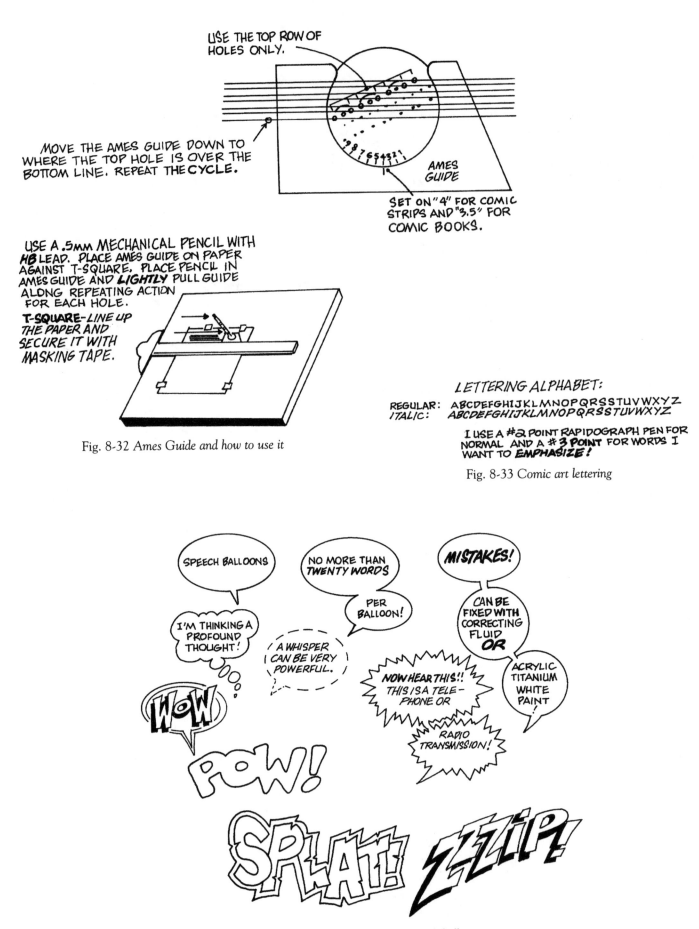

USE THE TOP ROW OF HOLES ONLY.

MOVE THE AMES GUIDE DOWN TO WHERE THE TOP HOLE IS OVER THE BOTTOM LINE. REPEAT THE CYCLE.

9 9 8 7 6 5 4 3 2 1

AMES GUIDE

SET ON "4" FOR COMIC STRIPS AND "3.5" FOR COMIC BOOKS.

USE A .5MM MECHANICAL PENCIL WITH *HB* LEAD. PLACE AMES GUIDE ON PAPER AGAINST T-SQUARE. PLACE PENCIL IN AMES GUIDE AND *LIGHTLY* PULL GUIDE ALONG REPEATING ACTION FOR EACH HOLE.

T-SQUARE - *LINE UP THE PAPER AND SECURE IT WITH MASKING TAPE.*

Fig. 8-32 Ames Guide and how to use it

LETTERING ALPHABET:

REGULAR: ABCDEFGHIJKLMNOPQRSSTUVWXYZ
ITALIC: ABCDEFGHIJKLMNOPQRSSTUVWXYZ

I USE A #2 POINT RAPIDOGRAPH PEN FOR NORMAL AND A #3 POINT FOR WORDS I WANT TO *EMPHASIZE*!

Fig. 8-33 Comic art lettering

SPEECH BALLOONS

NO MORE THAN TWENTY WORDS

PER BALLOON!

MISTAKES!

CAN BE FIXED WITH CORRECTING FLUID OR

I'M THINKING A PROFOUND THOUGHT!

A WHISPER CAN BE VERY POWERFUL.

NOW HEAR THIS!! THIS IS A TELEPHONE OR

ACRYLIC TITANIUM WHITE PAINT

RADIO TRANSMISSION!

WOW

POW!

SPLAT!

ZZZIP!

Fig. 8-34 Display lettering and speech balloons

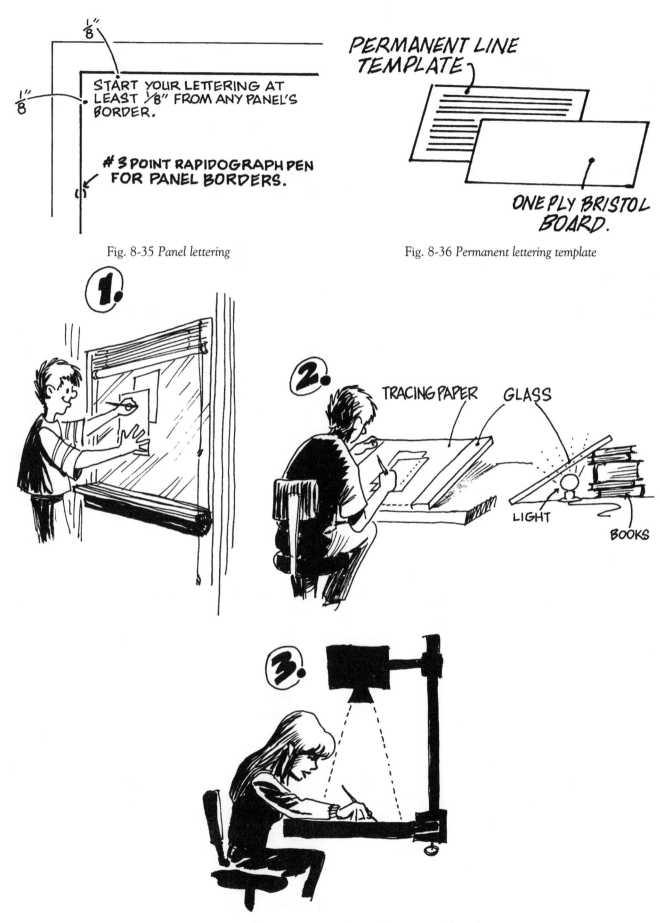

Fig. 8-35 Panel lettering

Fig. 8-36 Permanent lettering template

Fig. 8-37 Three ways to transfer rough art to finish board

advantage of the projector is that you can enlarge or reduce your drawings. You can draw your roughs any size you wish, and then compose your panels on the art board.

PENCILING AND INKING THE STRIP

Step one:

Work out a quick sketch of the cartoon on scratch paper. Decide how many panels it will take to get the gag across. Three panels are pretty common since most gags have a beginning, middle, and end, and although gags can be done in one or two panels with just as much set up and punch. Be sure to remember to leave room for the words. Since the words are so important, they should even be taken into consideration when designing the strip. All through the process, hold the strip up to a mirror or at least look at it upside down. Looking at it from a different perspective will show any glaring problems.

Step two:

Draw or transfer the art onto the board. Using an Ames Guide, make your lines and gutters for the words to be lettered. Lettering can be done without the Ames Guide, but it is the only way to have uniformly written letters. Once your strip is lettered, then ink your lettering and the border around your panels. Use at least a number 3 point on a Rapidograph pen to ink your borders. You can use a ruler or anything straight that has a raised edge. This will keep the ink from spreading out under the ruler and messing up your art. You don't have to use a hard-edged line around your panels, but you must be careful not to do too much that can take away from or dilute the joke.

Step three:

Now, using a pen, ink over the art within the panels. As I mentioned earlier, I like to use a number 22 B Hunt nib for inking because it can vary the thickness of the lines in the art. A technical pen has little, if any, personality of line. Lines around the character are thicker than lines within the characters. Ink the character and props before inking any background or settings. For the most part, the background is not as important as the joke or the characters delivering it. Backgrounds are like the old adage

about children: they should be seen but not heard. Avoid having any background elements touch your characters. Anything that touches in a cartoon is considered to be on the same dimensional plane.

Any solid black areas should be done after the strip has been inked, because dark areas attract the eye of the reader to the joke. By putting them in the wrong places, you dilute the impact of the joke. Little is much when inking.

Step four:

Sign your name. In recent years it has become fashionable for some cartoonists to sign their names where no one can read it. This is really on the dumb side. Attaching your name to your art is your best advertisement. Practice signing your name. I've looked at a lot of Norman Rockwell's initial sketches for his world-famous paintings. Even when he first started to rough out an idea, he was strategically placing his name on the scratch paper. I was amazed to see that he saw the placement of his name to be just as important as any other element of the painting.

Assignment #4: Create a Comic Strip

Well, the moment of truth has arrived. It is time to create your own comic strip. Don't get nervous, just have fun with it. Restudy each section of this chapter as it applies to each step. Here are the steps to follow in order to fulfill this assignment:

1) *Setting:* Decide on a setting. Keep it simple. My setting was in a nursing home because that is where my characters lived. For your purposes here, the setting could be simply outdoors or indoors.

2) *Characters:* Create at least two or three characters. Write out a brief character synopsis on each character. Make a model sheet showing each character in different poses and views. If you can't come up with a character, you can use an ink pad to make characters out of your thumb and fingerprints. Just add some arms, legs, and a few distinguishing clothes and props.

3) *Devices:* Create at least two recurring plot devices for your characters. Ideas for these should come out of your character synopsis.

4) *Jokes:* Write out at least enough jokes to produce five daily comic strips. If you can't easily generate any jokes, refer back to the chapter on humor

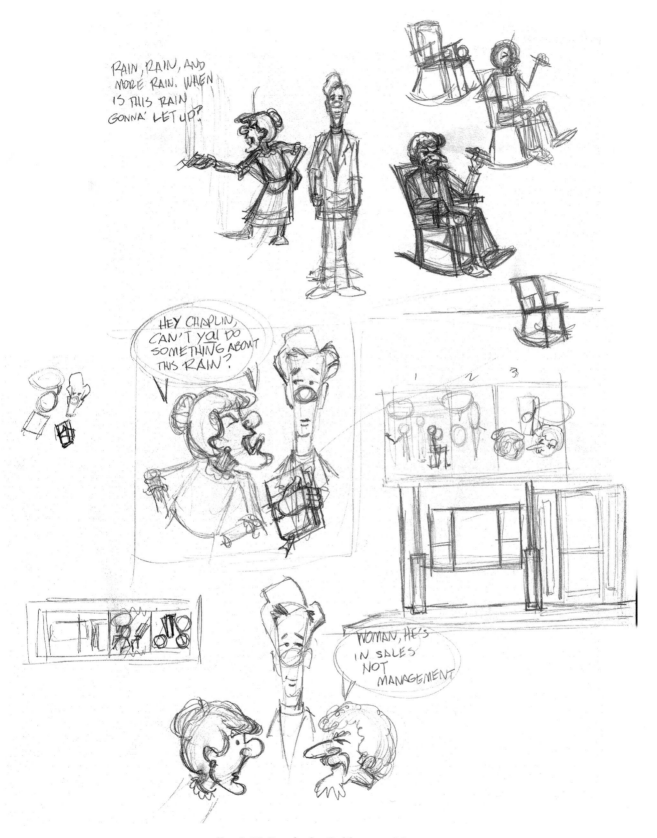

Fig. 8-38 *Roughs for* Goldenview Manor

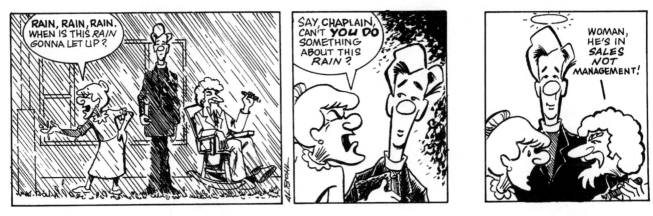

Fig. 8-39 *Finished strip*

writing. The eight types of gags and the seventeen idea starters should help give you five good ideas for jokes. Bounce your jokes off a few friends and relatives. They may help you refine the gag.

5) *Draw the strip:* Pencil, letter, and ink the five strips. Place them in your cartooning notebook.

Review Questions

1. What is the main difference between comic strip cartoons and editorial cartoons?

2. A comic strip is simply defined as: _____ _____.

3. What is a newspaper syndicate?

4. What are the three main ingredients necessary to be a comic strip cartoonist?

5. True or false: in comic strips the art is more important than writing.

6. The two most important parts of a successful comic strip are _____ and _____ _____.

7. What are three ways to transfer a rough cartoon sketch to an art board?

8. What is an Ames Guide, and how is it used?

CHAPTER NINE

COMIC BOOKS

Finally, we come to the infant of the cartooning industry, the comic book. Whenever I have spoken to any group about the subject of cartooning, I always, without exception, have someone ask me how they can get into the comic book business. I suppose this is because of the comic book's popularity. It is also the one area of cartooning where anyone who has the money can self-publish and possibly get his book distributed nationally. One little guy from Nowheresville can potentially have his comic book in the same rack as the big publishers.

Comic books are, for the most part, illustrated stories told through sequential panels with just enough art and words to convey a full message. In many ways, comic books are very close to motion pictures. They both tell a story by shaving it down to its barest minimum requirements. I retold and illustrated the classic book *The Pilgrim's Progress*. My mammoth task was to translate an old book that was hundreds of pages long and written in old English down to thirty-two color comic book pages. I had to modernize the language without losing the feel of the period. Spatial constraints made me eliminate characters and story elements in order to give an overall representation of the author's intent. Movies can tell a little more of the story because a movie moves at twenty-four frames or panels per second. A comic book reader has to fill in the story that occurs between panels on a page.

Comics have their largest appeal to young people ages six through seventeen, but there is also a collec-

tor's market that knows no age boundaries. Almost half the households in America with children ages six through seventeen buy comic books. Parents generally buy children their first comics, and boys are bigger comic fans than girls.

Comic books are now popular all over the world. The books are geared toward ages eight to twelve in Great Britain. In France, Belgium, and Italy, versions are somewhat pornographic in content. The biggest selling books in Germany feature the Walt Disney characters. The Chinese prefer books filled with martial arts, and some interest is evident there for romance, sports, science fiction, superheroes, and horror stories.

THE INDUSTRY AND THE CARTOONIST

This industry has always had a shaky foundation. It was established as an afterthought to find a means of making a little more profit from used comic strips. A roller coaster ride is the best parallel I can think of to describe it, because the rules were made up as they went along. Like movies and music, comic books are artistic slaves to the fickle tastes of the ever-changing public. We live in a fast-paced, disposable society where the "new and improved" quickly gives way to the "latest and greatest."

LEVEL OF ENTRY

The most difficult aspect of joining the ranks of the professional is the level of talent necessary for

entry. There are a number of very famous *older* comic book creators who would be laughed out of most editors' offices today. They simply cannot draw as well as a Jack Kirby, Joe Kubert, Wil Eisner, or Rich Buckler. I know there are a lot more good comic book artists, but these are a few of my personal favorites. I know you hear about cartoonists who are very popular at the moment. Sometimes their testimonials are that they always loved comics, and one day decided to try drawing. Then poof, suddenly they became pros overnight. Take it from me, there are no shortcuts to true lasting success. This chapter will teach you the philosophy and practical methods of sequential storytelling, but only practice, education, and the will to succeed can get you through. Every pro I know encourages young people to study more art forms than just comics. As I mentioned in this book's first chapter, you need to get a solid education. There are many excellent art institutes and technical schools around the world. There are great universities that afford you the opportunity to learn grammar, literature, foreign languages, history, and, of course, art. Do whatever it takes to be the best you can, because you will be competing with the best.

SELF-PUBLISHING

There are two ways to have your work published. The first way is self-publishing. This method is sometimes called "table top" or "coffee table" publishing. If you have the money, you can produce and print your own book. I know two young men who in their late teens put out their own comic book. And the famous Teenage Mutant Ninja Turtles were created and published by two regular (talented) guys. What makes this type of comic book publishing different from regular books is the unique way in which they can be distributed, which will be discussed later in this section. The major rewards of self-publishing are that you completely control your book and receive all the profits. The down side poses some big problems, such as the following.

You have to wear many hats. You are publisher, publicist, writer, artist, editor, printing negotiator, sales force, and shipper. Partnerships do work, but not very often—it is sometimes difficult to determine who works the hardest or makes the most contributions. You have to be very careful to figure all your costs for artwork, printing, publicity, advertising,

shipping, storage, and distribution. You have to juggle the price of your book between what the public will pay for it and what your many costs are.

Always do as much research as you can, and get as many price bids as you can before committing to anyone. Provide printers with what is called a "spec" sheet. This describes every detail of your book so they can bid what it will cost to have your book printed. You have to be *very* careful, because printers will try to alter your specs to give them an advantage that generally ends up costing you more. An example of a spec sheet is included in the resource appendix.

The second negative about self-publishing is that you compete with the big publishers who have a lot more money than you to print a higher grade of book and promote it more thoroughly. They release a flood of books, while your entire income rests on the shoulders of one title.

ESTABLISHED PUBLISHERS

The other way of getting published is to take your work and/or idea to an already established publisher. You can find a publisher's address by looking at the *indicia* (pronounced in-dee'-shah) in the front of your favorite comic book. Generally, there is a little section of fine print that gives all the publishing information under the first page of art or on the inside front cover. You can obtain a little more information by consulting the current issue of the *Artist's and Graphic Designer's Market*.

Write to them and ask for their submission guidelines. This is important because I once heard about a publisher that was looking for artists. I called them and learned that I shouldn't draw their characters without having first signed a release form from their office. My hard work of preparing a portfolio for them would have been rejected if I hadn't known that.

You can meet publishers and editors at comic book conventions. There may not be a larger "con" in your town, but there probably is one in your region during the year. The larger conventions last a week or a weekend, and have helpful panel discussions and seminars on how to break into the business. They also have portfolio reviews, and professional cartoonists attend. Some of these people are not very friendly, but most remember what it was like trying

to get started. Don't feel that you will be out of place carrying your work around. You will see a lot of people doing the same.

GOLDEN NUGGET: If anyone should ever give you a compliment, accept it graciously. Don't try to talk them out of it or deflect it. I always accept their comment, and reply that they are very thoughtful to have said something so kind. Your thoughtfulness returns their compliment to them, as it should.

DISTRIBUTION

Oddly enough, the difficult part about publishing a comic book isn't really becoming or finding a publisher, it is distribution. You, yes you, can own your very own publishing company, *but* being a publisher means nothing if you can't get your books to the public. There are two ways to distribute comic books. One is known as *newsstand distribution*, and the other is called *direct market distribution*. Newsstand distributors sell all kinds of books and magazines to retail outlets (bookstores, grocery stores, and newsstands) on the basis that whatever doesn't sell can be returned for credit. Sometimes up to half of a print run will be returned unsold. This type of distributor takes a smaller percentage of the cover price to sell your books, but the publishers take a big risk because they never know how many books to print. One landslide of returned books could (and has) wiped out entire companies.

The other kind of company is direct market distribution. Comic book specialty shops came into being in the mid-1970s. This, combined with the collectibility of older (back issue) books, gave rise to a non-returnable system. For a bigger slice of the pie (60 to 70 percent—meaning you sell your comic book at a 60 to 70 percent discount), the direct distributor will notify all the comic shops in the U.S. about your book. The shops will place orders through the distributor's catalogs, which are sent out two to three months in advance of the book's release. They buy the books at a 45 to 50 percent discount from the distributor, who tells the publisher how many books it has orders for. Books are paid for on delivery.

The reason this works so well for self-publishers is that you know how many books you have sold before you go to press. You should always print 10 to 15 percent more to satisfy back issue orders. If you don't get enough orders to assure you of a profit, you can cancel the title. You can ask a comic specialty shop near you how to reach these distributors.

HOW TO CREATE COMIC BOOKS

When I first decided that I wanted to illustrate comic books, I thought that there must be some magical formula or mystery behind it all. I read everything I could get my hands on. There were many tricks of the trade, but I found that comic book art is not as deep or mystical as some might try to present. Nevertheless, it is a difficult medium that requires a lot of commitment to learn.

We will now go through the production of a comic book, one step at a time. I will describe the team and then go over their job assignments. Most

Ill. 9-1 *One of my first comic book efforts at the age of 12 or 14 years old*

comic books are produced with the combined efforts of a number of people. The reason for this is that generally, books are released on a monthly basis. I have done entire books by myself, and thirty-two pages of story writing, penciling, inking, lettering, and color indicating takes me about two and a half months of hard work. It is also difficult for one person to be proficient in every area of production. Many books are done in studios, or "bullpens," as they are sometimes called. Other books are shipped all over the country to be handled by experts of different talents. No matter what the area, it takes lots of practice to become really good. The creative team most often consists of:

1. *Editor:* An editor pulls together his creative team and has input into every phase of the process.

2. *Writer:* The writer develops a plot or a basic outline of the story. I've had plots that are one to ten pages in length. The writer is also the one who does the script. The script is a full description of all the action and the dialogue.

3. *Penciler:* This person or persons works out the layout of the book page by page, and draws the story in pencil.

4. *Letterer:* Once the book is penciled and the dialogue is sharpened, the letterer writes the words in the panels and then goes over the words in ink. The letterer also inks the panels' borders.

5. *Inker:* This artist doesn't trace over the penciler's work. He redraws it, considering the pencils as a finished guide. Using pen nibs and brushes, the inker finishes the black and white version of the book. If any Benday or Zipatone graduated dot screens are needed, the inker will handle them also.

6. *Colorist:* The colorist is given photocopies of the original artwork and a color guide by the publisher's printer or color separator. The colorist will then color the photocopied pages and indicate the proper colors for the separator to use in order to print the book.

 GOLDEN NUGGET: There have been many artists who have broken into the business as a letterer or colorist. Once they became known and trusted, they were given opportunities to prove themselves as writers, pencilers, or inkers.

THE EDITOR

For the purpose of this course, your instructor and classmates—or your friends—will assist you in the editing of your work. It doesn't matter what kind of cartooning you might do professionally, you will have to deal with editors. I have been very fortunate through the years to have gotten good editorial support. A good editor can spot glaring problems in the story, the art, or the grammar, and keep you on a timeline.

If you aren't willing to work under the restrictions of a deadline, then professional cartooning isn't for you. Artists sometimes have been made to feel that meeting the deadline is almost more important than their artwork. This is not really true. If possible, make your deadline agreement up front and try to add a little extra time, because it will always take you longer than you think. I've had editors call me with an assignment that had an unbelievably short deadline, and I had to do what it took to make it happen. It is part of a good editor's job to clip the wings of a free-spirited artist. They are *not* your enemy.

THE WRITER

In the comic strips chapter of this book, we learned that writing is more important than art. This is not exactly the case in comic books; here, the art is equal to the writing. The best stories are mostly told through art, with dialogue used to fill in what the art can't say.

The writer has to start with a story. The two most important elements of a story are the *characters* and the *ending*. If you are chosen to write a story for an established character, it is important to know that character and storyline thoroughly. Most publishers want their characters to act and look the same no matter who works on them. For our purposes, we will deal with new characters. You can chose to use the characters that I created for this book or make up your own.

THE CHARACTERS

Strong, believable characters are an absolute must for the success of a story. The first story of Superman was sandwiched between other stories in a comic book. The book sold like hot cakes, leaving the publishers scratching their heads and wondering why the book did so well. A quick investigation told

them that kids loved Superman—it was the character they bought. However, a strong character will not carry a book series very long if the stories aren't conceived and written well.

Take the time to develop your main characters. Write a description of your good guys and bad guys. A hero is nothing without a worthy villain. The world or environment where your characters live is also to be considered a story character. The storyline for my superhero character Zaanan has a full, rich *backstory*. Backstory is a history of your characters and their environment. I've worked on Zaanan for years, so I have an in-depth description of the Viral Wars, the religion of the Eternals, the origin of the Sphere computer, a written manifesto of the Sphere society, the Fatal Limit, and even how citizens are born and die.

There are several things to consider when creating a character. It needs a good name that people will remember and like. I had the character of Zaanan long before I had the name. I generated a list of nearly a hundred name ideas before finding the name Zaanan in Micah 1:11 of the Old Testament. I knew in an instant that Zaanan was the word that best described my creation. It had a kinetic action feel that reminded me of other hero names like Tarzan, Shazam, Zorro, or Conan. In the case of the old

prospector character, I tried the names Pappy B. Miner, Daddy B. Miner, Prospector Pete, Pappy Prospector, Ole Pap, and more.

Next, look at some realistic elements of the occupation of your character; this may give you some ideas to help shape his personality. Here's what I mean:

• A real prospector looks for gold, silver, or diamonds in the mountains.

• He stakes claims.

• He works with a pick, shovel, and wash pan.

• He's a dreamer and not too smart, or he wouldn't be out searching for precious stones.

• He is at the mercy of good and bad weather.

• He is probably a collector of anything he feels might be useful.

Considering these potential traits of an average prospector aided me in developing this character. At first your descriptions may be only a few sentences. As you are fleshing out a word description of your character, work up a few model sheets of how your character will look. Here are my character synopses and model sheets for characters I created for this book:

Pappy B. Miner, the prospector: Ole Pappy decided to go West and strike it rich a year or two too late after the gold rush of 1849. Timing and good

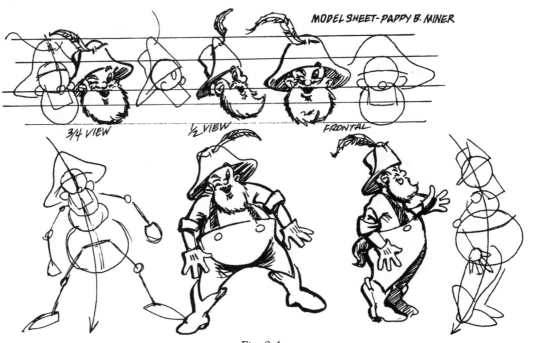

Fig. 9-1

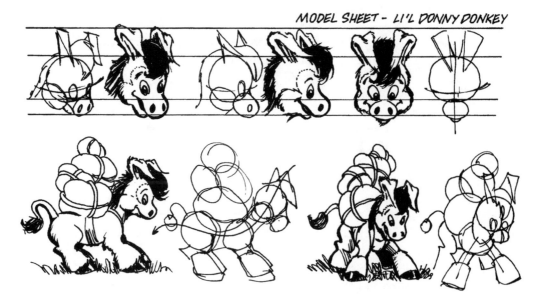

Fig. 9-2

MODEL SHEET BUSH WHACKER BOB

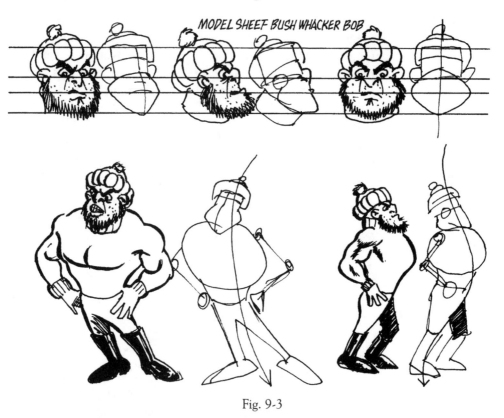

Fig. 9-3

fortune have never smiled on our hero. His heart is bigger than his brain. Pappy is a kindly soul, but has an explosive temper. He lives in the mountains in search of a mountain of golden wealth with his little burro named Li'l Donny Donkey. He collects things he finds, which he eventually adds to the big pile in Donny's backpack.

Li'l Donny Donkey: He may be small but he makes up for it in brains. Donny is saddled with a really big backpack that holds nearly everything possible in the world. As Donny walks, things are forever falling out of the pack. Donny doesn't speak, so all his communication is done through mime or thought balloons.

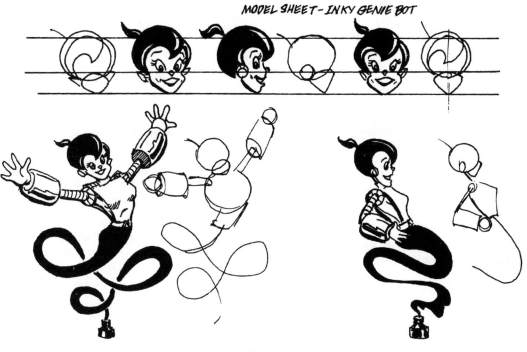

MODEL SHEET - INKY GENIE BOT

Fig. 9-4

Bush Whacker Bob: He is the villain of the story. He is forever trying to steal anything Pappy digs up. He cheats at everything he does. He is never happy except when he can make Pappy's life a little more miserable.

Inky-Genie-Bot: Inky lives in an artist's ink bottle from the future. She arrived in the mountains when the space ship owned by her master bounced back in time to 1849. Someone found her bottle and took it to his cabin in the mountains without opening it. She is part robot and part genie. She grants three wishes.

THE PLOT

Now that we have our characters, we need a story for them to act out. *High concept* stories make the best movies and comics. That is where you boil the entire story into a one-sentence statement like you see in the descriptions for movies in the television section of a newspaper. The story I will illustrate for you in this chapter is called *The Wishy Washout.* The high concept statement for the story is: A starving old prospector unknowingly releases a magical genie and wastes his three wishes. That is the story in a nutshell. From that sentence I could write a one-

page comic book or maybe an entire novel.

Earlier I stated that the most important things in a story were the characters and the ending. If you are going on a vacation, you must have a destination and a plan to get you there. You will never have a good story until *you know your ending.* My personal style of writing is to start at the back and then cover my tracks. I figure out how I want the story to end and then I create an exciting plan to get my characters and the reader to that goal.

Once I have my high concept statement and ending nailed down, I write out my plot. It is important that you consider the length of your story when considering your plot. At first, try to create stories that can be easily told in a few pages. The story I have provided here was written to be executed in four pages. The plot is like a person's skeleton: it is just the bones with no flesh and muscles attached. Write your plot in a page or two.

A story needs to be told with a single *point of view* (POV). Generally, this is the hero's viewpoint because that is who the reader should sympathize with. Here is my plot for the story *The Wishy Washout,* which is told from the viewpoint of Pappy B. Miner.

The Wishy Washout

Way out West an old miner named Pappy B. Miner and his faithful burro named Li'l Donny Donkey were out looking for a mountain of gold. Pappy was never on the side of good fortune, and as his luck would have it, a terrible snow storm forced them to hunt for shelter. They fought the blinding blizzard a half-step at a time until they found an old abandoned shack.

Inside, Ole Pappy searched for some food but found none. He realized that he wouldn't survive the storm. He lit a candle and found an inkwell and a feather pen. He decided that he would write a note to the next person who found the cabin to explain his life and death. He opened the inkwell and a wind blew out his candle. He grudgingly relit the candle, but was unaware that a genie had come out of the inkwell and was floating above his head. Li'l Donny saw the genie but couldn't tell Ole Pappy.

Pappy began to write, saying his words out loud. He mused to himself that he wished he had a Thanksgiving meal with all the trimmings. The genie joyously granted his wish in a flash. Pappy couldn't believe his eyes, and hungrily began to devour the feast. He told Li'l Donny that he wished that his archenemy Bush Whacker Bob could have been with him at that very moment, because he would have been green with envy. Suddenly, Bob appeared, and to Pappy's dismay started to consume Pappy's dinner. Pappy was now miserable, and wished that none of this had ever happened. The genie granted his third wish, and as quickly as it all arrived, it left.

Inky-Genie-Bot shocked Pappy as she spoke for the first time. She said that she hoped he had enjoyed his three wishes, and thanked him for setting her free. She picked up her inkwell and flew away. Pappy sat frozen for a little while and then asked Donny how he was supposed to leave a farewell note without any ink. He packed Donny up and headed back down the mountain, saying that if he couldn't leave a note then he refused to die.

The End

A good story has a beginning, middle, and an end. The beginning of a story is separated from the middle by a change in story direction. The motion picture industry calls these *plot points*. The middle is separated from the end by another spin or turn in direction. The plot points for the story *The Wishy Washout* are:

The beginning: A snow storm forces Pappy indoors. He finds no food and decides to leave a farewell note before starving to death.

The middle: The story takes a new direction when the genie appears. Pappy unwittingly wastes his three wishes.

The end: The final spin is when the genie identifies herself, takes her inkwell, and departs. Pappy leaves too.

Each story is made of numerous little stories, or scenes. Each scene has a beginning, middle, and end. In a story like *The Wishy Washout*, I didn't have time for subplots. A *subplot* is a smaller story within a story that ultimately intersects with and serves to deepen the bigger story. The introduction of Bush Whacker Bob could have added a subplot if I had more room in the story. I hinted in the plot that there was more to Bob when he "puffed" in from a card game. A subplot could have been that he was about to be killed for cheating when he was brought into my story.

If you are going to take writing seriously, I suggest that you study books on writing screenplays for motion pictures. One of the best books I know of is called *Screenplay* by Syd Field, published by Dell.

EXTENDED PLOT AND PAGE BREAKDOWN

Once you and your editor are satisfied with the basic story, then you write a more extended plot. Stories are generally told in multiples of four pages. This means that your story can be four pages long, or eight, twelve, sixteen, etc. I feel that *The Wishy Washout* can be told in four pages. The extended plot will have descriptions that will help the artist know what characters and props are necessary. Once the extended version is done, decide how much of the story must be illustrated on each page. The following is my extended plot and page breakdown.

The Wishy Washout

Page 1: Pappy B. Miner and his donkey are fighting an uphill battle against a terrible snowy blizzard. The wind whips at their possessions. All kinds of

things are falling out of the donkey's oversized backpack. We see a computer monitor, birthday present, bird in a wire cage, etc. In the distance they see an old abandoned cabin. We see the blizzard pulling at the small log cabin's roof and forcing it to lean. Once inside we see that it is filled with dust and spiderwebs. Pappy looks for food and drink but finds nothing. He realizes that he and the donkey will not be able to survive.

Page 2: He picks up a piece of paper and blows the dust off the paper, making a huge mess. Pappy and the donkey sneeze. He sits at a small wooden table and lights a candle with a match. He opens an inkwell bottle and a wind from the inkwell blows out the candle. He lights the candle with a match again, but this time Inky-Genie-Bot is floating a few feet above his head. Without seeing the genie, Pappy begins to write his farewell note. He muses to Donny that he wished he had a Thanksgiving meal with all the trimmings. Puff—instantly a giant meal is on the table in front of him. A delightfully surprised Donny and Pappy dig in.

Page 3: As Pappy munches on a turkey leg, he wishes that his archenemy, Bush Whacker Bob, could see him at that moment because ole Bushy would be green with envy. Puff—Bob appears with poker cards flying everywhere. He digs into the feast, taking over the meal from Pappy and Donny. In miserable desperation, Pappy wishes that none of this had ever happened. Puff—the feast and Bob disappear.

Page 4: Inky-Genie-Bot speaks for the first time and shocks Pappy. She tells him that she hoped he enjoyed his three wishes, picks up her ink bottle, and flies away. Pappy freezes for a panel or two, letting it all soak in. He thaws to say that if he can't leave a note then he refuses to die. He and Donny pack up and head back down the mountain.

This is the pattern to follow, whether your story is four pages or twenty-four.

SCRIPT

There are two ways of writing scripts for comic books. The first is where the writer continues from his page breakdown and plans every panel on the page and writes the dialogue. The other way of writing comics is where the writer finishes the plot and the page breakdown, and stops. The plot and breakdown are then sent to the layout and pencil artist. The cartoonist pencils the pages and returns them to the writer, who then scripts the dialogue. This is commonly referred to as the *Marvel method*, because Stan Lee and his stable of artists at Marvel Publishing pioneered this writing style.

I've done comics both ways, and I prefer the Marvel method. My reasoning is simple. Writing the script before the art is done tends to make the story very wordy. A panel with a total of forty words is too wordy.

The script method has a tendency to overlap the words and art. A script caption may read: "The white sailboat was lost on the deep blue sea." The description of the boat and the water are not necessary since the artist can communicate that. The script should deal with the fact that the boat is lost.

At this point we will go on to the penciling portion of the story and come back to the script later.

PENCILING

The cartoonist lays the story out and draws the finished story, using pencil. Sometimes the artist uses a non-reproducing blue pencil because the blue pencil will not photograph, making it unnecessary to erase the basic art after it is inked. I prefer staying with HB pencil.

Covers

Like it or not, people do judge a book by its cover. If it doesn't grab the buyer, then the greatest story in the world will not get read. The cover hooks the buyer and whets his appetite for more. An editor usually provides the cover idea. Several thumbnail sketches need to be done to make sure the best idea surfaces. Leave room at the top of the art for the title to be placed. Keep the main action of the art near the center and at least a half-inch from all sides, since the finished book will be trimmed when bound. If you choose to have a dark area on the bottom of the cover, have it lighter in color on top. The reverse is also true. Allow for some areas in which an editor can add *word balloons* or *teaser word* blurbs. Use lots of color. Keep the action central. Don't let your characters look off the page; this subliminally tells the buyer to look at the book next to yours on the rack, rather than yours. Make your cover ideas as heroic as possible.

Fig. 9-5 Rough sketches of cover design

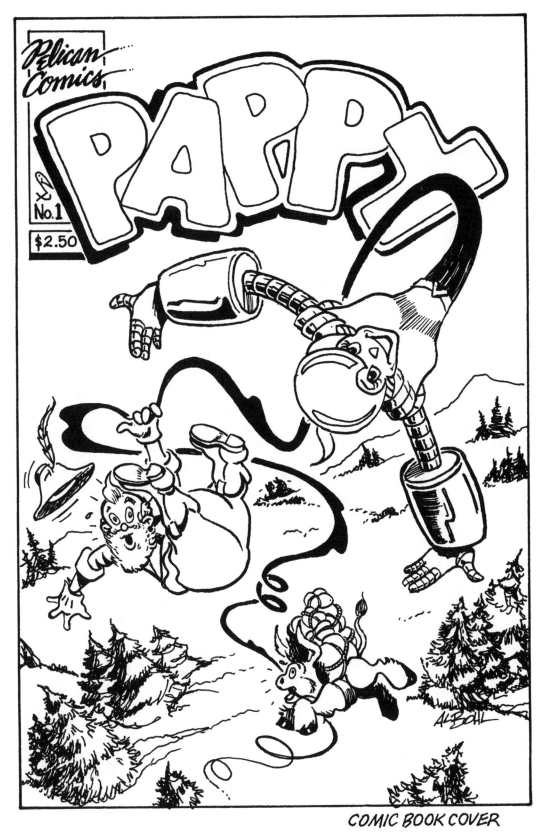

COMIC BOOK COVER

Fig. 9-6 Finished inked cover for Pappy comic

Thumbnails

The cartoonist is the camera operator, and must use camera angles to tell the story. After the penciler has read the plot numerous times, he draws the story in little pages about one or two inches wide and three or four inches high. In a loosely drawn manner, he determines how many panels each page will require to tell the story, and what is included in each panel. By drawing at this small size, the penciler can get a feel for the layout and design of all the pages. The thumbnails clarify the story for the artist. You can see the story at a glance and determine camera angles, light sources (mood), and story pacing. Most of my stories end up with about 70 percent of the pages having an action sequence of some kind, and action has to be carefully planned.

A thumbnail sketch shouldn't take more than ten to fifteen minutes to knock out. At this stage, your figures should look kind of like doodles. Make any story, props, or camera angle notations around the sketch. You may wish to refer back to chapter two of this book, under the section covering layouts and composition. Diagonal lines show action, horizontal lines denote tranquillity.

The average comic book has around twenty-two pages of story with five or six panels per page. I've used many more panels per page and a lot less. In stories that have more pages to work with, the first page is generally a large single panel called a *splash page*.

Every scene needs an *establishing shot*. This panel shows the location of the action. In the case of *The Wishy Washout*, the establishing shot is the first panel showing Pappy and Donny's climb through the blizzard to the shack. Another establishing shot is needed to show the interior of the shack.

Each page needs one or two close-ups. Fig. 9-8 shows examples of the different types of panels you can use to tell your story.

Two other devices that are needed to drive a story are *inserts* and *montage*. An insert is a panel that is sandwiched in between two other panels to add clarity or suspense to a scene. A montage is a compilation of several events together to summarize one complete thought.

The 180 Degree Line

The violation of the 180 degree line is the biggest mistake beginners make. As you can see in the diagram, two people are talking. An imaginary line is drawn through the center of the action. The camera can move back and forth along the line without a problem, but if the camera just jumps the line, it will disorient the reader. The only time the camera can cross the line is when an establishing shot is inserted between the panels or physical action, such as a fight, erupts.

Panels and Gutters

The speed at which a comic book story is told is determined by the panel sizes, the action within the panel, the number of panels per page, and the gutters between the panels. Normally, the gutters are a quarter of an inch wide. Compressing the gutters speeds up the story; spreading them out slows the story down. The panel can be sped up by having more than one action taking place at the same time. Varying the size of the panels can make the story slow down or speed up. Be sure that you don't get so fancy with your page layout that your readers get lost. Keep your panel borders simple so that they don't draw undue attention to themselves. Fancy borders take away from the story, and remind the readers that they are just reading a comic book. The only time the cartoonist should change a panel border type is to communicate a *flashback* to an event that takes place at another time in the past or future. Generally, other artistic devices (coloring or art style) are used to denote a change in the events of the storyline. You want the reader to be caught up in the story and not thinking about who wrote it or drew it or that this is even a book until they are finished.

Roughs

After you've worked the bugs out of your entire story in thumbnail sketches, it is time to move on to the rough pages. By this time, when I do roughs, I feel a little more relaxed about the story, because I know I can tell the story within my page count. I have also visualized the entire story in my mind. I draw rough pages on typing paper. I lay out the entire page in a more refined manner than the thumbnail sketch, and make any final changes in design. I check for possible new camera angles and to see if I've violated the 180 degree line.

If I am the writer and illustrator, I work out my script right on the roughs or in the one-inch margin I leave around the art. The cartoonist must remember

SPLASH PAGE/ESTABLISHING SHOT/BIRD'S-EYE-VIEW (DOWN SHOT)

Fig. 9-7 *Splash page and establishing shot from the comic book,* At Home Alone, *used by permission of Puppet Productions*

LONG SHOT

MEDIUM CLOSE-UP

OVER-THE-SHOULDER SHOT (VARIATION)

WORM'S-EYE-VIEW (UP SHOT)

MEDIUM CLOSE SHOT TWO SHOT

MEDIUM THREE SHOT

EXTREME CLOSE

Fig. 9-8 *Medium close-up, extreme close-up, medium three shot, over-the-shoulder shot, long shot used by the permission of Barbour and Company, Inc. Close-up, medium close-up, and worm's-eye-view used by permission of Puppet Productions.*

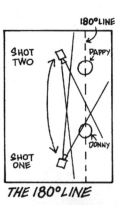

THE 180° LINE

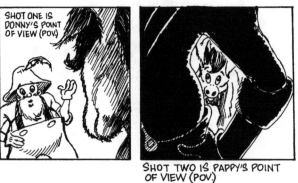

Fig. 9-10 *The 180 degree line rule*

Fig. 9-9 *Panel insert and montage; montage used by permission of Barbour and Company, Inc.*

during all his planning that there will be speech balloons to place. He must take this into consideration. Comic books should not be action from cover to cover. You need dialogue sequences to let your reader breathe and to add depth to your story, but dialogue

does not mean that you can get by with talking heads. This is the time that your actors or characters must listen and react. Hand gestures and facial expressions aided by dramatic lighting will deepen the power of the story.

If the penciler is also the inker, he may not need to provide detailed pencils. If someone else is the inker, the pencils must be tighter. Large areas of black can be indicated by a tiny X, rather than having to use a lot of gray pencil.

Finished Pencils

After the penciler has done the roughs, it is time to sharpen all images and transfer them to the art board. The art boards are 11" x 17". The normal art image is 10" x 15". If the pages are going to bleed or run off the edge of the paper when printed, the artist must add at least ³/₄" of art outside the 10" x 15" normal art image area. Most comic book art is reduced to 59 percent of its original size for printing. There are several ways to transfer art.

1. *Redrawing:* The hardest method of transfer is to redraw the roughs larger to fit the panel. This is

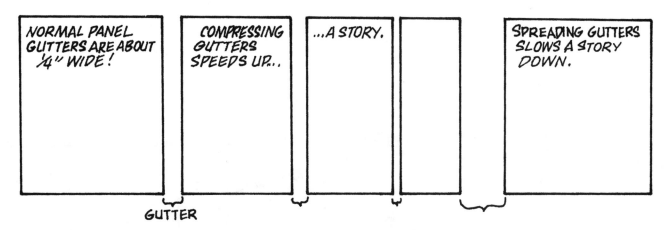

NORMAL PANEL GUTTERS ARE ABOUT ¼" WIDE!

COMPRESSING GUTTERS SPEEDS UP...

...A STORY.

SPREADING GUTTERS SLOWS A STORY DOWN.

GUTTER

PANELS AND GUTTERS

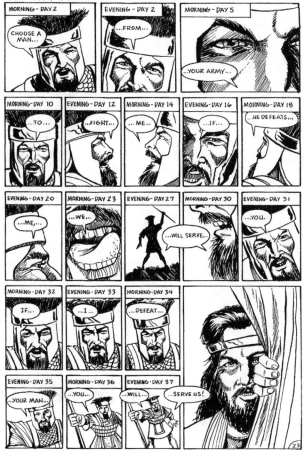

Fig. 9-11 *Panels control the pacing of the story. In this comic book page from the story of David and Goliath, notice how the panels dictate the pacing of the scene. Used by permission of Barbour and Company, Inc.*

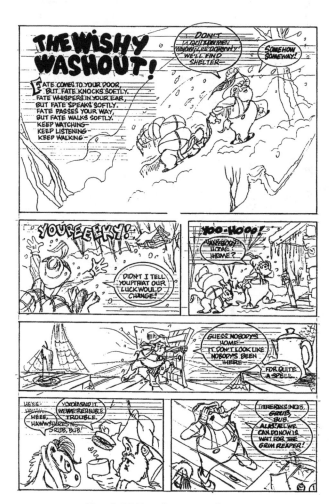

Fig. 9-12 *Rough pages and script*

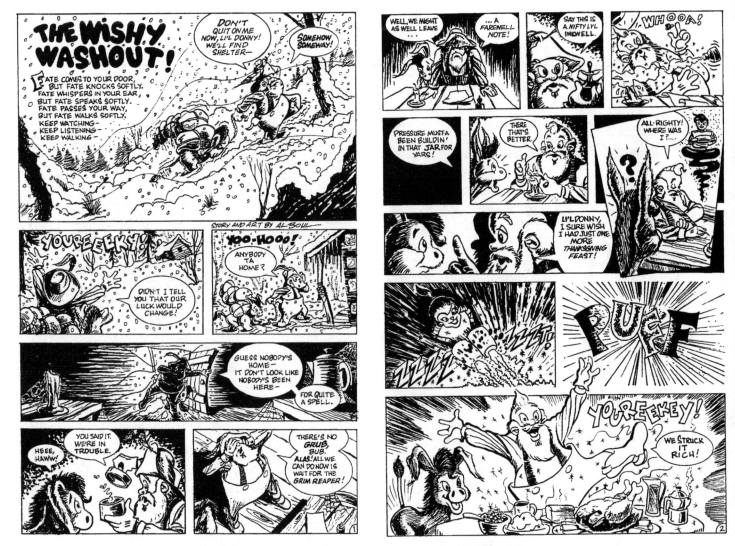

Fig. 9-13 *The finished pencils with inked words: panels 1 and 2*

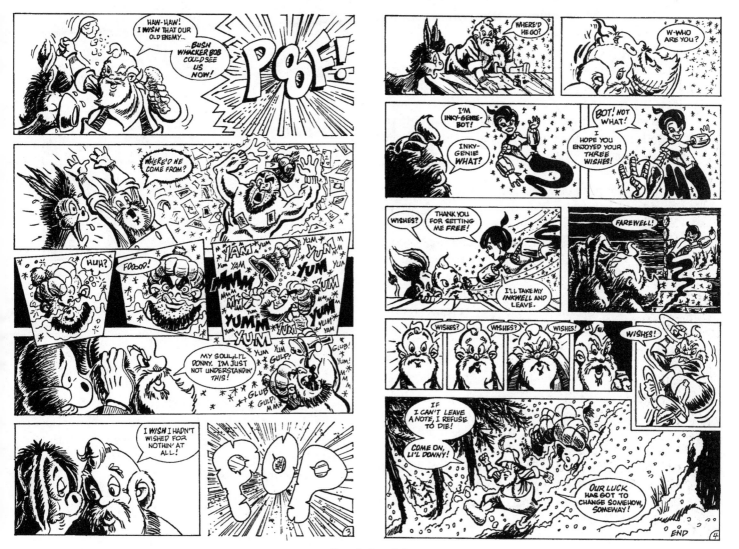

Panels 3 and 4

difficult because you probably will end up erasing and possibly marring the surface of the paper.

2. *Lightbox:* If you can get to a photocopier that enlarges and reduces, you can size your art for a panel. Then place it on a light box so you can see to redraw it. The finishing art board should be a 1-ply or maybe 2-ply Bristol board (smooth finish). An outside window can suffice in the daytime, but it is very tiring to draw standing up.

3. *Opaque projector:* I use an opaque projector or Art-o-graph enlarging machine. I draw any size I want and then put it in the projector which projects my rough drawing onto the finishing board. I trace my art and make any changes I desire. If you intend to become a professional, you will need a projector.

GOLDEN NUGGET: Using photos for references is not bad as long as you don't become a slave to them. Drawing superheroes makes photo referencing difficult due to the size and types of the heroes. I get friends to pose for positions that require extreme foreshortening or certain action scenes. It is not necessary to make them wear a costume.

When I have finished the penciled pages, I take them to a copy shop where I reduce them with a photocopier and have them bound into a book using inexpensive plastic binders. Again I see if my story is told in the best way possible. I send this onto the editor and scripter. A shorter story doesn't need to be plastic-bound. Most copy shops have a stapler with a deep throat to bind your pages together. Stapling is referred to as *saddle stitching*.

WRITER

Once the pencils are done, the art is returned to the writer, who scripts the dialogue. The trick is to refrain from writing too much or too little. Excessive dialogue can kill a reader's excitement and underwriting makes the reader zip through the book and feel cheated. Remember, you should have no more than forty words total in a single panel. Comic books are melodramatic in nature. Use descriptive words to tell the portion of the story that the art cannot. The

PHOTO REFERENCE

Fig. 9-14 *I sometimes use photo references. This is our friend Mike. He is one of our best models. Used by permission of Barbour and Company, Inc.*

writer is also responsible for supplying sound effects for the letterer to place dramatically. The sound effects do not have to be spelled correctly, but the reader does need to be able to pronounce them phonetically. The following is what a page of script would look like if I were sending the story to someone else to finish.

Script for *The Wishy Washout*

Page One

Panel one:

Title caption: The Wishy Washout

Caption: "Fate comes to your door, but Fate knocks softly. Fate whispers in your ear, but Fate speakes softly. Fate passes your way, but Fate walks softly. Keep watching—Keep listening—Keep walking."

Pappy B. Miner: "Don't quit on me now Li'l Donny! We'll find shelter—somehow someway!"

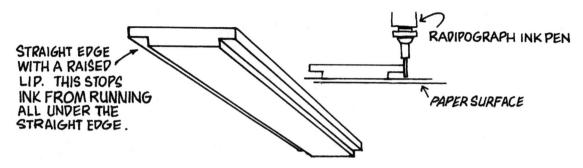

STRAIGHT EDGE WITH A RAISED LIP. THIS STOPS INK FROM RUNNING ALL UNDER THE STRAIGHT EDGE.

RADIPOGRAPH INK PEN

PAPER SURFACE

Fig. 9-15

Panel two:

Pappy B. Miner: "YOUREEEKY! Didn't I tell you that our luck would change!"

Panel three:

Pappy B. Miner: "YOO-HOO! Anybody ta home?"

Panel four:

Pappy B. Miner: "Guess nobody's home—it don't look like nobody's been here for quite a spell."

Panel five:

Li'l Donny Donkey: "HEEE, HAWW!"
Pappy B. Miner: "You said it. We're in trouble."

Panel six:

Pappy B. Miner: "There's no grub, bub. ALAS! All we can do now is wait for the Grim Reaper!"

LETTERING

The next person to contribute to the success of a comic book story is the letterer. The letterer or letterist receives the finished penciled pages. His or her tools are a mechanical pencil with HB lead, a T-square, an Ames Guide, ink, dip pen nibs or a refillable ink pen, and acrylic white paint to correct mistakes. Believe it or not, lettering is the area of this process that has the most problems with mistakes. See this book's chapter on comic strips for a more detailed discussion on the Ames Guide. For comic books, set the Ames Guide on $3^1/_2$ instead of 4. I use a number 2 and 3 pen point rapidograph pen for inking my letters. Some people like felt tip pens but they are harder to cover with correcting paint. Others like a dip pen Speedball B-5 or B-6 pen nib.

I'm afraid that in the near future most lettering for comic books will be done by computers. Some comic books have always used typesetting in their speech balloons. There is now a comic book lettering font for computers. For this course, you will learn the old-fashioned way. Besides, I enjoy lettering.

A letterer's job is to pencil and ink the words in the panels, pencil and ink the display words (titles and sound effects), and pencil and ink the panels' borders. I ink borders with a number 3 rapidograph pen point. Be sure that any straight edge used in the inking process has a raised lip so that ink doesn't run up under the edge. If you want to experiment with panel borders, that is fine, but remember that a border's function is to frame the story, not attract attention to itself.

It is odd to me that people pick up so easily on how to read comic books. As far as I know, there are no books that teach the universally accepted speech, thought, whisper, or electronic balloons. I guess it is somehow innate. The following are examples of how to produce the speech balloons.

Some Don'ts:

1. Don't have any lettering closer than an eighth of an inch from any side of a panel's border.

2. Don't have a speech balloon pointer, which indicates who is talking, directed at a person's ear or nose. It is better to have the pointer aimed at the head or body than an ear.

3. Don't make the speech balloon pointer too long in length, or curved unless the balloon is indicating a song or the character is fainting. A slender V shape is best.

4. Don't have speech balloon pointers criss-crossing each other. This is a major reason the cartoonist does thumbnails and roughs, so that this can be avoided.

5. Don't have a person's speech balloon pointers cutting across another person's body.

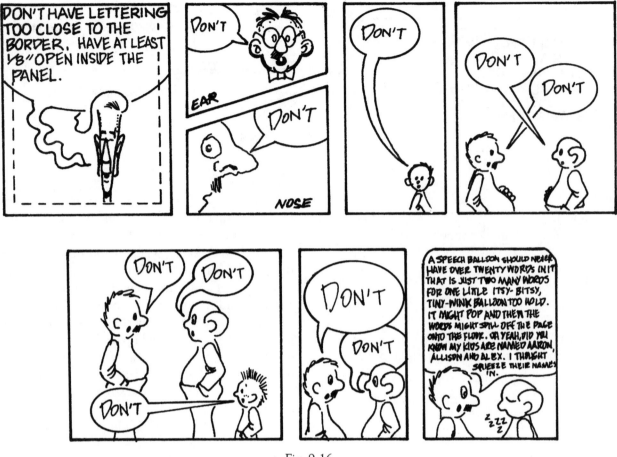

Fig. 9-16

6. Don't have one speech balloon overlapping or crowding another speech balloon.

7. Don't fill up a balloon with more than twenty words. If at all possible, break twenty words into two or more balloons.

Some letterers do their lettering on separate paper and then paste it onto the original art. This is also done if a mistake has been made that acrylic white paint can't correct. If this is done, there is usually a little edge of white paper around the outside of the balloon. The letterer must carefully reconnect any lines in the artwork to the new balloon so that they remain as one piece of art when printed.

INKING

The next person to touch the art is the inker. Using a variety of pen nibs and brushes, the inker solidifies the story. Some things to remember in inking are:

• Vary the thicknesses of your lines. Thicker lines go around the outside and thinner lines dominate the inside of a character.

• Place all solid black areas very carefully. Dark areas are for centering the focus or interest of the panel.

• Avoid putting in scratchy ink marks to fill up a panel. Every line or marking should be there for a reason. If you don't know how to fix or add to a panel, look at it upside down or in a mirror. If that doesn't help, take a few minutes' break from the panel. A little time may give you the answer. A little ink is better than a big mess. Don't forget that you are drawing almost twice the size that your art will be seen in its final form. If a panel is over-inked it will look like a real blob. Notice the feathering techniques displayed in Fig. 9-17.

• Mistakes can be easily corrected with acrylic white paint.

• Work on a page for a panel or two and then

FEATHERING IS EASIER
WHEN THE INK IS FRESH
AND THE BRUSH IS CLEAN.

Fig. 9-17 *Feathering technique with a brush works really great in rendering clothing.*

set it aside to dry. Work on another page for a while. This keeps you from smudging the ink before it's dry.

• The inker is responsible for adding any Benday or Zip-a-tone adhesive dot patterns.

• I use a #22B Hunt pen nib and a coquille pen nib to ink, and a #2 or #3 Windsor Newton sable brush.

• My ink of choice is Higgins Black Magic India Ink.

SUPERHEROIC FIGURES

I assume that most people interested in comic books are interested in superheroes since they dominate the books published and the portfolios of cartoonists I've seen. In the second chapter of this book there is a section on superhero anatomy. I suppose the long-underwear-type costumes came about as a means of riding the coattails or "cape" of Superman's success. Saving time may be the other reason. Drawing folds in clothing takes time and planning. The artists could put their efforts into getting the anatomy correct, then simply add a collar, cuffs, belt, boots, and a little color.

COLORIST

Once the editor has carefully checked the final artwork of the story in black and white, it is handed off to the person who indicates where the color will fit and how it will look. With the advent of computer coloring, the look of comic books has improved dramatically. Many printers who specialize in comic

books have their own computer color separators, but there are other companies who only do "seps." There are three ways to accomplish color separations.

Color Scanning

Color scanning is where the artist paints the actual artwork or a reproduction of the original page. The art is taken as is, placed on an electronic scanner drum, and separated into the dot patterns necessary for printing. This is done if you desire a painterly look. Most book publishing is done in this manner, but it is rarely done in comic books.

Gray Line Separating

Gray lines are seldom used in comic books. The cartoonist has a printer make a clear transparency (made by a reproduction camera, not a photocopy machine). The transparency would be reduced 59

Fig. 9-18 *30 percent gray line for coloring comic books*

percent to the size that the art would be printed. *Remember*, this is not a negative or a "film positive," this is a transparency. What is black on the original art is black on the transparency. What is white on the original art is clear on the transparency.

Next, the printer makes a 30 percent screen of the reduced art on paper. The art would appear to be light gray on the paper and *not* black. Using Dr. Martin's Dyes, the colorist paints the gray artwork just like he or she wants it to look when printed. For the dyes to adhere to the paper, the colorist must wear white cotton gloves and be sure the painted dye is dry before touching it. He works on several pages at once to avoid smearing the color. The colorist lines up the transparency with the painted gray line paper so that the black line art covers the gray lines. The printer electronically scans and separates the art into dot patterns and four color separations. The result is a painterly look. The reason for the transparency is so the black lines will remain dark and rich without being diluted by the paint. This an expensive way of color separating.

Computer Coloring

Today, this is the most popular means of color separating a comic book for color printing. The publisher selects whoever will do the color separations and negatives for the printing. There are different levels of computer coloring available. Level one is less expensive but is similar to how comics were done before computer coloring came along. The other levels increase in quality and price. The colorist must work within the price constraints determined by the publisher.

The separator provides the colorist with a color guide to work with. The color guide has all the possible hues the artist can choose. Under each color swatch or sample is either a number or coded notation. An example is that Reflex Red may simply have a number such as 217, or some guides may use letters of the alphabet such as *YR*, which means 100 percent yellow and 100 percent red. Sometimes instead of saying 100 percent, it is referred to as "solid."

The colorist makes reduced photocopies of the original art, being certain that the art has plenty of white area around it. The colorist paints the photocopy using Dr. Martin's Dyes, watercolor, acrylic paint, airbrush, colored pencil, crayons, or oils to get any desired effect. The color should be done as close as possible to how you want the finished color to look, especially if you desire some airbrush effects. I've seen some color indication pages that are more beautiful than the printed page.

After the pages are colored, the colorist will use an ink pen to put a dot in the center of the colored area. A line is then drawn over into the white margins. The color's guide number or letters are clearly written at the end of the line. Be sure that the lines are easy for the computer separator to follow. Sometimes a publisher doesn't want the color pages to be marked up; then you place a clear transparency over the color work and make your indications on the transparency. The computer separator will scan in the reduced black and white pages from original art. Going by the color indications of the colorists, the computer technician will put the color in the correct place.

When finished, a *color key* is made and sent to the colorist and publisher to decide if the pages are colored correctly. At this point changes can be made easily. Once changes are done and everything is approved, the computer will separate the art into four negatives that have all the right dot patterns, or rather *turn screens*, made so the metal printing plates can be produced. The book is then printed on large sheets, or webs, of paper. A *press test* is done, and if given the "Okay," the comic is printed. After the book is printed it is folded into a book, cut, stapled (saddle stitched), and trimmed. The finished books are then boxed and shipped to the publisher.

All along the process, an editor or team of editors checks each step, because once the book is printed, it is too late to notice problems. I've seen big mistakes made in art, lettering, coloring, and printing. After all, we are only human.

Assignment #1: Comic Book Morgue

This morgue is a little different from your other morgue assignments. Instead of collecting a folder of comic books, photocopy examples from various comics in these categories: A splash page, bird's-eye-view (down shot), worm's-eye-view (up shot), example of 180 degree rule, close-up, medium close-up, extreme close-up, medium shot, two shot, three shot, an establishing shot, a montage, good lettering/ sound effects, coloring effects, costuming you like

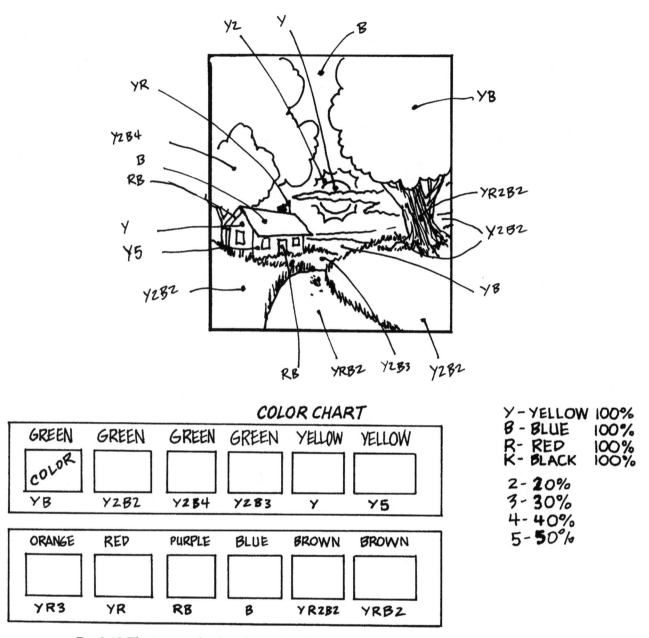

Fig. 9-19 *This is a sample of a color guide and how a comic book is marked up for color separating.*

and don't like, foreshortening, and perspective buildings/landscapes. These examples should be from superhero books and others.

Assignment #2: Create a One-Page Comic Story

As you saw in the course of this chapter, I wrote and illustrated a four-page story as an example. This assignment is for you to plot, break down, sketch thumbnails, do a rough layout, pencil, ink, and letter a one-page comic book story. You can pick the type of character you wish. It can be a superhero, funny animal, or whatever to tell the story. Remember to have a beginning, middle, and end. Let the story start pleasantly, then have something terrible happen, and finish the story with a happy ending. Really put some thought into this seemingly impossible task.

Assignment #3: Create Another Comic Story

Your assignment is to use what you have learned to produce a four-page story plus a cover, from plot to

color indications. I hope you consider doing something besides a superhero, but if you simply "gotta," then go ahead.

1. *Character:* Create your own characters, use the ones I have provided in this book, or use one of your personal favorites. As long as you are drawing a story for this course and are not intending to sell your comic book, there should be no problem with copyright or trademark infringement. No matter if you use your own, my, or other characters, include a brief written description of the characters and model sheets.

2. *Plot:* Write your own plot. It can be a retelling of *The Wishy Washout* or a reworking of a story you have seen before. It can be a comic version of a short story, biography, fairy tale, or poem. Start with a your high concept sentence, develop it into a one-page plot description, write an extended plot, and do page breakdowns. Keep your story simple. Don't bother with crossing subplots. Tell one simple story.

3. *Thumbnails:* In ten to fifteen minutes per page, draw a thumbnail sketch of the entire story and the cover. The cover can fit the front page or be a wraparound cover spanning the back and front. If doing a wrap-around cover, remember that the front will be on the far right half of the art.

4. *Roughs and finishes:* Draw the story in the four pages. Start with larger roughs, and then transfer them to 11" x 17" finishing art board. Do very tight pencil pages.

5. *Script:* From your plot and roughs, write your script or dialogue, captions, and sound effects. You can hand-write or type the script. Since you are also writing the script, you may make photocopies of your roughs and write the script in the margins around the art.

6. *Lettering:* Pencil and ink the lettering, sound effects, and borders onto the finished illustration boards.

7. *Inking:* Ink the art for your story.

8. *Coloring:* Using whatever color devices are at your disposal, make up your own color guide with corresponding numbers. It doesn't have to be elaborate since this is just an exercise. Then make photocopies of your story and color the pages. Mark up your colored pages, indicating the color you want done. If you don't want to mark on the actual color pages, place a clear transparency over the art and make your indications.

Reduce the pages with a photocopy machine to 8$\frac{1}{2}$" x 11" size. Put them on both sides of an 11" x 17" sheet and make a booklet. Add the cover to an 11" x 17" sheet and staple it to your story. Congratulations! You've written a comic book!

Review Questions

1. Define what a comic book is.

2. Name the two kinds of comic book distribution companies and describe how they are different.

3. What are the two most important elements of a story?

4. What is *backstory*?

5. Define the term "high concept story."

6. What is meant by the term "the Marvel method," and who invented that style of comic book writing?

7. Draw a diagram and explain the 180 degree rule.

8. List and briefly explain the steps taken to produce a comic book.

APPENDIX:

RESOURCES

RECOMMENDED SCHOOLS

American Center for Computer Imaging and Animation; 2526 27th Avenue S., Minneapolis, MN 55406; (800) 800-2835 Minneapolis; (800) 288-7442 Raleigh

Cal Arts; 24700 McBean Parkway, Valencia, CA 91355; (805) 255-1050

Joe Kubert School of Cartoon and Graphic Art, Inc.; 37 Myrtle Ave. , Dover, NJ 07801; (201) 361-1327

Ringling School of Art and Design; 1111 Twenty-Seventh St., Sarasota, FL 33580; (813) 351-4614

School of the Art Institute of Chicago; Columbus Dr. and Jackson Blvd., Chicago, IL 60603; (312) 443-3712

School of Visual Arts; 209 East 23rd Street, New York, NY 10010-3994; (212) 592-2100

CORRESPONDENCE INSTRUCTION

Cartoonarama; P.O. Box 854, Portland, ME 04104; (207) 773-5040

"Famous Names" course in cartooning/gagwriting; *Cartoon World*, P.O. Box 30367, Lincoln NE 68503

RESOURCES

Cox, Mary, ed. *Artist's and Graphic Designer's Market*. Cincinnati, OH: Writer's Digest Books, 1995. (Published annually)

Greeting Card Association; 1200 G Street, NW Suite 760, Washington, DC 20005; (202) 393-1778.

"HOW TO" BOOKS AND VIDEOS

ANIMATION

Blair, Preston. *Animation #26*. Tustin, CA: Foster Art Service, Inc., 1986.

—————. *How to Animate Film Cartoons #190*. Tustin, CA: Foster Art Service, Inc., 1986.

Disney artists. *Disney's How to Draw*. Tustin, CA: Walter Foster Publishing, 1993. (A series of books that teach how to draw *Bambi*, *The Little Mermaid*, *Beauty and the Beast*, *Aladdin*, etc.)

Gush, Byron. *The Shoestring Animator*. Chicago, IL: Contemporary Books, Inc., 1981. (Out of print.)

Jenkins, Patrick. *Flipbook Animation and Other Ways to Make Cartoons Move*. Toronto, Canada: Kids Can Press, Ltd., 1991.

Locke, Lafe. *Film Animation Techniques: A Beginner's Guide and Handbook*. Cincinnati, OH: Better Way Books, 1992.

Rubin, Susan. *Animation: The Art and the Industry*. Englewood Cliffs, NJ: Prentice-Hall, Inc., 1984.

Solomon, Charles. *The History of Animation: Enchanted Drawings*. Avenel, NJ: Wings Books, 1994.

Thomas, Bob. *Disney's Art of Animation*. New York, NY: Hyperion, 1991.

CARICATURE

Gauthier, Dick. *Drawing and Cartooning 1001 Caricatures*. New York, NY: Perigee, 1995.

Lucie-Smith, Edward. *The Art of Caricature*. Ithaca, NY: Cornell University Press, 1981.

Redman, Lenn. *How to Draw Caricatures*. Chicago, IL: Contemporary Books, Inc,. 1984.

The One Minute Caricature (an excellent book and 70-minute video); Jim van der Keyl Productions; 13691 Gavina Ave. #508, Dept CP 2, Sylmar, CA 91342; or call (800) 944-1799 for free brochure

COMIC BOOKS

Buckler, Rich. *How to Become a Comic Book Artist*. Brooklyn, NY: Solson Publications, 1986.

_____. *How to Draw Superheroes*. Brooklyn, NY: Solson Publications, 1986.

Eisner, Will. *Comics & Sequential Art*. Tamarac, FL: Poorhouse Press, 1985.

Hart, Christopher. *How to Draw Comic Book Heroes and Villains*. New York, NY: Watson-Guptill Publications, 1995.

Kurtzman, Harvey. *From Aargh! To Zap: Harvey Kurtzman's Visual History of Comics*. New York, NY: Prentice-Hall Press, 1991.

Lee, Stan, and Buscema, John. *How to Draw Comics the Marvel Way*. New York, NY: Simon and Shuster, Inc., 1978.

McKenzie, Alan. *How to Draw and Sell Comic Strips for Newspapers and Comic Books*. Cincinnati, OH: North Light Books, 1987.

EDITORIAL CARTOONING AND COMIC STRIPS

Brooks, Charles, ed. *Best Editorial Cartoons of the Year*. Gretna, LA: Pelican Publishing Company, 1996. (New book released annually. Most editions available from 1972 to present.)

Glubok, Shirley. *The Art of the Comic Strip*. New York, NY: Macmillan, 1979.

Hess, Stephen, and Kaplan, Milton. *The Ungentlemanly Art: The History of the American Political Cartoon*. New York, NY: Macmillan, 1968.

Hoff, Syd. *Editorial and Political Cartooning*. New York, NY: Stravon Educational Press, 1976.

Lane, Susan. *How to Make Money in Newspaper Syndication*. Los Angeles, CA: Newspaper Syndication Specialists, 1987.

GENERAL CARTOONING

Ames. Lee. *Draw 50 Famous Cartoons*. Garden City, NJ: Doubleday, 1979. (Lee Ames has at least eighteen *Draw 50 . . .* type books.)

Erskine, Jim. *The Cartoonist Survival Guide*. Bowling Green, KY: Arf Arf Studios, 1986.

Hamm, Jack. *Cartooning the Head and Figure*. New York, NY: Perigee Books, 1967.

_____. *Drawing & Cartooning for Laughs*. New York, NY: Perigee Books, 1990.

_____. *Drawing Scenery*. New York, NY: Perigee Books, 1972.

_____. *Drawing the Head and Figure*. New York, NY: Perigee Books, 1963.

_____. *How to Draw Animals*. New York, NY: Perigee Books, 1969.

Hart, Christopher. *Everything You Ever Wanted to Know about Cartooning but Were Afraid to Draw*. New York, NY: Watson-Guptill, 1994.

Kistler, Mark. *Draw Squad*. New York, NY: Simon and Shuster, Inc., 1988.

Markow, Jack. *Cartoonist's and Gagwriter's Handbook*. Cincinnati, OH: Writer's Digest Books, 1967. (Out of print, but great if you can locate one.)

Sidebotham, Jack. *The Art of Cartooning*. New York, NY: Grumbacher, 1977.

FIGURE ANATOMY

Bridgman, George. *Bridgman's Complete Guide to Drawing from Life*. Avenel, NJ: Wings Books, 1992.

Burne, Hogarth. *Drawing Dynamic Hands*. New York, NY: Watson-Guptill, 1977.

_____. *Dynamic Figure Drawing*. New York, NY: Watson-Guptill, 1970.

_____. *Dynamic Wrinkles and Drapery*. New York, NY: Watson-Guptill, 1992.

Sheppard, Joseph. *Anatomy: A Complete Guide for Artists*. New York, NY: Watson-Guptill, 1975.

ILLUSTRATION

Meglin, Nick. *Humorous Illustration*. New York, NY: Watson-Guptill, 1981.

Rockwell, Norman. *Rockwell on Rockwell*. New York, NY: Watson-Guptill, 1979.

BIOGRAPHIES

Adamson, Joe. *Tex Avery: King of Cartoon*. New York, NY: Popular Library, 1975. (animation)

Barrier, Michael. *Carl Barks and the Art of the Comic Book*. New York, NY: M. Lilien, 1981. (comic book)

Dr. Seuss from Then to Now: A Catalogue of the Retrospective Exhibition. The San Diego Museum of Art, 1986. (book illustration)

Duncan, David, with Drucker, Mort. *Familiar Faces: The Art of Mort Drucker*. Redford, MI: Starbur Press, Inc., 1988. (caricature)

Harrison, Hank. *The Art of Jack Davis*. Redford, MI: Starbur Press, Inc., 1987. (illustration)

Johnson, Rheta Grimsley. *Good Grief: The Story of Charles M. Schulz*. New York, NY: Pharos Books, 1989. (comic strip)

Kelly, Mrs. Walt, and Crouch, Bill, ed. *Phi Beta Pogo*. New York, NY: Simon and Shuster, 1989. (comic strip)

Thomas, Bob. *Walt Disney: An American Original*. New York, NY: Hyperion, 1994. (animation)

Yronwode, Catherine. *The Art of Will Eisner*. Princeton, WI: Kitchen Sink Press, 1982. (comic book and comic strip)

PERIODICALS

Cartoonist Profiles; P.O. Box 325, Fairfield, CT 06430 (quarterly magazine)

Comic Buyer's Guide; 700 East State Street, Iola, WI 54990-0001; (715) 445-2214 (publishes weekly newspaper covering comic books)

Editor and Publisher Magazine; 11 West 19th Street, New York, NY, 10011; (212) 675-4380 (annual syndicate directory for comic strips and editorial cartoons)

Greetings Magazine; 307 Fifth Avenue, New York, NY 10016 (greeting cards)

The Animation Magazine; 28024 Dorothy Drive, Suite 200, Agoura Hills, CA 91301; (818) 991-2884 (animation)

CARTOONING SUPPLIES

Cartoon Colour Co., Inc.; 9024 Lindblade Street, Culver City, CA 90232-2584; (800) 523-3665. (supplies for animation)

Chartpak; One River Road, Leeds, MA 01053; (800) 628-1910 (artist material catalog concerning prefabricated adhesive screens)

Dick Blick; P.O. Box 1267, Galesburg, IL, 61402; (800) 447-8192 (artist material catalog)

Pro Video & Film Equipment Group; 11419 Mathis Street, Dallas, TX 75234; (214) 869-0011 (new and used film and video equipment)

The Re-Print Corporation; 2025 1st Avenue North, Birmingham, AL 35203; (800) 248-9171 (artist material catalog)

Animation Controls Video Pencil Test System; Animation Controls, Inc., 425 S. Horne, Oceanside, CA 92054; (619) 722-4540

SPECIFICATIONS FOR PRINTING
A COMIC BOOK

Product: Comic book (catalog) air dried

Stock: *(paper)* 40# or _____# Coated cover with 30# or _____# News text
 (# = pound; means the weight of the paper)

Quantity: 2,000; 5,000; 10,000

Number of Pages: ____ text (art) pages with 4-page cover.

Size: _____ 6¾" X 10½" Full bleed artwork on all pages
(Bleed means that art work goes past the edge of the trimmed page.)

Trim size: 6½" X 10"
 _____ 6¾" X 10½" No bleed except on cover
Trim size: 6½" X 10"

Color: ____ Four color on all pages including the cover *(outside and inside: front and back on cover)*
 ____ Black and white interior art with full color cover *(outside: front and back on cover)*
 ____ Black and white interior art with full color cover *(outside and inside: front and back on cover)*

Preparation: Composite film furnished
(film means the color separated negatives provided by the color separator.)

Binding: Stitch *(stapled)* and trim; quarterfolding included

Packing: Bulk stacked on skids or _____ .

Shipping: F.O.B. our dock *(you pick up)* or _____ .

Price: 2,000 - _____/M *(per thousand)*
 5,000 - _____/M
 10,000 - _____/M
 Plate change charge: _____